ART DIRECTORS' INDEX TO PHOTOGRAPHY 22

RotoVision

CREDITS – COPYRIGHT

DUST JACKET ILLUSTRATION
ILLUSTRATION DE LA JAQUETTE
SCHUTZUMSCHLAGILLUSTRATION
· · · ·

Patrick Toselli
33b Muller Street
North Buccleuch Sandton
South Africa
Tel: 2711 802 7621

BOOK DESIGN
DESIGN DU LIVRE
BUCHDESIGN
· · · ·

PINEAPPLE DESIGN SA
Rue de la Consolation 56
B-1030 Brussels
Belgium
Tel. +32(0)2 242 78 20
Fax: +32 (0)2 242 96 40

PUBLISHER
ÉDITEUR
VERLAG
· · · ·

ROTOVISION SA
7, rue de Bugnon
CH-1299 Crans
Switzerland
Tel: +41 22 776 0511
Fax: +41 22 776 0889

SALES OFFICE:
Sheridan House
112-116a Western Road
Hove, East Sussex
BN3 1DD
United Kingdom
Tel: +44 (0)1273 727268
Fax: +44 (0)1273 727269

COPYRIGHT
· · · ·

© 1997 ROTOVISION SA
ISBN 2-88046-302-5
Printed in Singapore

CONTENT / CONTENU / INHALT

EUROPE

BELGIUM
BELGIQUE
BELGIEN
277

FRANCE
FRANCE
FRANKREICH
301

GERMANY
ALLEMAGNE
DEUTSCHLAND
17

GREECE
GRÈCE
GRIECHENLAND
77

HOLLAND
HOLLANDE
HOLLAND
285

ITALY
ITALIE
ITALIEN
89

PORTUGAL
PORTUGAL
PORTUGAL
129

SPAIN
ESPAGNE
SPANIEN
137

SWITZERLAND
SUISSE
SCHWEIZ
49

UNITED KINGDOM
GRANDE-BRETAGNE
GROSSBRITANNIEN
209

PORTFOLIO PAGE SALES AGENTS

ARGENTINA

DOCUMENTA SRL.
Córdoba 612 entrepiso
1054 Buenos Aires
Tel. +54 (1) 322-9581
Fax: +54 (1) 326-9595
Contact: Aquiles Ferrario

AUSTRALIA

MOTIF VISION
69 Alder Way
Duncraig
WA 6023
Tel. 09-387 7798
Mobile: 041 211 4221
Contact: Peter Pendrill

AUSTRIA

INSIDER
MODELLAGENTUR
Semperstrasse 31-15
1180 Vienna
Tel. 1-479 66 22
Fax: 1-479 66 22 74
Contact: Marina Baumann

BELGIUM

SEDIP
Rue Vanderkindere 318
1180 Bruxelles
Tel. +32 2-343 44 99
Fax: +32 2-343 79 51
Contact:
Mr. P. de Vanssay /
Mrs E. Wibaut

BRAZIL

CASA ONO COMÉRCIO E
IMPORTAÇÃO LTDA.
Rua Fernão Dias 492 - Pinheiros
São Paulo SP - CEP 05427
Tel. +55 11-813 6522
Fax: +55 11-212 6488
Contact: Hirokazu Taguchi

CHILE

BOOKMAN
Pedro de Valdivia 1781
Local 176
Santiago
Tel. +56 2-204 5172
Fax: +56 2-204 5172
Contact:
Christian and Mirko Bulat

COLOMBIA

Carrera 63A - Nro. 60-56
Santafé de Bogota
Tel. +57 (1) 231 2314
Fax: 5793 228 0068
Contact: Pilar Gaitan Sandoval

COSTA RICA

HEVIN PUBLIC SA
Pavas del Cementerio 100
Sur 250 Oeste, Casa 31
1200 San José
Tel. +506 231 6921
Fax: +506 231 6921
Contact: Henry Vindas Calderón

ECUADOR

LIBRI MUNDI
Juan León Mera 851
PO Box 17-01-3029
Quito
Tel. +593 2-521 606 / 544 185 /
234 791 / 529 587
Fax: +593 2-504 209
Contact:
Marcela Garcia Grosse-Luemern

FRANCE

SEDIP
53, rue Jules-Ferry
F-59310 Orchies
Tel. +33 (3) 20 64 87 29
Contact: Françoise Lalanne

MAT CONSEIL
"Fayel"
F-35320 La Couyère
Tel. +33 (2) 99 43 19 84
Fax: +33 (2) 99 44 23 36
Contact: Graham Keysell

GERMANY

MARGRET
OSTROWSKI-WENZEL
Am Weiher 14
20255 Hamburg
Tel. 40-40 56 12
Fax: 40-40 56 12

GUDRUN
TEMPELMANN-BOEHR
Am Rosenbaum 7
40699 Erkrath
Tel. 211-25 32 46
Fax: 211-25 46 32

MANFRED OSTNER
Osterwaldstrasse 10, H23
80805 München
Tel. 89-361 01 985
Fax: 89-361 02 481

GREECE

STUDIO CLIP
121th Anexartisias Str.
16451 Argyroupolis, Athens
Tel. +301 996 1342/995 5374
Fax: +301 993 3334
Contact: Joanna Papadopoulou

HONG KONG

MANIFEST MARKETING LTD
16A Hollywood Centre
79-91 Queens Road West
Tel. 2915 2157
Fax: 2975 4374
Mobile: 9481 5586
bvd@hk.super.net.
Contact: Bryan VanDale

INDIA

MAGNUM BOOKS
Suite 9, "Ajanta" Chheda Nagar
Bombay-400 089
Tel. 555 26 60
Fax: 91-22-5563953
Contact: K.S. Ganesh

INDONESIA

PT GRAFINDO INTER PRIMA
32 Kwitang Road
PO Box 4215
Jakarta
Tel. 62 21 390 1613
Fax: 62 21 310 7886
Contact: Wani Kusmulyana

ITALY

ZANDRA MANTILLA
Monte Amiata, 3
20149 Milano
Tel. +39 2 498 4926/480 12684
Fax: +39 2 498 4926

JAPAN

AGOSTO INC.
7F Shine Building
4-4 Kojimachi
Chiyoda-ku
Tokyo 102
Tel. 03-3262 4595
Fax: 03-3262 9463

KOREA

AHN GRAPHICS LTD
260-88 Songbuk 2-Dong
Songbuk-gu
Seoul 136-012
Tel. 02-743 80 65 / 6.
02-763 23 20
Fax: 02-743 33 52

MALAYSIA

FLO ENTERPRISES
SDN.BHD.
24 Lorong PJS 1/2A
Taman Perangsang
Batu 6, Jalan Kelang Lama
46000 Petaling Jaya
Selangor Darul Ehsan
Tel. 60 3793 3118
Fax: 60 3793 1066
Contact: Johnny Leong

MEXICO

PRODUCTION MGA S.A.
Montes Cárpatos 210
Col. Lomas Virreyes
11000 México D.F.
Tel. +52 5-540 2076
Fax: +52 5-540 2076
Contact: Marcela Gaxiola

SCANDINAVIA

BOE MEDIA
Stockholmsvägen 33-35
181 33 Lidingö
Sweden
Tel. 08-767 00 15
Fax: 08-767 00 14
Contact: Barbro Olson-Ehn

PHILIPPINES

MARKETING HORIZONS
Room 202 Veca Building
Pasong Tamo cor. Estrella Streets
Makati City
Metro Manilla
Tel. 63 2890 7612
Fax: 63 2890 7637
Contact: Betty B. Bravo

PORTUGAL

DESTARTE
Rua Santo António da Glória, 90
1200 Lisboa
Tel. +351 1 347 9164/347 0199
Fax: + 351 1 347 5811
Contact: Jorge Linhares

SINGAPORE

PAGE ONE -
THE DESIGNERS
BOOKSHOP PTE LTD
Blk 4 Pasir Panjang Road
08-33 Alexandra Distripark
0511 Singapore
Tel. 65 273 0128
Fax: 65 273 0042
Contact: Mark Tan

SOUTH AFRICA

TRUDY DICKENS
ASSOCIATION
OF MARKETEERS
P.O. Box 98853
Sloane Park
2152 Johannesburg
Tel. 011-462 2380/706 1633
Fax: 011-706 4151
Mobile: 083-250 8635

SPAIN

INDEX BOOK SL
Consell de Cent 160 - Local 3
08015 Barcelona
Tel. +34 (3) 454 5547
Fax: +34 (3) 454 8438
indexbook@interfad.es
Contact: Sylvie Estrada

SWITZERLAND

T-CASE AG
Zollikerstrasse 19
CH-8008 Zürich
Tel. +41 (1) 383 4680
Fax: +41 (1) 383 4680
Contact: Katja Cavazzi

TAIWAN

TANG YUNG CO.
8F-2 No. 291 Sec 2
Fu Hsing S. Road
Taipei
Tel. 886 2708 9572
Fax: 886 2703 1642
Contact: Danny Chao

UNITED KINGDOM

INDEPENDENT SPIRIT
BUSINESS
2nd Floor - 22 Greek Street
Soho
London W1V 5LF
Tel. (0) 171 287 4908
Fax: (0) 171 439 0559
Mobile: 0973 553082
Contact: Jonathan Roberts

URUGUAY

GRAFFITI
Convención 1366 - Local 8
CP 11100 Montevideo
Tel. +598 2-922 976
Fax: +598 2-922 976
Contact: Carlos Mañosa

USA

AMERICAN SHOWCASE INC.
915 Broadway, 14th Floor
New York NY 10010
Yel. 001 212 673 6600
Fax: 001 212 673 9795
Contact: Rob Drasin

VENEZUELA

CONTEMPORÁNEA DE
EDICIONES
Av. La Salle Cruce con Lima
Edificio Irbia - Urb. Los Caobos
1050 Caracas
Tel. +58 2-793 7591 / 793 0396
Fax: +58 2-793 6566
Contact: Luis Fernando Ramirez

REGIONAL OFFICES:
ASEAN COUNTRIES

PROVISION
1 Selegie Road N°. 08-23
Paradiz Center
Singapore 188306
Tel. 334 77 20
Fax: 334 77 21
Contact: Alice Goh

SOUTH AMERICA

DELEGACIÓN AMÉRICA
LATINA
Alsina 120
5147 Argüello
Córdoba
Argentina
Tel. & Fax: +54 543-20 925
Contact: Alejandro Christe

GEOGRAPHICAL

ALPHA

INDEX

B E L G I U M
B E L G I Q U E
B E L G I E N

BAETENS, PASCAL 279

Studio P.J.J.
Wllem Coosemansstraat 122
B-3010 Kessel-Lo
Tel. +32 16 25 8411
Fax: +32 16 25 8470

BRUYNSEELS, DANIEL 280

BVBA
Bergensesteenweg 407
B-1600 St Pieters Leeuw
Tel. +32 2 377 6900
Fax: +32 2 378 2219

CHERPION, ERIC 281

Shimera
Rue de L'Orient 65
B-1040 Bruxelles
Tel. +32 2 648 9913
Fax: +32 2 640 4918

DE KINDER, GEORGES 283

Chee D'Alsenberg 216
B-1190 Bruxelles
Tel./Fax: +32 2 346 6825

DE MEYER, MICHEL 284

Vinkendam 6
B-9120 Beveren
Tel. +32 3 755 3474
Fax: +32 3 755 3015

DEPREZ, KOENRAAD 282

Koenraad Deprez Photography
Wielewaalstraat 102
B-9000 Gent
Tel. +32 9 227 7822
Fax: +32 9 226 7175

F R A N C E
F R A N C E
F R A N K R E I C H

DELEU, SERGE 304

13, rue Hameau de Prez
F-59710 Avelin
Tel. +33 3 20 61 4040
Fax: +33 3 20 59 5740

FERRER, PHILIPPE 312-313

Domino
3-5, rue Mélinge
F-75019 Paris
Tel./Fax: +33 1 40 03 85 11

FORZI, MARC 310-311

Studio Looker
Geouresset
F-01101 Oyonnax
Tel. +33 4 74 73 06 76
Fax: +33 4 74 73 0903

**HEIMERMANN,
ÉTIENNE 302-303, 47-48**

Le Fotographe
32a, quai Arloing
F-69009 Lyon
Tel. +33 4 78 83 46 31
Fax: +33 4 78 83 21 06

LUCIANI, PASCAL 314-315

Domino
3-5, rue Mélinge
F-75019 Paris
Tel./Fax: +33 1 40 03 85 11

PÉROUSE, PIERRE 305

Union des Photographes
Créateurs
100, rue Vieille-du-Temple
F-75003 Paris
Tel. +33 1 42 77 2430
Fax: +33 1 42 77 2439

QUAEGEBEUR, FABRICE 308

Studio 4 x 5
31, chemin du Halage
F-59290 Wasquehal
Tel. +33 3 20 24 02 29
Fax: +33 3 20 26 17 30

STUDIO NEW LOOK 306-307

245 rue Jean-Jaurès
F-59491 Villeneuve-d'Ascq
Tel. +33 3 20 20 36 36
Fax: +33 3 20 20 36 30

G E R M A N Y
A L L E M A G N E
D E U T S C H L A N D

BAUER, KLAAS 18

Hegestr. 40
D-20251 Hamburg
Tel. +49 40 480 2176
Fax: +49 40 477 514

BROMBA, ANDREAS 19

Nukleaform
Stargarder Straße. 75
D-10437 Berlin
Tel. +49 30 444 7307
Fax: +49 30 444 7308

CASTELL, GIOVANNI 21

Parkallee 82
D-20144 Hamburg
Tel. +49 40 45 22 12

DARLISON, HANS JÜRGEN 25

Winterhuder Weg 112
D-22085 Hamburg
Tel. +49 40 227 228 /0
Fax: +49 40 229 11 32

DEISENROTH, WERNER 22-23

Benzstraße 4
D-85551 Kirchheim
Tel. +49 89 991 50 40
Fax: +49 89 903 11 11

EISELE, WERNER 24

Schwabstraße 2
D-70197 Stuttgart
Tel. +49 711 617 181

FÖRSTERLING, STEPHAN 26

Friedensallee 29
D-22765 Hamburg
Tel. +49 40 390 58 39
Fax: +49 40 390 58 00

FRITSCHE, JÖRG 27

Peutestraße 53
D-20539 Hamburg
Tel. +49 40 789 34 11

GARRELS, ANDREAS 28

Süderstraße. 159A
D-20537 Hamburg
Tel. +49 40 250 7756

GERMANY
ALLEMAGNE
DEUTSCHLAND

HARTENFELS, ROLF 29

Von Huttenstr. 16
D-22761 Hamburg
Tel. +49 40 899 2116
Fax: +49 40 899 3469

HIRSCHMÜLLER, SVEN 30-31

Schellingstr. 17
D-22089 Hamburg
Tel. +49 40 203 236

HNIZDO, JAN 32

Studia 3000
Cistovicka 44
CZ-16300 Praha 6
Czech Republic
Tel. +42 2 302 27 87
Fax: + 42 2 302 46 06

IOAKIMIDIS, NEKTARIOS 33

Gorenstr. 4
D-80802 München
Tel. +49 89 33 59 36

KAMMER, ARMIN 34-35

AK Werbefotografie GmbH
In den Fichten 5
D-32584 Löhne-Gohfeld
Tel. +49 5731 7477-0

KOCH, CHRISTIANE 36

Ruhrstraße 13
D-22761 Hamburg
Tel. +49 40 851 29 86

LINK, MICHAEL 37

Rotodesign
Hauptstraße 1
D-55257 Rudenheim
Tel. +49 6139 92340
Fax: +49 6139 5435

MAYEN, PIT 38-39

Corneliusstraße 72
D-40215 Düsseldorf
Tel. +49 211 31 76 37
Fax: +49 211 31 76 37

MOOG, MARCO 40

Löwenstr.40
D-20251 Hamburg
Tel. +49 40 420 5058
Fax: +49 40 420 5077

RABEN, SVEN C 41

Rutschbahn 11A
D-20146 Hamburg
Tel. +49 40 4504088
Fax: +49 40 450 4090

SCHÖN, HARALD 48

Lukas-Moser Straße 33
D-75173 Pforzheim
Tel. +49 7231 767 276

STEMMLER, KLAUS 42-43

Eppendorfer Weg. 87A
D-20259 Hamburg
Tel. +49 40 40 17 33 40
Fax: +49 40 40 17 33 48

VAN DEN BERG, JO 20

Holstenstr.110
D-22767 Hamburg
Tel. +49 40 38 16 48
Fax: +49 40 389 4817

**WARTENBERG,
FRANK P 44-45**

Leverkusenstr. 25
D-22761 Hamburg
Tel: +49 40 850 8331
Fax: +49 40 850 3991

GREECE
GRÈCE
GRIECHENLAND

BIANCHI, STEFANO 78

7 Iolis Street
G-116 36 Athens
Tel: + 301 92 25 623
Fax: +301 92 24 775

CHRISAGIS, ARIS 86-87

12-16 Archita Street
G-116 35 Athens
Tel: 90 28 994
Fax: 90 28 924

KOUTOULIAS, GABRIEL 79

40 Kritovoulidou Street
G-104 45 Athens
Tel: 83 10 029

NICOLAIDIS, GEORGE D 80

Studio Image & Photographic Art
36 Filaretou Street
G-176 72 Athens
Tel: 95 97 480 / 95 97 260
Fax: 93 29 929

REPPAS, ANDREAS 81

16 Atlantos Street
G-152 34 Athens
Tel: 60 08 991 / 60 08 639
Fax: 60 04 428

SAMIOS, STEFANOS 82-83

Phobia Image Studio
14 - 16 Sirini Street
G-115 28 Athens
Tel: 72 14 410 / 72 50 949

**SOFIANOPOULOS,
ALEXIS 84-85**

2 Iteas Street
G-151 25 Athens
Tel: 68 47 875
Fax: 68 21 044

TZETZIAS, STELIOS 88

14-16 Ferekidon Street
G-116 36 Athens
Tel. 70 16 145
Fax: 72 61 517

HOLLAND
HOLLANDE
HOLLAND

DE WINTER, HERMAN 296-297

Ondernemingenweg 22
NL-5627 BV Eindhoven
Tel. +31 40 242 9657
Fax: +31 40 242 5415

HAGEMAN, KEES 288-295

Prinsengracht 516
NL-1017 KJ Amsterdam
Tel. +31 20 622 5554
Fax: +31 20 625 3780

TROMP, JOHN 287

Studio Tromp
Griseldestraat 2
NL-3077 CN Rotterdam
Tel. +31 10 479 3606
Fax: +31 10 479 5251

**VAN TONGEREN,
ROBERT 298-299**

Fotostudio Robert Van Tongeren
Julianaplein 105
NL-6640 AB Beuningen
Tel. +31 24 677 3291
Fax: +31 24 677 4818

I T A L Y
I T A L I E
I T A L I E N

AGOSTINI, FRANCESCO 92-93

Agostudio
Via Diodoro Siculo, 36
I-20125 Milano
Tel. 02 66106640
Fax: 02 66106637

BENEDETTI BRÀ,
RAFFAELLO 97

Via San Siro, 31
I-20149 Milano
Tel. 02 4986035
Fax: 02 48003241

BROIA, DANIELE 122-123

Fotoscientifica S.N.C.
di Finzi E Broia
Via Paradigna, 76
I-43100 Parma
Tel. (0521) 271447/271457
Fax: (0521) 271467

BUTTINONI, GIUSEPPE 95

B & B Photo Communications
Via de Gasperi, 2
I-24050 Lurano BG
Tel. 035 800465
Fax: 035 800565

CECCHIN, PAOLO 98-99

Via Principessa Clothilde, 85
I-10144 Torino
Tel. 011 899 56 16
Fax: 011 899 56 16

CIGOGNETTI, MAURIZIO 121

Via Cislaghi, 21
I-20128 Milano
Tel. 02 27001760
Fax: 02 270 01 774

DE BERT, GIUSEPPE
& TRENCHI, RAFFAELE 120

Studio Weston
Via dell' Agricoltura, 2
I-37012 Verona Bussolengo
Tel. 045 6702852
Fax: 045 6702852

DEL GOVERNATORE,
PIERO 127

Italcolor SRL
Via Nazionale, 165
I-64026 Roseto degli Abruzzi TE
Tel. 085 8999245

FERRERI, EZIO 91

Via Catania, 35
I-90141 Palermo
Tel. 091 6259673
Fax: 6259670

FINAZZI, ANTONIO 94

Via Pizzo Arera, 20
I-24060 Chiuduno BG
Tel. +39 35 4427277
Fax: + 39 35 4427277

FINZI, FLORIANO 122-123

Fotoscientifica S.N.C.
di Finzi E Broia
Via Paradigna, 76
I-43100 Parma
Tel. (0521) 271447/271457
Fax: (0521) 271467

GENUZIO, CESARE 100

Via Montereale, 139
I-33170 Pordenone
Tel. +39 434 366664
Fax: +39 434 553243

ISAIA, ENZO 96

Corso Quintino Sella, 11
I-10131 Torino
Tel. 011 8193081

LOMBARDI, GIULIANO 101

Via Don L. Milani, 92
I-41100 Modena
Tel. +39 059 253073
Fax: +39 059 253 34 33

LOPEZ & BARRELLA 124-125

Studio Orizzonte
Via Barberini, 60
I-00187 Roma
Tel. 06 4825333
Fax: 06 4743339

MAJNO, GIORGIO 112

Via Cappuccio, 7
I-20123 Milano
Tel. 02 72000400

MANCUSO, ROBERTO 102-103

Italimage Fotografi Association
Via Altaguardia, 2
I-20135 Milano
Tel. 02 58306385

MARCIALIS, RENATO 111

Via Jacopo Palma, 8
I-20146 Milano
Tel. 02 406354

MAZZANTI, PAOLO 110

Via degli Abeti, 108
I-61100 Pesaro
Tel. +39 0721 403912
Fax: +39 0721 403914

MERLO, GIULIANO 114-115

L'Occhiello di Merlo Guiliano
Via Trozzetti, 77
I-36061 Bassano del Grappa VI
Tel. 0424 30018
Fax: 0424 30765

MONTAINA, EDOARDO 116-117

Via Vicenza, 15
I-01100 Viterbo
Tel. 0761 326265

MUSCETTI, STEFANO 113

Studio Prisma
Via S. Rocco, 6
I-20135 Milano
Tel. +39 2 583 097 06
Fax: +39 2 583 054 32

PERAZZOLI, LUCA 105

Fotostudio Perazzoli SRL
Via Santa Sofia, 14
I-20122 Milano
Tel. 02 58303497

PICCOLI, TITO/ENRICO 104

Piccoli & Piccoli
Via Cancano, 2
I-20152 Milano
Tel. 02 4562556
Fax: 02 489 10926

RATTÁ, GREG 90

Via Cibrario, 32
I-10144 Torino
Tel./Fax: 011 487177

RICCI, BERNARDO 118

Via Calamelli, 12
I-40026 Imola BO
Tel. 0542 641810

ROSSI, GUIDO ALBERTO 119

Action Press
Via Terraggio, 17
I-20123 Milano
Tel. 02 874693

TOMASINI, OTTAVIO
& CELLA, GIUSEPPE 106-109

Via Camozzi, 8
I-25126 Brescia
Tel. 030 4 72 78
Fax: 030 377 22 35

Cella Giuseppe
Via Alcaini, 10
I-24123 Bergamo
Tel. 0337 438 393

P O R T U G A L
P O R T U G A L
P O R T U G A L

S P A I N
E S P A G N E
S P A N I E N

**ALMEIDA,
MANUEL DE ÓSCAR 135**

Rua 28 de Janeiro, 350
P-4400 Vila Nova de Gaia
Tel. +351 2 370 70 43
Fax: +351 2 370 70 44

CABRITA GIL, MARIO 134

Rua Guiljerme Braga 38
P-1100 Lisboa
Tel. +351 1 886 20 22
Fax: +351 1 887 91 79

DÓRIA, JOÃO LUIS 132

Rua Tomás
de Figueiredo, 12-2° Esq
P-1500 Lisboa
Tel. +351 1 760 83 38
Fax: +351 1 760 54 90

PICTO 130-131

Rua Luis Fernandes 32A
P-1200 Lisboa
Tel. +351 1 396 1401
Fax: +351 1 395 6410

STUDIO 8A 133

Rua Luciano Freire 8A
P-1600 Lisboa
Tel. +351 1 796 0007
Fax: +351 1 795 4106

AF/EP 184

C/Juan Hurtado de Mendoza 9
E-28036 Madrid
Tel. +34 1 350 4722
Fax: +34 1 359 6977

AFP/PMC 138

Ptge. Maluquer 8-10
E-08022 Barcelona
Tel. +34 3 418 4525
Fax: +34 3 418 4435

ALBEROLA, PACO 207

Santa María Micaela N° 18
E-46008 Valencia
Tel. +34 6 384 1298
Fax: +34 6 384 1298

A.J.J. ESTUDI S.C.P. 169

J.A. Montoya & J. Soldevila
Antoni Gaudí 8
E-08970 San Joan Despí
(Barcelona)
Tel. +34 3 373 8953
Fax: +34 3 373 8953

ALONSO PEREZ, CARLOS 202

Fotoalvix S.L.
C, Torrecedeira 103
E-36202 Vigo
Tel. +34 86 23 85 61

**ANGEL INVARATO,
MIGUEL 180**

Raimundo Fdez.
Villaverde, No. 10
E-28003 Madrid
Tel. +34 1 534 4718
Fax: +34 1 534 9867

ARARÁ & PELEGRIN 162

Paco Arará & José Luis Pelegrin
Roger de Lluria 96 Entlo 1°
E-08009 Barcelona
Tel. +34 3 457 4293
Fax: +34 3 207 7858

ARNÓ, FRANCESC 142-143

Gral. Mitre 95 - Baixos Esquerra
E-08022 Barcelona
Tel. +34 3 417 8514
Fax: +34 3 418 7022

**BARBERO CASTILLO,
JOSEP 156-157**

Avda Sant Pere 11
E-25005 Lleida
Tel. +34 73 24 50 48

Studi 11
Avda Batlle Porquares 67
E-25005 Lleida
Tel. +34 73 22 18 36

BLANCAFORT, JORDI 148-149

C/Bailen 152 1° 1°
E-08037 Barcelona
Tel. +34 3 459 4346
Fax: +34 3 207 5394

BOU, JOSEP 170-171

Bertran 44 baixos, int
E-08023 Barcelona
Tel. +34 3 434 0507
Fax: +34 3 434 0519

**CHAMIZO,
JESÚS MARTÍN 182-183**

González Solá, 5
E-28029 Madrid
Tel. +34 1 323 0562/0610
Fax: +34 1 323 0610

COLL, PEDRO 174-175

C/Cercanya, 1
E-07012 Palma de Mallorca
Islas Baleares
Tel. +34 71 72 10 78
Fax: +34 71 71 98 58

DE BENITO, ANTONIO 193

Juan de Dios 8 Bajos
E-28015 Madrid
Tel. +34 1 548 4450

DE BUSTOS, FERNANDO 165

P° Del Faro 13-15
E-20008 San Sebastian
Tel. +34 43 21 25 80
Fax: +34 43 21 95 16

EGEA, JOSÉ ANTONIO 158-159

Estudio Egea Comunicación
Fotográfica S.L.
Rda San Pedro 32 1° D
Barcelona
Tel. +34 3 319 6167

EIKON FOTOGRAFIA SL 198

Avenida de la Cova, 32
E-46940 Manises (Valencia)
Tel. +34 6 152 1458
Fax: +34 6 152 1454

**ESCODA BORRAS,
JOSEP MA 166**

PEP Escoda Photostudio
Carrer Comte N° 8
E-43003 Tarragona
Tel. +34 77 22 22 63
Fax: +34 77 22 22 63

FOTOMECANICA RAFAEL 206

Del Carmen Garcia,
Millán y Maria
Coruña No. 21
E-28020 Madrid
Tel. +34 1 572 0980
Fax: +34 1 571 3078

GOMEZ, RODOLFO 185

Rodolfo Gomez Fotografia
Publicitaria
c/ General Palanca, 33
E-28045 Madrid
Tel. +34 1 530 8163
Fax: +34 1 530 8954

GOMEZ BUISAN, RAFAEL 200

Buisan Estudio
República Argentina 68 Bajos
E-03007 Alicante
Tel. +34 6 528 2808
Fax: +34 6 528 2973

S P A I N
E S P A G N E
S P A N I E N

HIERRO, PERE 160-161

Rambla Sabadell 18
E-08201 Sabadell
Barcelona
Tel. +34 3 726 2268
Fax: +34 3 726 2268

J. CRISS FOTOGRAFO 190-191

Rodriguez Santos, José Carlos
Avenida Los Mallos 82
E-15007 La Coruña
Tel. +34 81 15 43 72
Fax: +34 81 15 43 72

c/Angel Senra, 35
E-15007 La Coruña
Tel. +34 81 23 86 71

JORDI MAS
LLOVERAS 152-153

Baldiri Reixach, 28
E-17003 Girona
Tel. +34 72 21 36 32
Fax: +34 72 21 36 32

LOPEZ DE ZUBIRIA,
JOSÉ LUIS 167

Pilotegui Bidea 12
B.° de Igara
E-20009 San Sebastian
Tel. +34 43 21 99 03
Fax: +34 43 21 99 04

LUCAS ALONSO, JAVIER 201

Irudi Centro de la Imagen
Kale Nagusia 17
E-20800 Zarautz (Gipuzkoa)
Tel. +34 43 13 30 03
Fax: +34 43 13 30 03

LUNES, FINA 172-173

Enrique Granados, 103
Bajos 1°
E-08008 Barcelona
Tel. +34 3 218 7055
Fax: +34 3 416 0358

MALÉ, JAIME 144-145

Gran Via de les Corts
Catalanes 554
E-08011 Barcelona
Tel. +34 3 323 5511
Fax: +34 3 323 5817

MARIN, CARLOS
& CUEVAS, MAITE 199

Urb. Cerro Santiago
Parcelas 11 y 12
E-26560 Autol (La Rioja)
Tel. +34 41 39 01 93
Fax: +34 41 39 01 93

MARLI, ALBERT 176-177

Aribau 252 3er 1°
E-08006 Barcelona
Tel. +34 3 200 8181
Fax: +34 3 202 3576

MIRO, JOAN 208

Avenida Diagonal 434 1er 2a
E-08037 Barcelona
Tel. +34 3 415 2338
Fax: +34 3 415 2075

MOLINOS, ROBERTO 186-187

Mango Producciones SL
Navaleno, 5
E-28033 Madrid
Tel. +34 1 766 2678
Fax: +34 1 766 9215

MONTAÑES & GEBBIA 139

José Fernando Gebbia
C/Pare Fidel Fita 13 Bajos
E-08023 Barcelona
Tel. +34 3 418 2088
Fax: +34 3 418 2088

MONTE, ENRIC 181

Premia 15 1°
E-08014 Barcelona
Tel. +34 3 421 3978
Fax: +34 3 422 6633

MORGADAS, JORDI 178-179

Diputació 317 1°
E-08009 Barcelona
Tel. +34 3 488 2568
Fax: +34 3 488 3465

MORINI, STEFANO 150-151

Mila i Fontanais 14-26 4° 9ª
E-08012 Barcelona
Tel/Fax: +34 3 458 7075

ORESTIS MAGIC BOX 204-205

Puente del Duero 1
E-28006 Madrid
Tel. +34 1 562 8325

PALACIOS, JOSÉ MARIA 192

Gurtubay, 6
E-28001 Madrid
Tel. +34 1 576 9435
Fax: +34 1 578 3651

PERIS CASTRO,
EDUARDO 196-197

Joaquin Costa No. 33 pta 13
E-46005 Valencia
Tel. +34 6 374 0579

PONS, EUGENI 163

Avda Vidreres 106
E-17310 Lloret de Mar, Girona
Tel. +34 72 37 25 05
Fax: +34 72 37 25 05

PUTMAN, TONY 164

Muntaner 575, 2° 2°
E-08022 Barcelona
Tel. +34 3 212 5633
Fax: +34 3 418 7508

ROCA, JOSEP MA 154-155

Seneca 17 Baixos
E-08006 Barcelona
Tel. +34 3 217 9133
Fax: +34 3 217 8988

ROIG & PORTELL 146-147

Mestre Dalmau 7-9
E-08031 Barcelona
Tel. +34 3 427 9186
Fax: +34 3 427 6248

SARDA, JAVIER 140-141

Teodora Lamadrid 31
E-08022 Barcelona
Tel. +34 3 418 4305

VARGAS, RAFAEL 168

Gran Via Corts
Catalanes 699 1er 1a
E-08013 Barcelona
Tel. +34 3 246 3602
Fax: +34 3 232 4151

VISUAL ESTUDIOS 194-195

Avenida Alborache, 20
E-46460 Silla (Valencia)
Tel. +34 6 121 1735
Fax: +34 6 121 2395

YEBRA, CARLOS 188-189

Santorcaz 4
E-28002 Madrid
Tel. +34 1-411 4723
Fax: +34 1-563 3759

S W I T Z E R L A N D
S U I S S E
S C H W E I Z

ALBISSER, CLAUDIA 52

Binningerstrasse 92
CH-4123 Allschwil
Tel. +41 61 482 0230
Fax: +41 61 482 0230

BALMELLI, GIORGIO 55

Im Hauried 51
CH-8055 Zürich
Tel. +41 1 461 4237
Fax: +41 1 461 6242

BERCLAZ, ANDREA 56

Schaffhauserstr. 512
CH-8052 Zürich
Tel. +41 1 301 0606
Fax: +41 1 301 0608

BRUN & BURGIN 53-54

Mühlebachstrasse 52
CH-8008 Zürich
Tel. +41 1 261 3538
Fax: +41 1 261 3553

CUGINI, THOMAS 57

Nordstrasse 110
CH-8037 Zürich
Tel. +41 1 361 5050
Fax: +41 1 363 1761

DIETRICH, ALF 58-59

Stadelhoferstrasse 28
CH-8001 Zürich
Tel. +41 1 261 6740
Fax: +41 1 252 7096

DUTOIT & HAYOZ 60-61

Forchstrasse 30
CH-8008 Zürich
Tel. +41 1 383 8784
Fax: +41 1 383 6284

EUGEN LEU
& ROGER HUMBERT AG 65

Baselstrasse 48
CH-4125 Riehen
Tel. +41 61 641 3355
Fax: +41 61 641 1578

FORSTER, PETER 64

Bommer Weiher Studio AG
CH-8573 Alterswilen
Tel. +41 71 699 1424
Fax: +41 71 699 1531

KÜENZI, CHRISTIAN 62-63

Stockenstrasse 122a
CH-8802 Kilchberg
Tel. +41 1 715 1990
Fax: +41 1 715 5220

MEYER, JEAN-DANIEL 66-67

Chemin des Grands-Champs 12
CH-1212 Grand-Lancy
Tel. +41 22 794 3024
Fax: +41 22 794 3022

MONKEWITZ, NICOLAS 68

Dolderstrasse 2
CH-8032 Zürich
Tel. +41 1 261 3105
Fax: +41 1 261 3106

MÜLLER, PETER 51

Schneeglöggliweg 54
CH-8048 Zürich
Tel. +41 1 493 0384
Fax: +41 1 493 0316

PLAIN, THOMAS 69

Bachstrasse 11
CH-8038 Zürich
Tel. +41 1 483 0222
Fax: +41 1 482 8088

SCHNEIDER, DOMINIC 70

Mythenquai 353 / Postfach
CH-8038 Zürich
Tel. +41 1 481 8066
Fax: +41 1 481 8096

URS, GALL 71

Brunnenstrasse 5
CH-8604 Volketswil
Tel. +41 1 945 2433

WALTER, MARGRITH 74

Albisriederstr. 379
CH-8047 Zürich
Tel. +41 1 493 5355
Fax: +41 1 492 5529

ZIMMERMANN, ALBERT 75

Trichtenhausenstrasse 231
Zollikerberg
CH-8125 Zürich
Tel. +41 1422 3700
Fax: +41 1 422 9367

ZIMMERMANN, BRUNO 72-73

Chemin Calvaire 7
CH-1005 Lausanne
Tel. +41 21 623 4156

U N I T E D K I N G D O M
G R A N D E - B R E T A G N E
G R O S S B R I T A N N I E N

ATKINSON, ANDREW 270

6a Poland St
London W1V 3DG
Tel. 0171 437 4985

BAJZERT, JULIAN 238

25 Heathmans Road
Parsons Green
London SW6 4TJ
Tel. 0171 736 6262
Fax: 0171 736 4707

BANANA PHOTOGRAPHY
COMPANY 212

Unit 12 Montford Enterprise
Centre
Wynford Sq. West Ashton St.
Salford M5 2SX
Tel. 0161 737 6789

BEDDIS, TERRENCE 231

26/27 Great Sutton Street
London EC1V ODS
Tel. 0171 2515333
Fax: 0171 253 0319

BELL, CHRIS 220

Unit 8a Cedar Way
Elm Village Industrial Estate
Camley Street
London NW1 0PD
Tel. 0171 388 4500
Fax: 0171 388 4119

BELLARS, JOHN 215

142 Central Street
London EC1V 8AR
Tel. 0181 814 9810
Fax: 0181 490 4073

BINGEL, BERRY 221

1 Keith Avenue
Balmedie
Aberdeen AB23 8ZR
Tel. 01358 742571

BURDEN, DESMOND 211

Studio 4
38 St Oswalds Place
London SE11 5JE
Tel. 0171 582 0559
Fax: 0171 582 4528

UNITED KINGDOM
GRANDE-BRETAGNE
GROSSBRITANNIEN

CAVALIER, STEVE 222-223

25 Woronzow Road
St. John's Wood
London NW8 6AY
Tel. 0171 586 7418
Fax: 0171 586 7419

CRISFORD, COLIN 260

ACE
Satellite House 2 Salisbury Road
London SW19 4EZ
Tel. 0181 944 9944
Fax: 0181 944 9940

DANN, GEOFF 232

164 Whitecross St
London EC1Y 8QN
Tel. 0171 251 2873
Fax: 0171 251 2873

GALLETLY, MIKE 269

The Peoples Hall
Olaf Street
London W11 4BE
Tel. 0171 221 0925
Fax: 0171 229 1136

GATWARD, PHIL 274

Unit 14b, Rosemary Works
Branch Place
London N1 5PH
Tel. 0171 613 1603

HARRIS, MATT 272

53 St Mary's Rd
Ealing
London W5 5RG
Tel. 0181 840 4822
Fax: 0181 840 4822

HENDERSON, GRAHAM 218

14 Mandela St
London NW1 0DW
Tel. 0171 388 0416
Fax: 0171 387 4259

HULME, MALCOLM 262

6a Pratt St
London NW1 0AB
Tel. 0171 388 7314

IRVINE, SIAN 273

12 Printing House Yard
15 Hackney Rd
London E2 7PR
Tel. 0181 739 5858
Fax: 0181 739 1756

JOSEPH, MICHAEL 216

46 Clapham Common
North Side
London SW4 0AN
Tel. 0171 720 0124
Fax: 0171 622 6366

KAINE, JEFF 264

10a Lant St
London SE1 1QR
Tel. 0171 357 9256
Fax: 0171 357 9258

KELLY, DAVID 236

Cassidy Road
London SW6 5QH
Tel. 0171 736 6205
Fax: 0171 384 2240

KNOWLES,
JONATHAN 248-250

48a Chancellors Road
London W6 9RS
Tel. 0181 741 7577
Fax: 0181 748 9927

KOMAR, BOB 230

The Soap Factory
9 Park Hill
London SW4 9NS
Tel. 0171 622 3242
Fax: 0171 498 6445

LLEWELYN DAVIES,
PATRICK 228

32 Great Sutton Street
London EC1V 0DX
Tel. 0171 253 2838
Fax: 0171 250 3375

LOGAN, GEORGE 247

50A Rosebery Avenue
London EC1R 4RP
Tel. 0171 833 0799
Fax: 0171 833 8189

LYTTLE, CARL 219

14a Dufours Place
London W1V 9FE
Tel. 0171 287 0884
Fax: 0171 287 0126

MACPHERSON, TIM 237

6 Apollo Studios
Charlton Road
London NW5 2SB
Tel. 0171 482 2032
Fax: 0171 482 3042

MACQUEEN, DUNCAN 214

101 Constitution Street
Leith
Edinburgh EH6 7AE
Tel. 0131 553 2447
Fax: 0131 553 1582

MARTIN, BOB 258-259

14 West End Gardens
Esher
Surrey KT10 8LD
Tel. 01372 464111
Fax: 01372 468335

MASSEY, RAY 235

The Church Hall
Camden Park Road
London NW1 9AY
Tel. 0181 267 9550
Fax: 0181 267 5612

MEEKUMS, BARRY 242-243

Bures Rd
Lamarsh
Suffolk CO8 5ER
Fax: 01787 228400

MILNER, NICK 227

Linton House
164-180 Union St
London SE1 0LH
Tel. 0181 633 0963
Fax: 0181 633 0963

MYRDAL, JAY 241

11 London Mews
London W2 1HY
Tel. 0171 262 7441
Fax: 0171 262 7476

NEWNHAM, ALAN 240

Unit 2 40-48 Bromells Rd
Clapham
London SW4 0BG
Tel. 0181 498 2399

NOY, TALY 266

40a River Road
Barking
Essex IG11 0DW
Tel. 0181 507 7572
Fax: 0181- 507 8550

ORSMAN, GILL 263

Southwek Forge
10 Lant Street
London SE1 1QR
Tel. 0181 378 1867
Fax: 0181 357 6909

PEDERSEN, DENNIS 226

Hoxton Towers
51 Hoxton Square
London
Tel. 0171 613 0603
Fax: 0171 613 1302

RIGG, NICHOLAS 251

Top Floor, 45 Mitchell Street
London EC1V 3QD
Tel. 0171 490 3594
Fax: 0171 250 1083

ROBERTSON, DOUGLAS 239

42 Royal Park Terrace
Edinburgh EH8 8JA
Tel. 0131 467 7028

ROSS, JOHN 217

Clink Wharf
Clink Street
London SE1 9DG
Tel. 0181 378 8080
Fax: 0181 378 8083

RYAN, TERRY 244-246

193 Charles Street
Leicester LE1 1LA
Tel. 0116 254 4661
Fax: 0116 247 0933

UNITED KINGDOM
GRANDE-BRETAGNE
GROSSBRITANNIEN

SEAWARD, DEREK 233

Unit 21 Tower Workshops
Riley Road
London SE1 3DG
Tel. 0181 237 2880
Fax: 0181 394 0367

SEYMOUR, ANDY 257

82 Princedale Road
Holland Park
London W11 4NL
Tel. 0171 221 2021
Fax: 0171 792 0702

SHIPMAN, STEVE 271

12 Printing House Yard
15 Hackney Rd
London E2 7PR
Tel. 0171 739 5858
Fax: 0171 739 1756

SIMON STOCK
PHOTOGRAPHY 275

47b Elder Ave
Crouch End
London N8 8PS
Tel. 0181 340 9147
Fax: 0181 340 9147

TAIT, CHARLES 213

Kelton Farm
Old Fuistown Road
St. Ola
Orkney
Scotland KW15 1TR
Tel. 01856 873738
Fax: 01856 875313

VENNING, PAUL 224

1 Stable Yard
Danemere Street
London SW15 1LT
Tel. 0181 780 0442
Fax: 0181 780 0441

WALES, DON 234

9 The Coachworks
80 Parsons Green Lane
Fulham
London SW6 4HU
Tel. 0171 610 6773
Fax: 0171 610 6772

WALLACE, STRUAN 268

16 Gibraltar Walk
London E2 7PR
Tel. 0181 739 4406
Fax: 0181 739 8784

WEBSTER, PAUL 254-256

2C MacFarlane Rd
London W12 7JY
Tel. 0181 749 0264
Fax: 0181 740 8873

WHALE, ANDY 261

16-24 Underworld Street
London N1 7JQ
Tel. 0181 608 3743
Fax: 0181 608 3743

WHITE, WILL 265

3 Lamp Office Court
Lambs Conduit Str.
London WC1N 3NF
Tel. 0171 404 0318
Fax: 0171 430 0411

WHITFIELD, JOHN 229

Unit B2 Linton House,
164-180 Union St
London SE1 0LH
Tel. 0171 928 2639
Fax: 0171 928 2639

WIEDER, FRANK 252-253

178 Royal College Street
London NW1 0SP
Tel. 0171 482 3830
Fax: 0181 981 3560

WILLIAMS, HUW 225

5 Cedar Way,
Camley Street
London NW1 0PD
Tel. 0181 383 4491

WONNACOTT, MARTIN 267

The Business Village
Broomhill Rd
London SW18 4GJ
Tel. 0181 870 1860
Fax: 0181 871 5008

G E R M A N Y

A L L E M A G N E

D E U T S C H L A N D

	International page	Local page		International page	Local page
AK WERBEFOTOGRAFIE GMBH	34-35	18-19	HIRSCHMÜLLER, SVEN	30-31	14-15
BAUER, KLAAS	18	2	IOAKIMIDIS, NEKTARIOS	33	17
BROMBA, ANDREAS	19	3	KOCH, CHRISTIANE	36	20
CASTELL, GIOVANNI	21	5	LINK, MICHAEL	37	21
DARLISON, HANS JÜRGEN	25	9	MAYEN, PIT	38-39	22-23
DEISENROTH, WERNER	22-23	6-7	MOOG, MARCO	40	24
EISELE, WERNER	24	8	RABEN, SVEN C	41	25
FÖRSTERLING, STEPHAN	26	10	SCHÖN, HARALD	48	32
FRITSCHE, JÖRG	27	11	STEMMLER, KLAUS	42-43	26-27
GARRELS, ANDREAS	28	12	STUDIA 3000	32	16
HARTENFELS, ROLF	29	13	VAN DEN BERG, JO	20	4
HEIMERMANN, ÉTIENNE	46-47	30-31	WARTENBERG, FRANK P	44-45	28-29

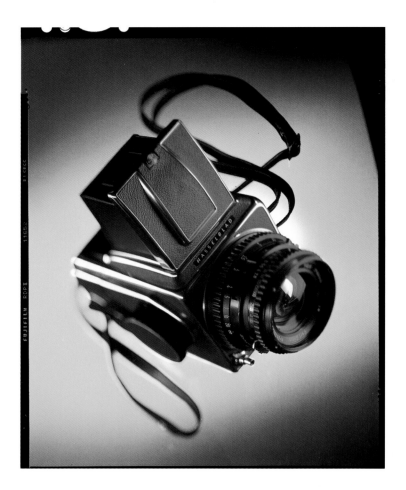 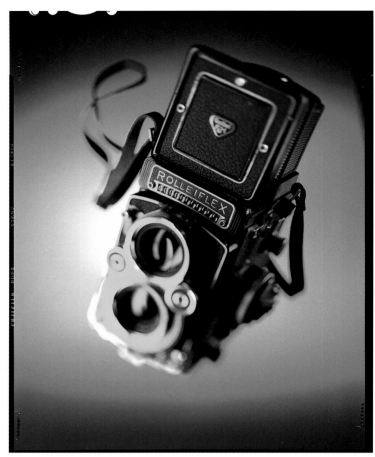

KLAAS BAUER
.

Hegestrasse 40
D-20251 Hamburg
Tel : 040 480 21 76
Fax : 040 47 75 14

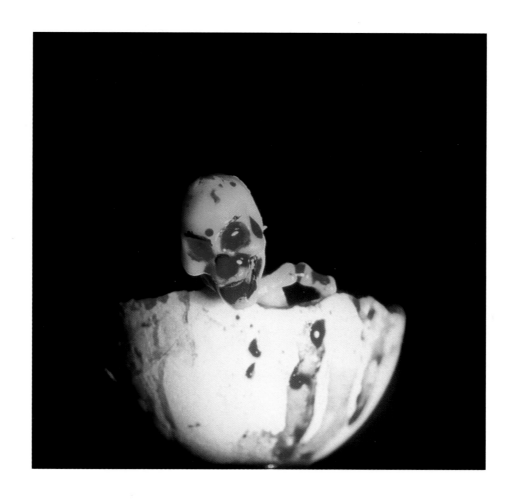

NUKLEAFORM
∎ ∎ ∎ ∎ ∎ ∎ ∎ ∎ ∎ ∎ ∎ ∎ ∎

Stargarder Str. 75
D - 10437 Berlin
Tel: 0049 (0) 30 444 73 07
Fax: 0049 (0) 30 444 73 08

Keine Werbung
für Leder und Pelz,
für Zigaretten und
für die
Fleischindustrie

No advertising
for the leather and
fur trade,
for the tobacco industry
nor the meat industry

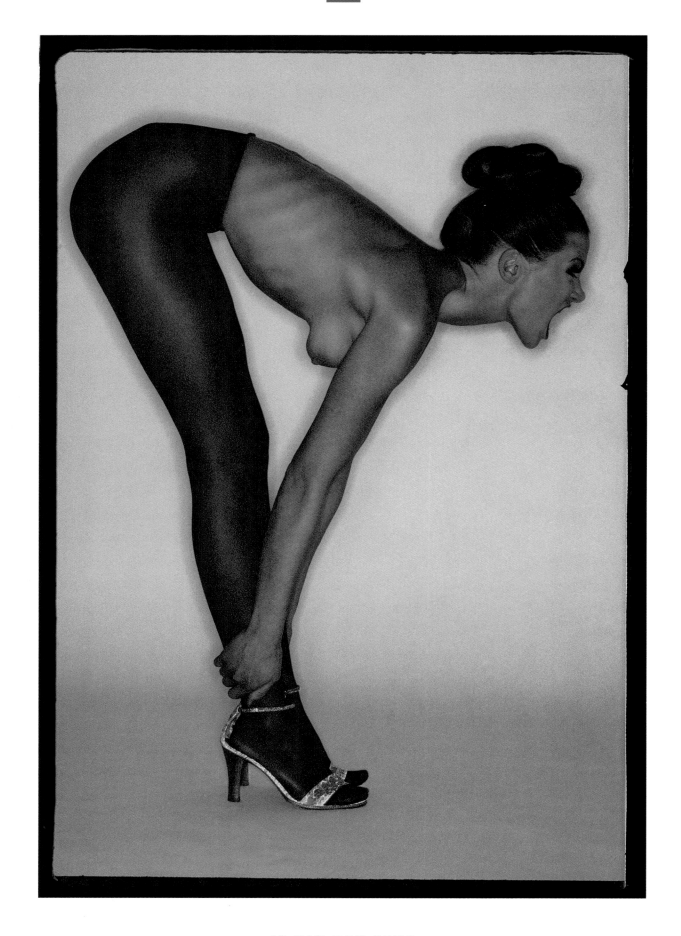

JO VAN DEN BERG
.
Holstenstrasse 110
D-22767 Hamburg
Tel: (040) 38 16 48 - Fax: (040) 389 48 17

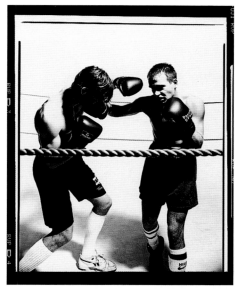

 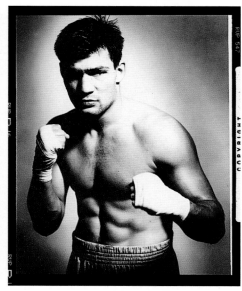

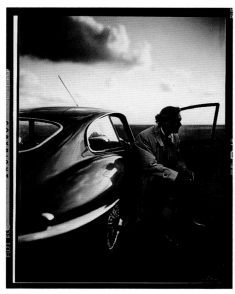 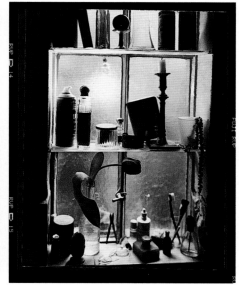 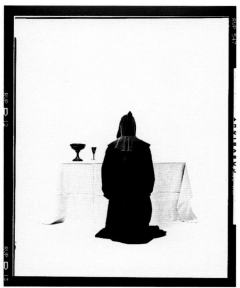

GIOVANNI CASTELL
.

Parkallee 82
D-20144-Hamburg
Tel : 040-45 22 12 Fax : 44 80 99 27

People/Stills

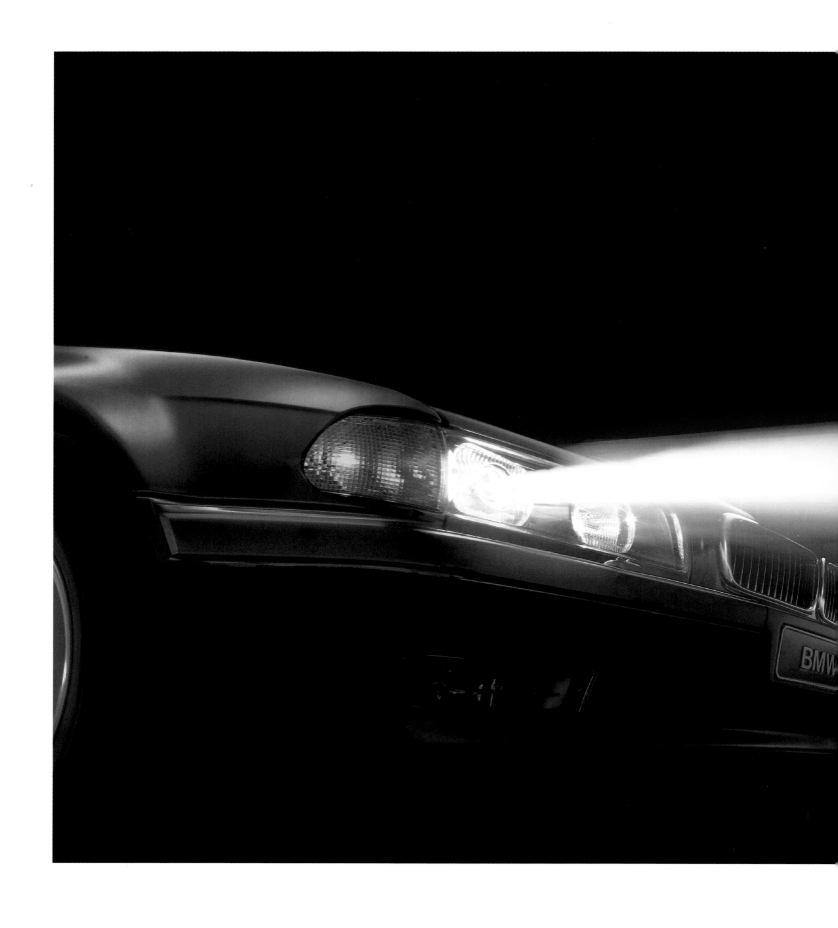

WERNER DEISENROTH 85551 KIRCHHEIM / MÜNCHEN

BENZ-STRASSE 4, TEL. 089 / 991 50 40 , FAX 089 / 903 11 11

WERNER EISELE PHOTOGRAPHY©

ARCHIVAL MOTOR RACING

SOMMERHALDENSTR. 16
D-70195 STUTTGART
FON: (0711) 61 71 81 / 69 88 04
FAX: (0711) 61 71 61

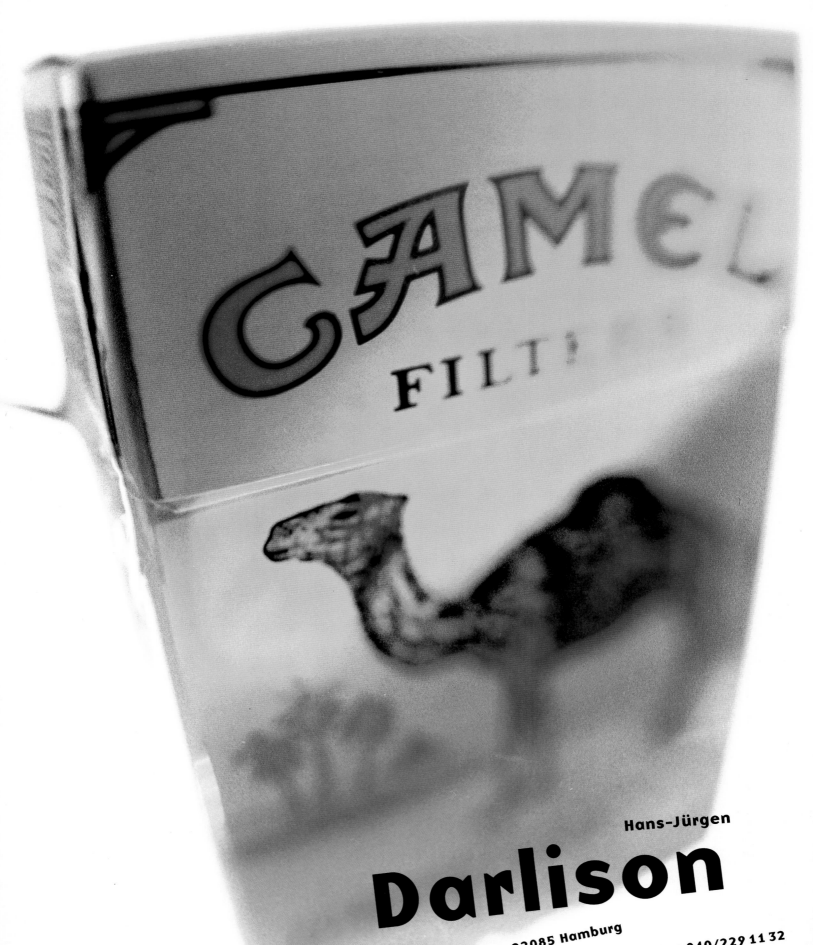

Hans-Jürgen

Darlison

Studio: Winterhuder Weg 112, D-22085 Hamburg
Telefon o4o/227 228-0, Fax 040/229 11 32
ISDN 227 228 32

analog und digital

STEPHAN FÖRSTERLING
.

Friedensallee 29
D-22765 Hamburg
Tel: (040) 390 58 39
Fax: (040) 390 58 00

JÖRG FRITSCHE

.

Peutestraße 53
D-20539 Hamburg
Tel. (040) 789 34 11
Fax: (040) 789 34 12

Experimentelle Fotografie
Action
Autos
Werbung

Digitale Fotografie
Industrie
Interieur
Stillife

ANDREAS GARRELS
.

Süderstr. 159A
D-20537 Hamburg
Tel: (040) 250 77 56
Fax: (040) 250 74 06

Internet: WWW.interact.de/foto/andreas-garrels
E-mail: a-garrels@interact.de

People/Portraits
inszenenierte Portraits

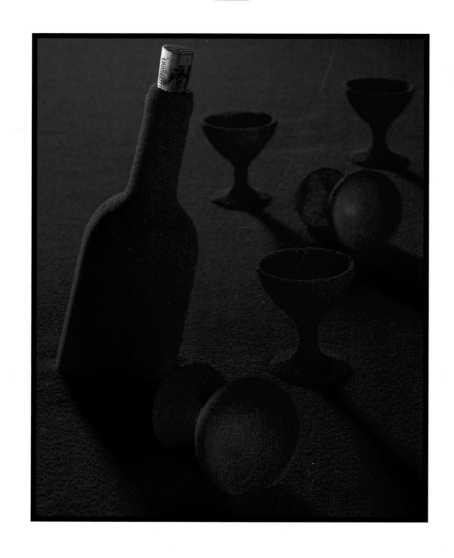

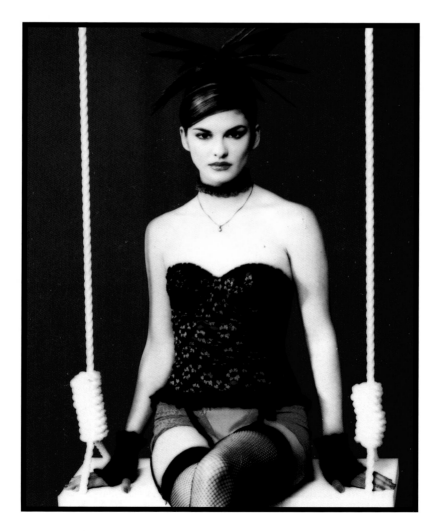

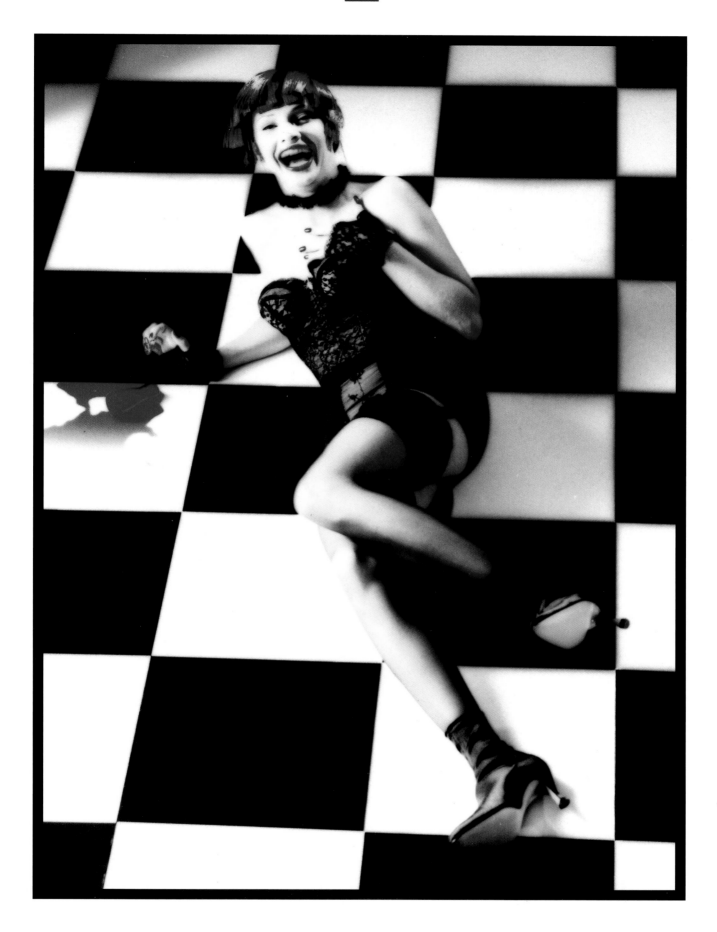

SVEN HIRSCHMÜLLER
.

Schellingstraße 17
D-22089 Hamburg
Tel: (040) 20 32 36

Styling: Pinny Daniel
c/o Profi Team
Make Up: Agnes Kollien
c/o Make Up Studio
Assistent: Martin Dzillack

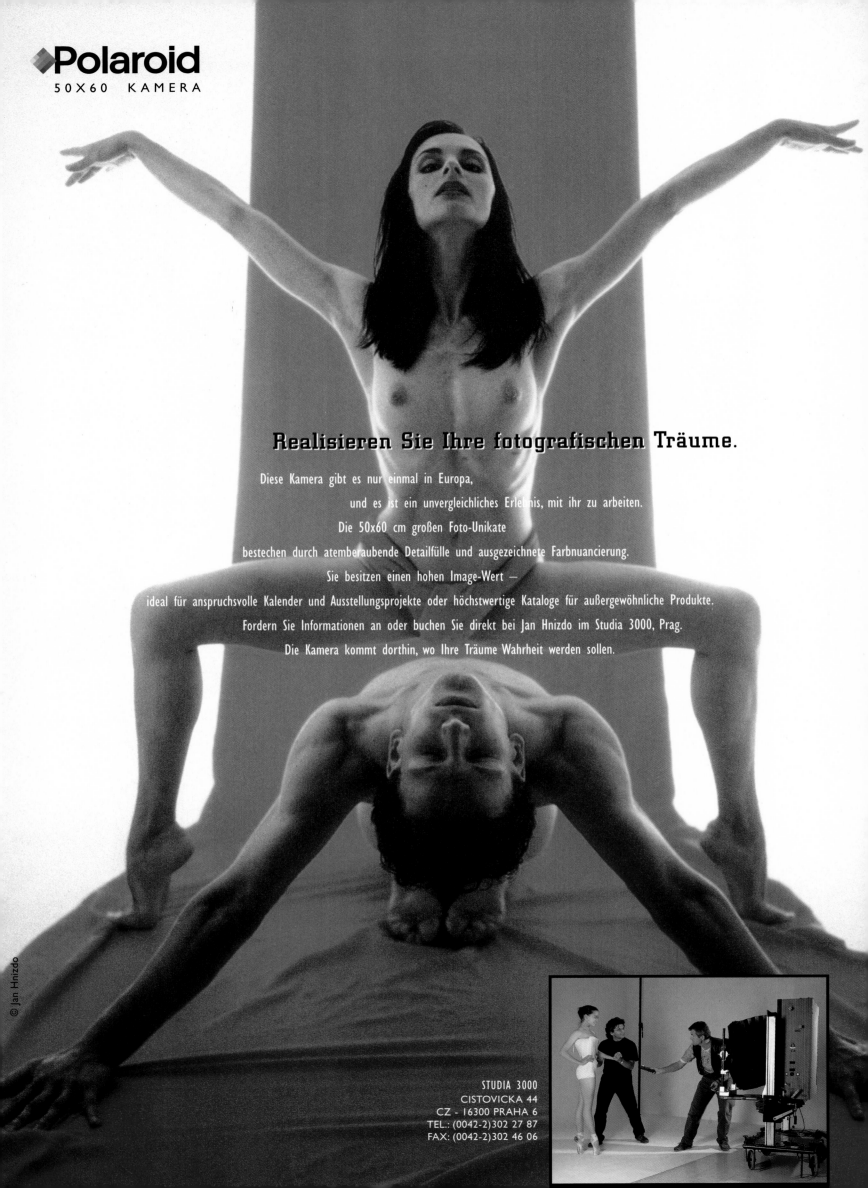

AK WERBEFOTOGRAFIE GMBH
· · · · · · · · · · · · · · ·

ARMIN KAMMER
In den Fichten 5
D-32584 Löhne
Tel: 05731/7477-0
Fax: 05731/41381

Agent: GUDRUN TEMPELMANN-BOEHR
Am Rosenbaum 7
D-40699 Erkrath
Tel: (0211) 25 32 46 - Fax: (0211) 25 46 32

AK WERBEFOTOGRAFIE GMBH
.

ARMIN KAMMER
In den Fichten 5
D-32584 Löhne
Tel: 05731/7477-0
Fax: 05731/41381

Agent: GUDRUN TEMPELMANN-BOEHR
Am Rosenbaum 7
D-40699 Erkrath
Tel: (0211) 25 32 46 - Fax: (0211) 25 46 32

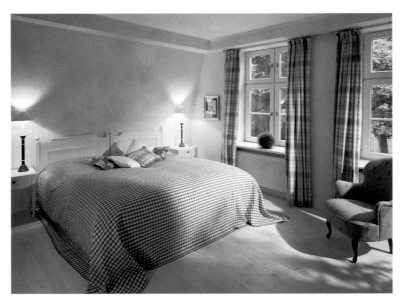

CHRISTIANE KOCH
.

Ruhrstr. 13
D-22761 Hamburg
Tel : 040-851 29 86
Fax : 040-851 46 78

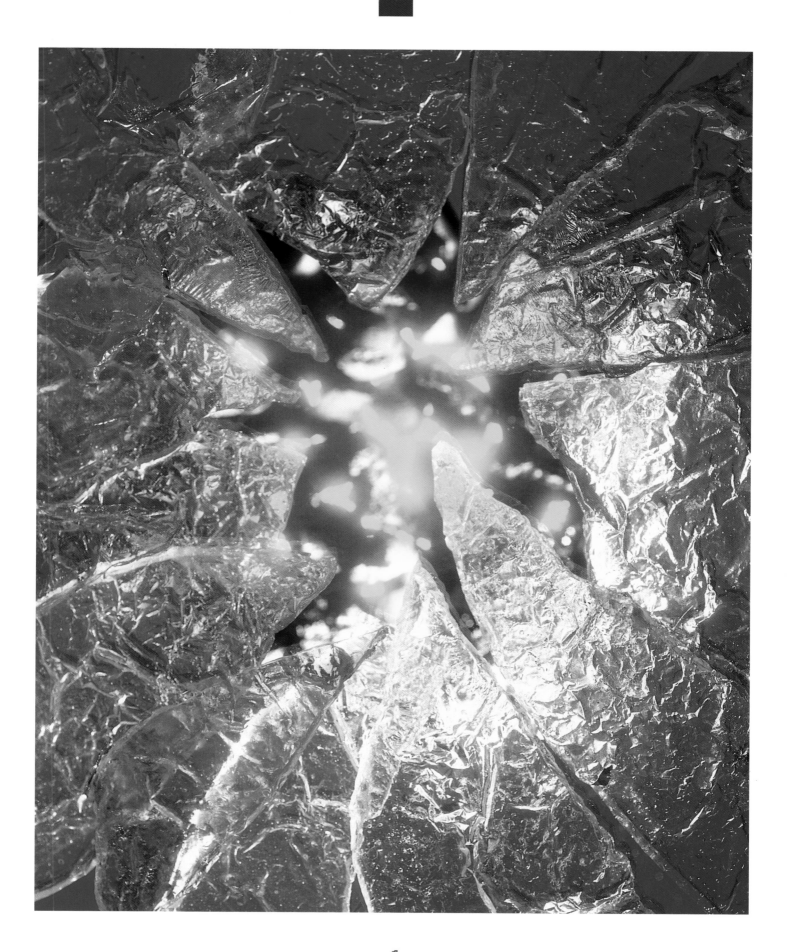

MICHAEL LINK

FON · 06139 · 92340 PHOTOGRAPHY · GERMANY FAX · 06139 · 5435

PIT MAYEN

.

Corneliusstr. 72
40215 Düsseldorf
Tel : +49 211 31 76 37
Mobile : +49 172 62 40 873

PIT MAYEN
.
Corneliusstr. 72
40215 Düsseldorf
Tel : +49 211 31 76 37
Mobile : +49 172 62 40 873

Löwenstraße 40
D-20251 Hamburg
Germany
Tel : (040) 4 20 50 58
Fax : (040) 4 20 50 77

97 Timberlane East
Newfoundland
N.J. 07435-1717
USA
Tel : 001-201-208-8432
Fax : 001-201-208-8448

SIMPLE, TOUT LE TEMPS!

SVEN CASPAR RABEN
.

Rutschbahn 11A, Hof
D-20146 Hamburg
Tel: (040) 450 40 88
Fax: (040) 450 40 90

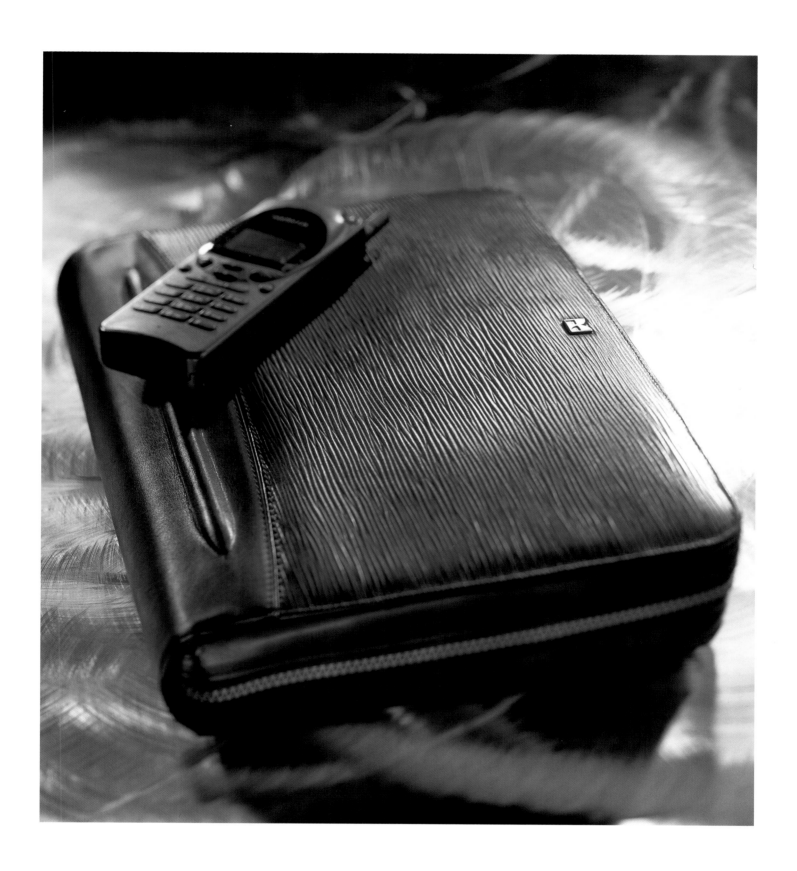

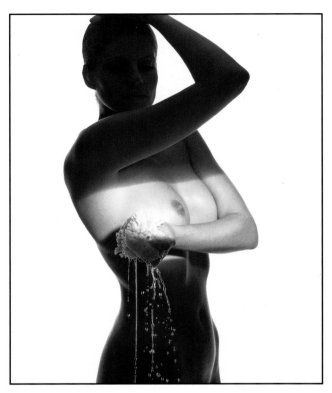

 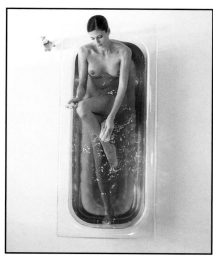 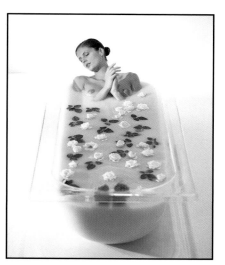

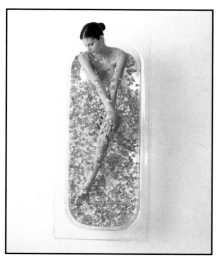 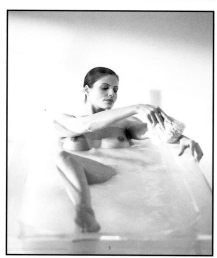 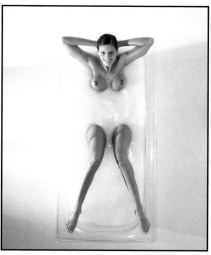

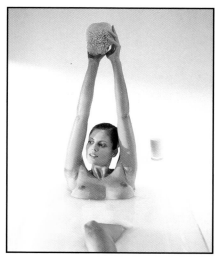 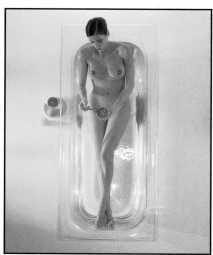 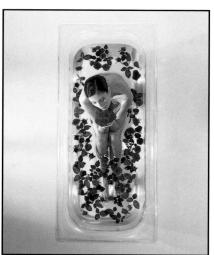

WARTENBERG

HAMBURG · NEW YORK

FON. 49·40·850 83 31 · FAX. 49·40·850 39 91
REPRESENTED BY:
USA/EUROPE · ZARI INTERNATIONAL · FON. 212·388·8541 · FAX. 212·420·8231 · E-MAIL - ZARI INT L@AOL.COM
GERMANY · HEIDRUN AMHOFF · FON. 49·69·704581 · FAX. 49·69·7078064

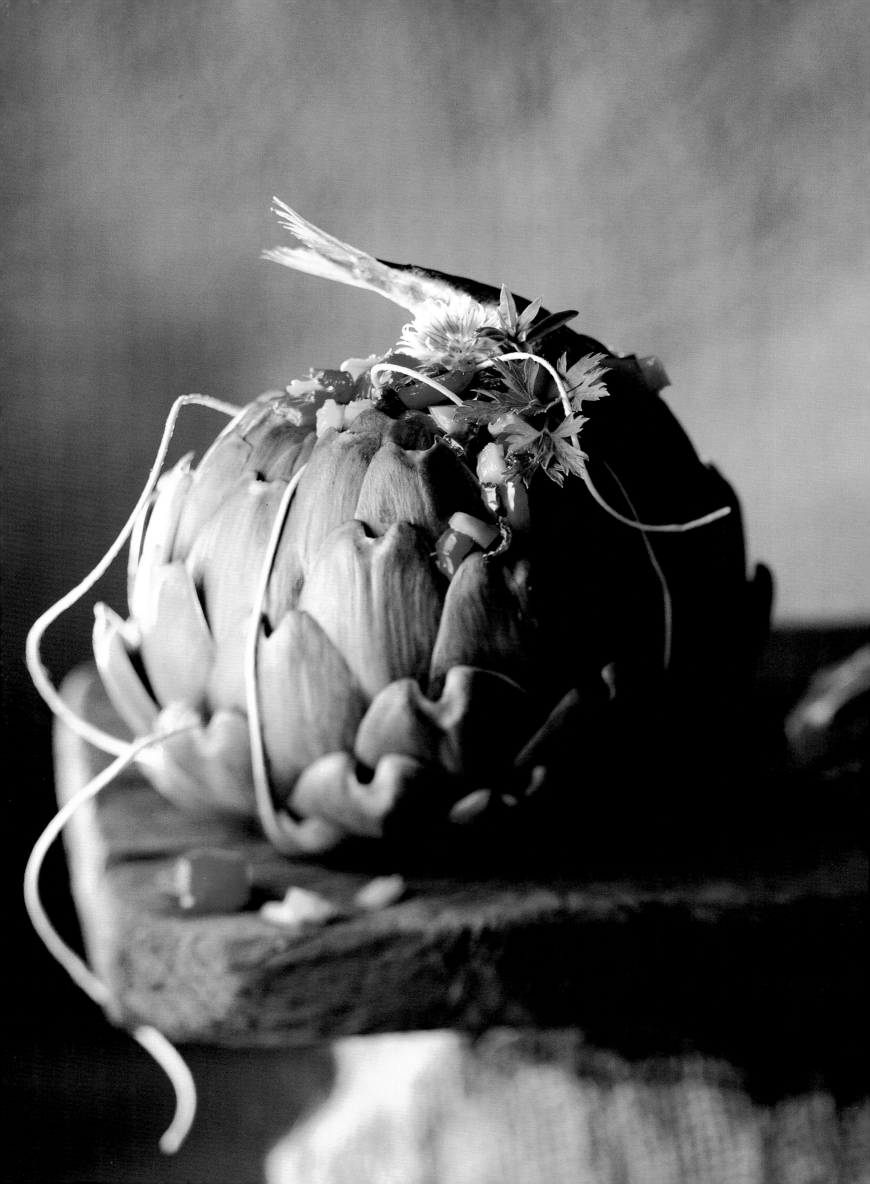

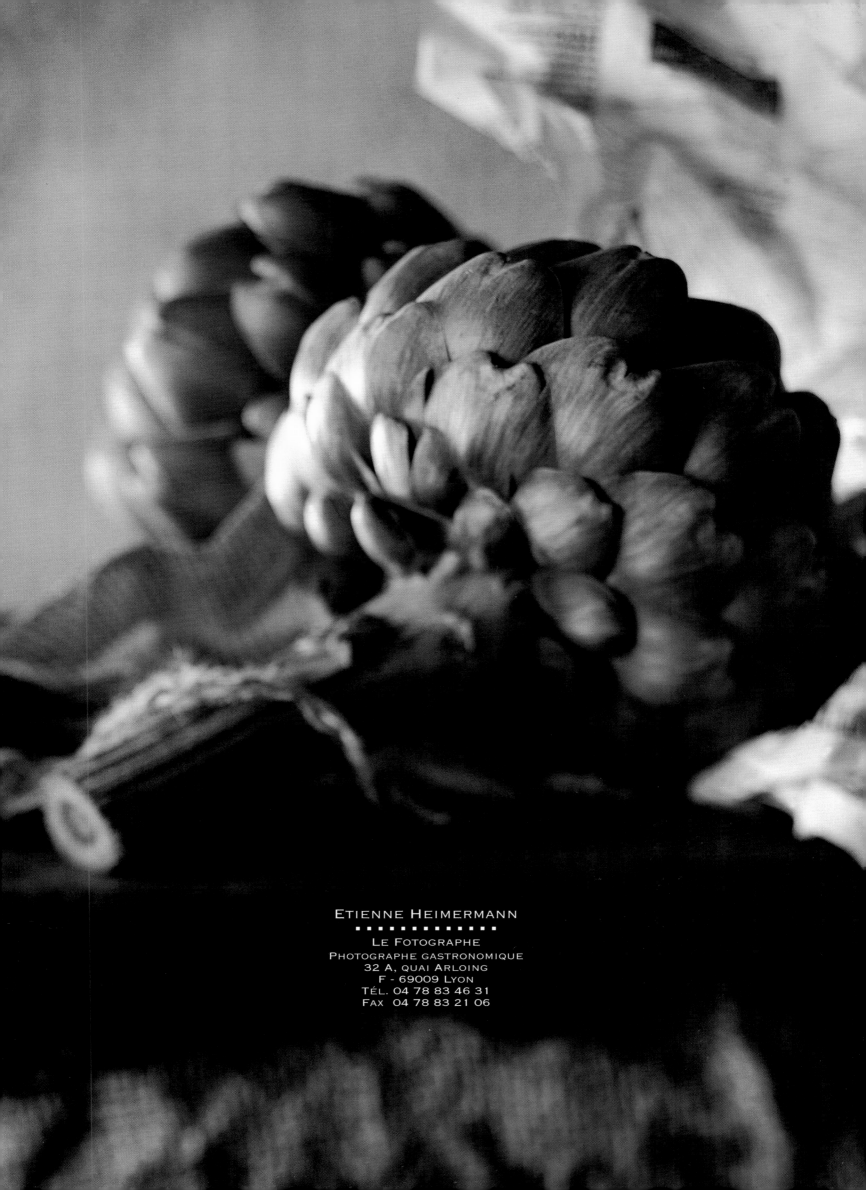

ETIENNE HEIMERMANN
· · · · · · · · · · · · · ·
LE FOTOGRAPHE
PHOTOGRAPHE GASTRONOMIQUE
32 A, QUAI ARLOING
F - 69009 LYON
TÉL. 04 78 83 46 31
FAX 04 78 83 21 06

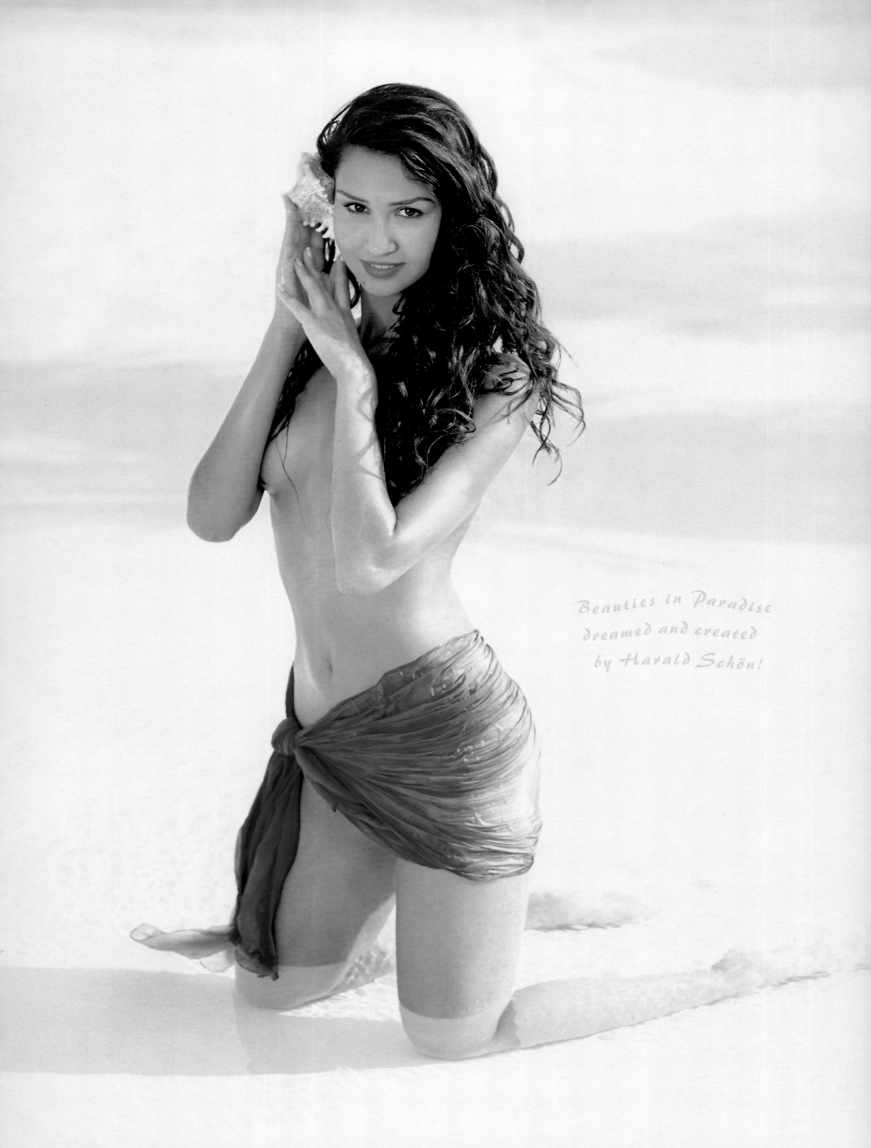

Beauties in Paradise
dreamed and created
by Harald Schön!

Harald Schön · Situations- and Photo-Design · D-75173 Pforzheim · Germany · Tel +49 7231 767276 · Fax +49 7231 767867

S W I T Z E R L A N D
. . . .
S U I S S E
. . . .
S C H W E I Z

	International page	Local page
ALBISSER, CLAUDIA	**52**	*4*
BALMELLI, GIORGIO	**55**	*7*
BERCLAZ, ANDREA	**56**	*8*
BRUN & BURGIN	**53-54**	*5-6*
CUGINI, THOMAS	**57**	*9*
DIETRICH, ALF	**58-59**	*10-11*
DUTOIT & HAYOZ	**60-61**	*12-13*
EUGEN LEU & ROGER HUMBERT AG	**65**	*17*
FORSTER, PETER	**64**	*16*
KÜENZI, CHRISTIAN	**62-63**	*14-15*
MEYER, JEAN-DANIEL	**66-67**	*18-19*
MONKEWITZ, NICOLAS	**68**	*20*
MÜLLER, PETER	**51**	*3*
PLAIN, THOMAS	**69**	*21*
SCHNEIDER, DOMINIC	**70**	*22*
URS, GALL	**71**	*23*
WALTER, MARGRITH	**74**	*26*
ZIMMERMANN, ALBERT	**75**	*27*
ZIMMERMANN, BRUNO	**72-73**	*24-25*

mediacolor's

Bildagentur Telefon: ++41 (1) 493 03 84
 Fax: ++41 (1) 493 03 16
 Email: mediacolors@access.ch
 WWW: http://www.bluewin.ch/mediacolors

CLAUDIA ALBISSER HUND

▪ ▪ ▪ ▪ ▪ ▪ ▪ ▪ ▪ ▪ ▪ ▪ ▪ ▪ ▪ ▪

Atelier Für Fotographie
C. Albisser Hund & Co
Binningerstr. 92-CH 4123 Allschwil
Tel/Fax: ++061 482 02 30

Stills/Foods/Interior/Special effects

BRUN + BÜRGIN FOTOGRAFEN
▪ ▪ ▪ ▪ ▪ ▪ ▪ ▪ ▪ ▪ ▪ ▪ ▪ ▪ ▪ ▪
Mühlebachstrasse 52
CH-8088 Zürich
Tel: +41 1 261 35 38
Fax: +41 1 261 35 53

Still Life • Cars

BRUN + BÜRGIN FOTOGRAFEN
▪ ▪ ▪ ▪ ▪ ▪ ▪ ▪ ▪ ▪ ▪ ▪ ▪ ▪ ▪
Mühlebachstrasse 52
CH-8088 Zürich
Tel: +41 1 261 35 38
Fax: +41 1 261 35 53

Still Life • Cars

GIORGIO BALMELLI
.

The Studio of GIORGIO BALMELLI AG
Im Heuried 51
CH- 8055 Zürich
Tel: (01) 461 42 37
Fax: (01) 461 62 42
Natel (079) 405 58 94

Mode Action
People Scenerie
Werbung Beauty

Λ n d r e a Ɜ e r c l a z
F O T O S T U D I O

S c h a f f h a u s e r s t r a s s e 5 1 2
8 0 5 2 Z ü r i c h S c h w e i z
T e l e f o n 0 1 · 3 0 1 0 6 0 6
T e l e f a x 0 1 · 3 0 1 0 6 0 8

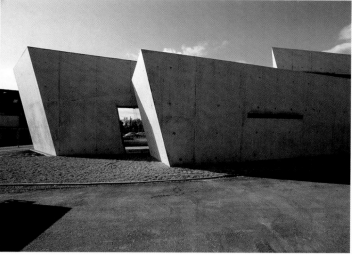

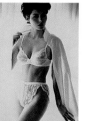

THOMAS CUGINI

▪ ▪ ▪ ▪ ▪ ▪ ▪ ▪ ▪ ▪ ▪ ▪ ▪ ▪

Nordstrasse 110
CH-8037 Zürich
Switzerland
Tel: +41 1 361 50 50
Fax: +41 1 363 17 61

PORTRAITS, ADVERTISING, FASHION, NATURE, ACHITECTURE,
STILL LIFE, EDITORIAL, INTERIORS

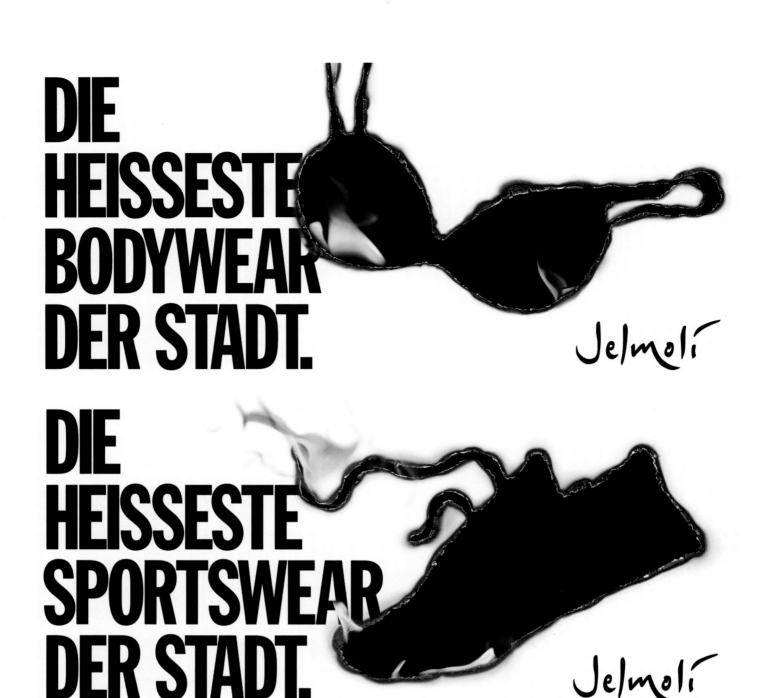

DIE HEISSESTE BODYWEAR DER STADT.

Jelmoli

DIE HEISSESTE SPORTSWEAR DER STADT.

Jelmoli

DIE HEISSESTE CASUALWEAR DER STADT.

Jelmoli

Posters for Jelmoli departementstore, Zurich (Switzerland)

Alf Dietrich Fotograf Stadelhoferstrasse 28 CH-8001 Zürich Tel +41 1 261 67 40 Fax +41 1 252 70 96

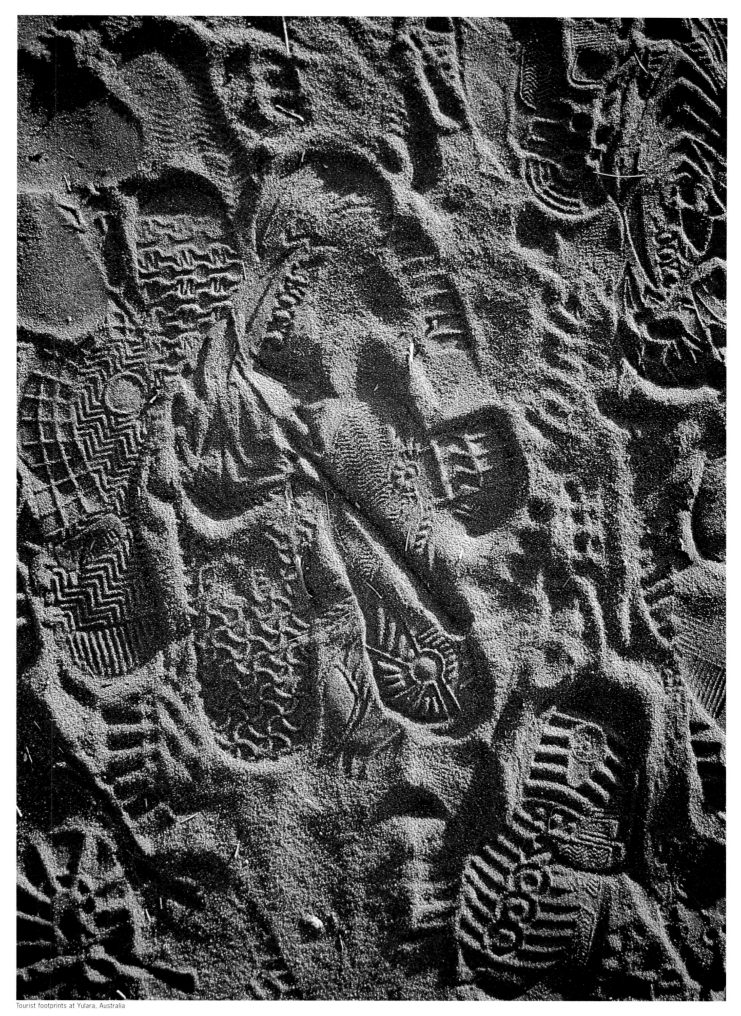

Tourist footprints at Yulara, Australia

Alf Dietrich Fotograf Stadelhoferstrasse 28 CH-8001 Zürich Tel +41 1 261 67 40 Fax +41 1 252 70 96

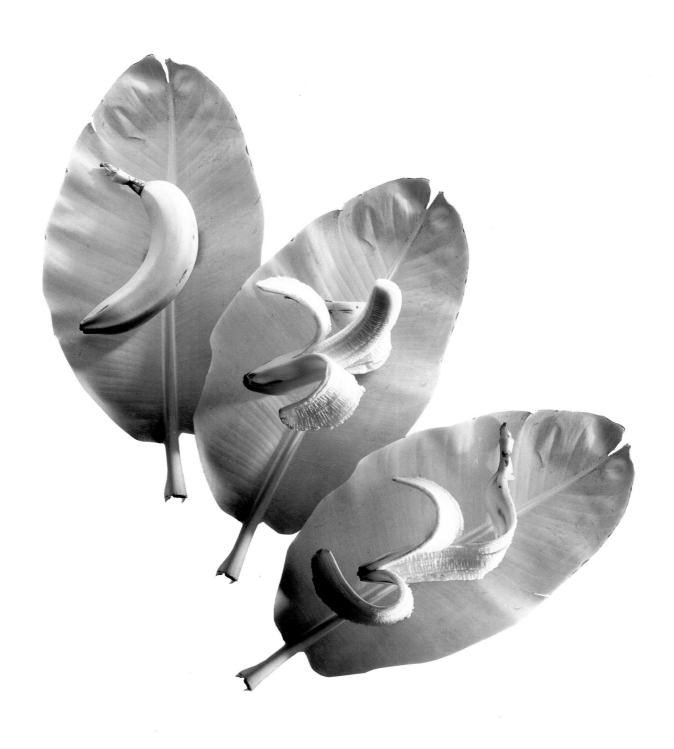

DUTOIT + HAYOZ
.
Forchstrasse 30
CH-8008 Zürich
Tel: +41 1 383 8784
Fax: +41 1 383 6284

Stills • Food • Schmuck • Editorial

DUTOIT + HAYOZ
.

Forchstrasse 30
CH-8008 Zürich
Tel: +41 1 383 8784
Fax: +41 1 383 6284

Stills • Food • Schmuck • Editorial

CHRISTIAN KÜENZI
.

Stockenstrasse 122a
8802 Kilchberg
Tel: 01/715 19 90
Fax: 01/715 52 20

People, Stills, Special Effects

CHRISTIAN KÜENZI

.

Stockenstrasse 122a
8802 Kilchberg
Tel: 01/715 19 90
Fax: 01/715 52 20

People, Stills, Special Effects

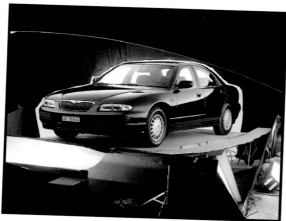

- *location archives*
- *car photography*
- *composing*

PETER FORSTER

■ ■ ■ ■ ■ ■ ■ ■ ■ ■ ■ ■ ■ ■ ■ ■

Bommer Weiher Studio AG
CH-8573 Alterswilen
Tel: ++071 699 14 24
Fax: ++071 699 15 31
Mobile: 089 601 09 73

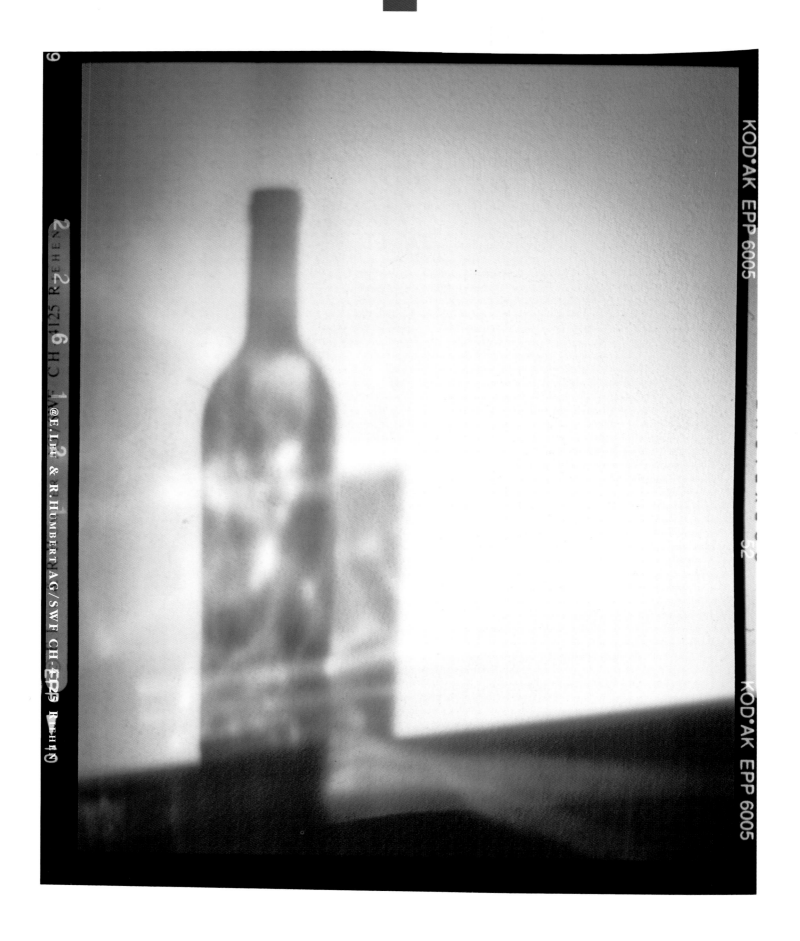

EUGEN LEU & ROGER HUMBERT AG

· · · · · · · · · · · · · ·

EUGEN LEU
Baselstrasse 48
CH-4125 Riehen
TEL: ++061 641 33 55 FAX: ++061 641 15 78

Adresse Deutschland:
LEU & PARTNER GmbH
Haagener Str. 32
D-79539 Lörrach

Advertising, furniture,
people, still life,
textile, editorial

Werbung, Möbel,
People, Stills,
Textilien, Editorial

Publicité, meubles,
gens, natures mortes,
textiles, éditorial

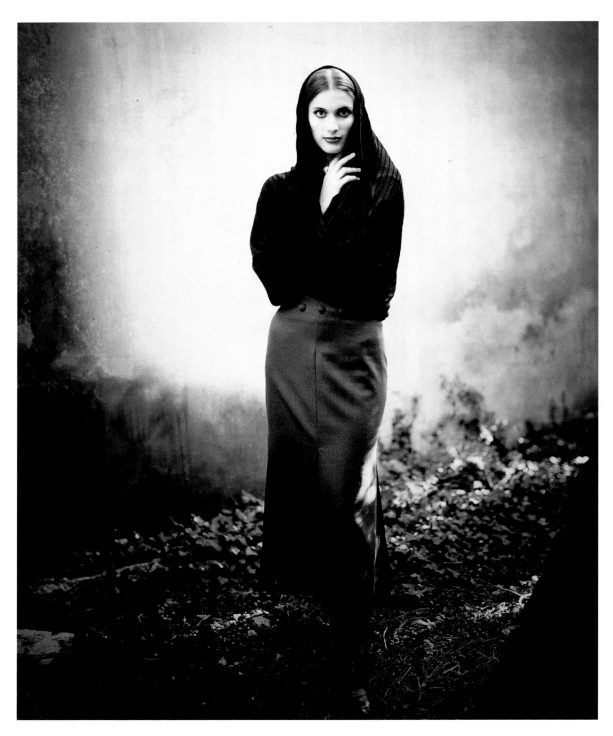

JEAN-DANIEL MEYER

Chemin des Grands-Champs 12
CH-1212 Grand-Lancy
Genève
Tel: +22 794 30 24
Fax: +22 794 30 22
Site web: http://www.le-studio.ch
e-mail: meyer@le-studio.ch

JEAN-DANIEL MEYER

∎ ∎ ∎ ∎ ∎ ∎ ∎ ∎ ∎ ∎ ∎ ∎ ∎ ∎

Chemin des Grands-Champs 12
CH-1212 Grand-Lancy
Genève
Tel: +22 794 30 24
Fax: +22 794 30 22
Site web: http://www.le-studio.ch
e-mail: meyer@le-studio.ch

NICOLAS MONKEWITZ
▪ ▪ ▪ ▪ ▪ ▪ ▪ ▪ ▪ ▪ ▪ ▪ ▪ ▪

Dolderstrasse 2
CH-8032 Zürich
Tel: 261 3105
Fax: 261 3106

THOMAS PLAIN
∙ ∙ ∙ ∙ ∙ ∙ ∙ ∙ ∙ ∙ ∙ ∙ ∙ ∙
Bachstrasse 11
CH-8038 Zürich
Tel: +41 1 483 02 22
Fax: +41 1 482 80 88

People • Scenes • Still Life • Digital I.P.

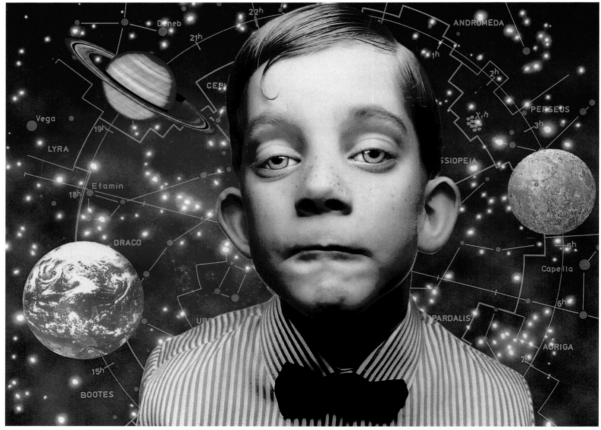

DOMINIC SCHNEIDER
■ ■ ■ ■ ■ ■ ■ ■ ■ ■ ■ ■ ■ ■

Mythenquai 353 / Postfach
CH-8038 Zürich
Tel: +41 1 481 80 66
Fax: +41 1 481 80 96

People	Menschen	Personnages
Scenes	Szenen	Scènes
Still life	Stilleben	Natures mortes
Digital imaging	Digitale Bildbearbeitung	Traitement numérique des images

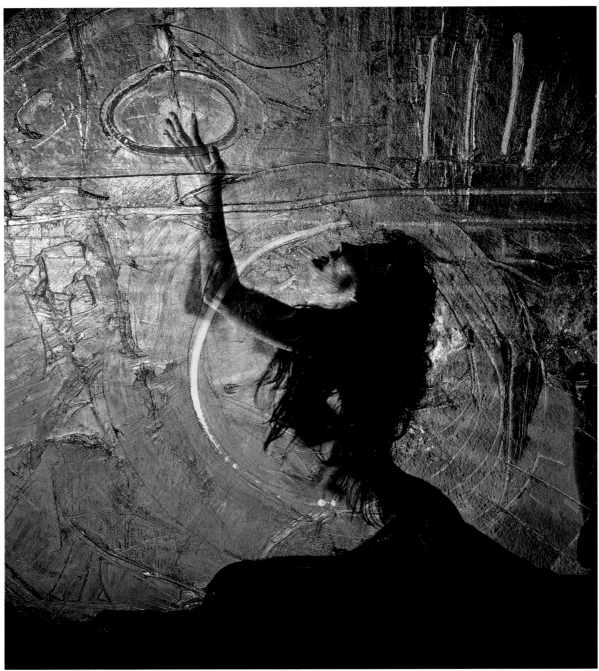

ZIMMERMANN BRUNO

.

Chemin du Calvaire 7
CH-1005 Lausane
TEL: *++021 623 41 56*

ZIMMERMANN BRUNO
∎ ∎ ∎ ∎ ∎ ∎ ∎ ∎ ∎ ∎ ∎ ∎ ∎
Chemin du Calvaire 7
CH-1005 Lausane
Tel: *++021 623 41 56*

MARGRITH WALTER

⬛ ⬛ ⬛ ⬛ ⬛ ⬛ ⬛ ⬛ ⬛ ⬛ ⬛ ⬛ ⬛

MARGRITH WALTER PHOTOGRAPHY
Albisriederstr. 379
CH-8047 Zürich
Tel: 01/ 493 53 55
Fax: 01/ 492 55 29

Advertising, Still life, Product, People, Beauty

ALBERT ZIMMERMANN
.
Trichtenhausenstr. 231
CH-8125 Zollikerberg
Tel: +41 1 422 37 00
Fax: +41 1 422 93 67

G R E E C E

G R È C E

G R I E C H E N L A N D

	International page	Local page
BIANCHI, STEFANO	78	2
CHRISAGIS, ARIS	86-87	10-11
KOUTOULIAS, GABRIEL	79	3
PHOBIA IMAGE STUDIO	82-83	6-7
REPPAS, ANDREAS	81	5
SOFIANOPOULOS, ALEXIS	84-85	8-9
STELIOS, TZETZIAS	88	12
STUDIO IMAGE & PHOTOGRAPHIC ART	80	4

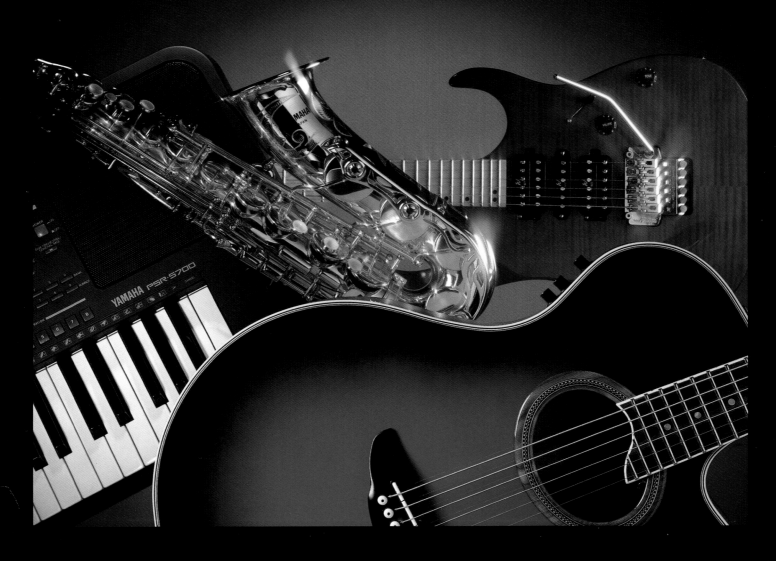

STEFANO-ROBERTO BIANCHI

STUDIO AXARLI
7 Iolis Street, Athens
Greece 11636
Tel : 301 9225623
Fax : 301 9224775

Mr. Stefano-Roberto Bianchi has more than 15 years experience as a professional photographer and the last 10 years he has specialized in
still life photography. He is working in the private enterprise named "STUDIO AXARI" which is resided in the center of Athens

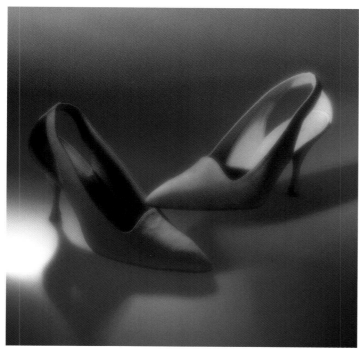

GABRIEL KOUTOULIAS
■ ■ ■ ■ ■ ■ ■ ■ ■ ■ ■ ■ ■ ■ ■ ■

40 kritovoulidou street
104 45 Athens
Greece
Tel / Fax: 8310 029
Mobil: 094 598 593
e-mail: gabi@hol.gr.

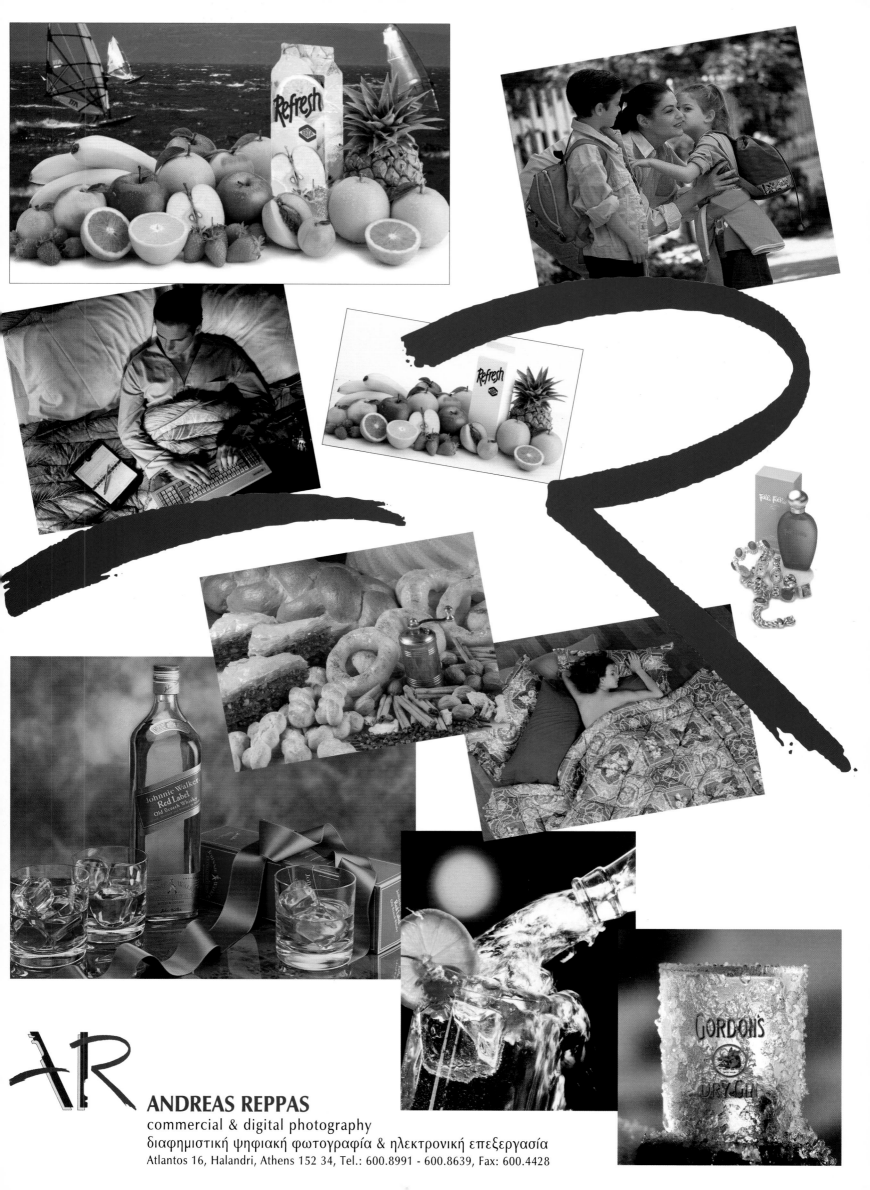

ANDREAS REPPAS
commercial & digital photography
διαφημιστική ψηφιακή φωτογραφία & ηλεκτρονική επεξεργασία
Atlantos 16, Halandri, Athens 152 34, Tel.: 600.8991 - 600.8639, Fax: 600.4428

PHOBIA IMAGE STUDIO, STEFANOS SAMIOS, SISINI 14-16

ATHENS GREECE, GR 115 28, TEL. (01)7250949, FAX: (01)7214410

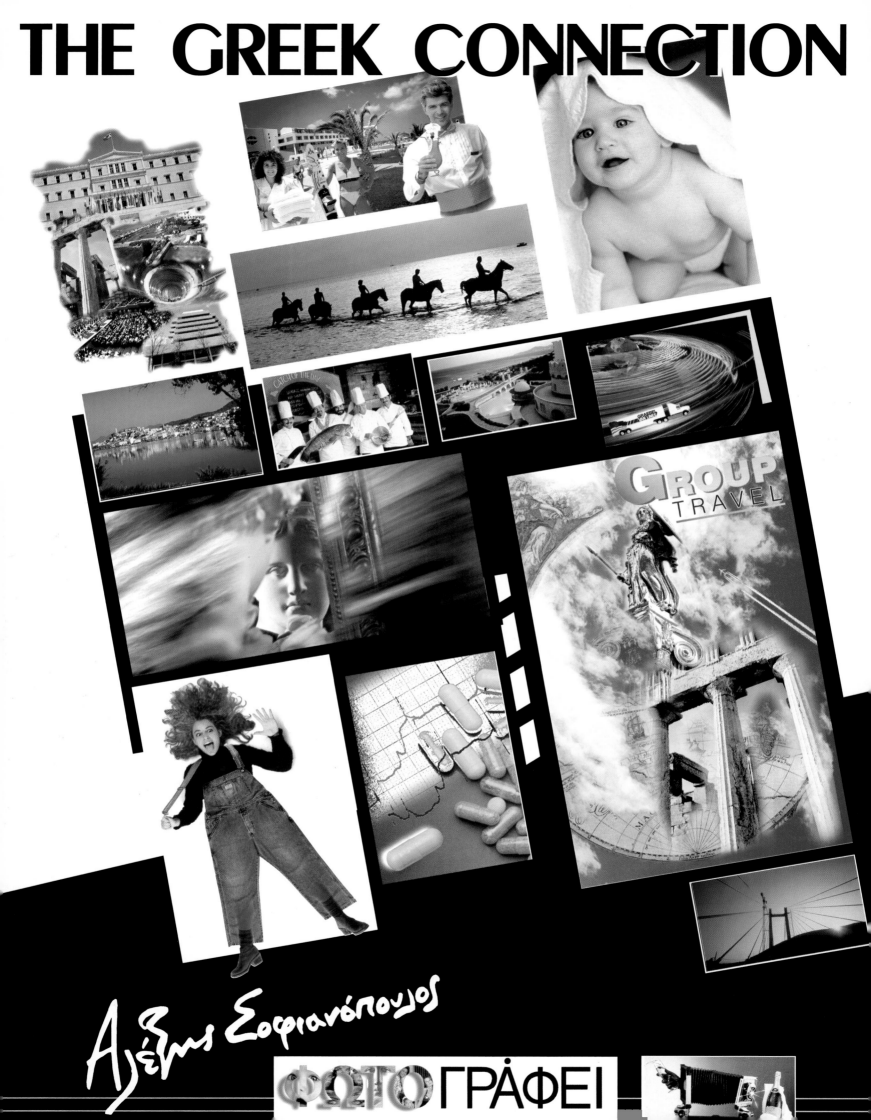

THE GREEK CONNECTION

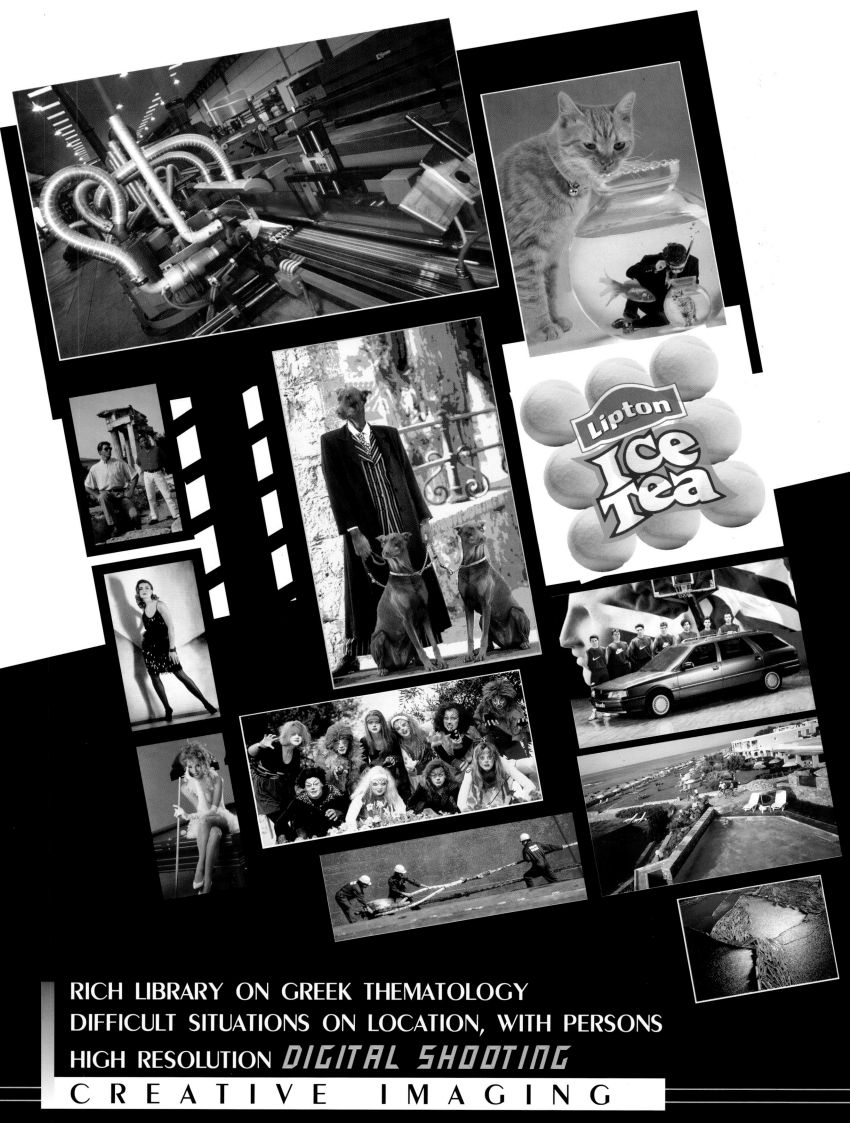

RICH LIBRARY ON GREEK THEMATOLOGY
DIFFICULT SITUATIONS ON LOCATION, WITH PERSONS
HIGH RESOLUTION *DIGITAL SHOOTING*

CREATIVE IMAGING

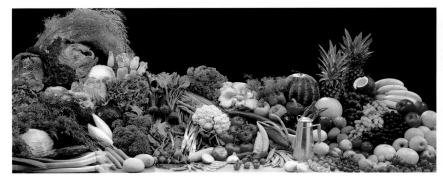
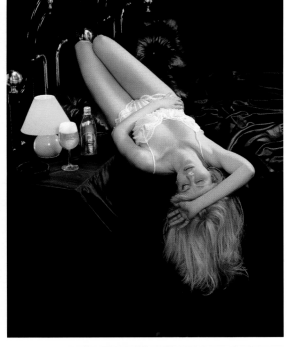

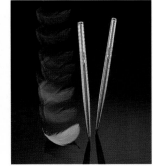
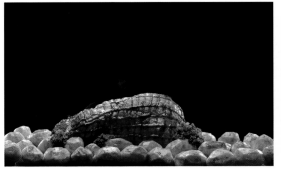
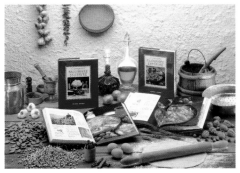
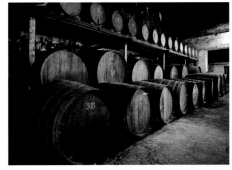
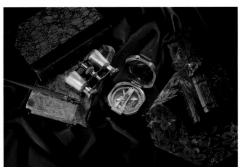

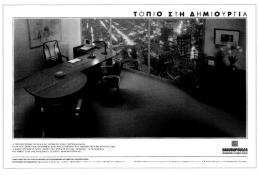

ARIS CHRISAGIS
Photography

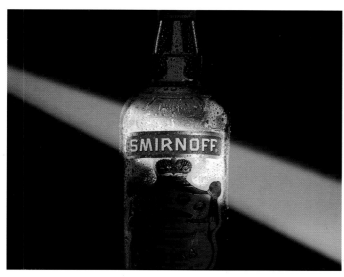

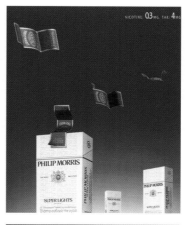

ARIS CHRISAGIS

Photography

12-16, Arhita str., 116 35 Athens, Greece, tel. (01) 9028994, fax : (01) 9028924

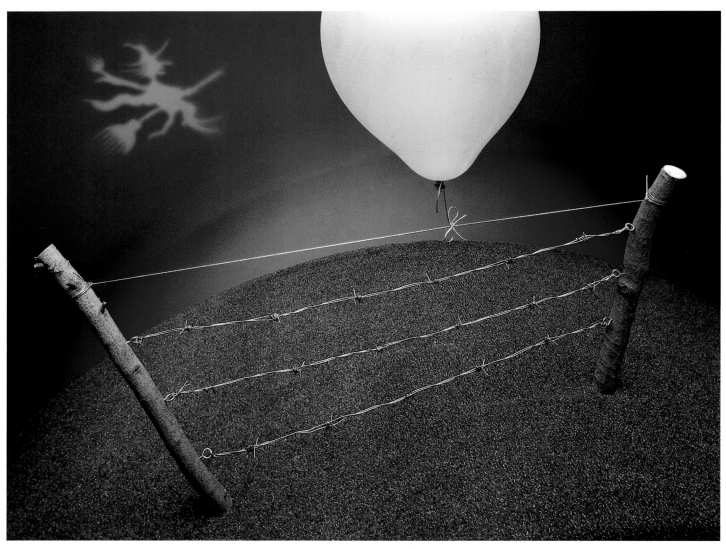

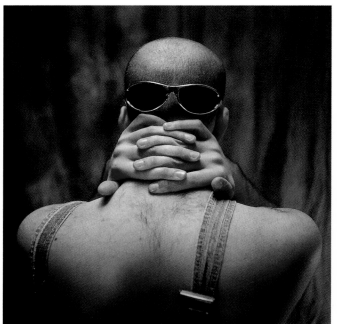

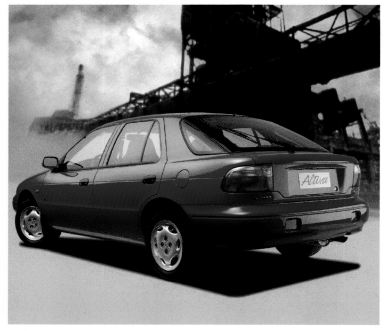

Tzetzias Stelios
PHOTOGRAPHER
· · · · · · · · · · · ·

FEREKIDOU 14-16, 11 636, TEL.: 70 16 145, FAX: 72 61 517

I T A L Y
• • • • •
I T A L I E
• • • • •
I T A L I E N

	International page	Local page		International page	Local page
AGOSTINI, FRANCESCO	92-93	*4-5*	**LOPEZ & BARELLA**	124-125	*36-37*
B & B PHOTO COMMUNICATIONS			**MAJNO, GIORGIO**	112	*24*
DI BUTTINONI G	95	*7*	**MARCIALIS, RENATO**	111	*23*
BENEDETTI BRÁ, RAFFAELLO	97	*9*	**MAZZANTI, PAOLO**	110	*22*
CECCHIN, PAOLO	98-99	*10-11*	**MERLO, GIULIANO**	114-115	*26-27*
CIGOGNETTI, MAURIZIO	121	*33*	**MONTAINA, EDOARDO**	116-117	*28-29*
FERRERI, EZIO	91	*3*	**MUSCETTI, STEFANO**	113	*25*
FINAZZI, ANTONIO	94	*6*	**PERAZZOLI, LUCA**	105	*17*
FOTOSCIENTIFICA	122-123	*34-35*	**PICCOLI & PICCOLI**	104	*16*
GENUZIO, CESARE	100	*12*	**RATTÁ, GREG**	90	*2*
ISAIA, ENZO	96	*8*	**RICCI, BERNARDO**	118	*30*
ITALCOLOR SRL	127	*39*	**ROSSI, GUIDO ALBERTO**	119	*31*
ITALIMAGE FOTOGRAFI ASSOCIATION	102-103	*14-15*	**STUDIO WESTON**	120	*32*
LOMBARDI, GIULIANO	101	*13*	**TOMASINI, OTTAVIO & CELLA, GIUSEPPE**	106-109	*18-21*

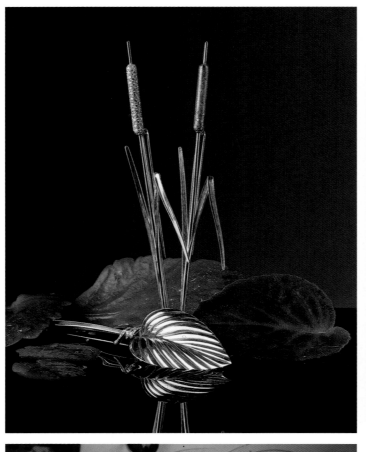

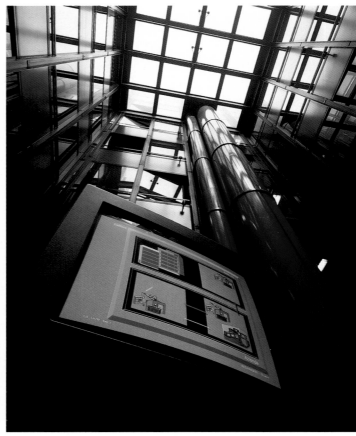

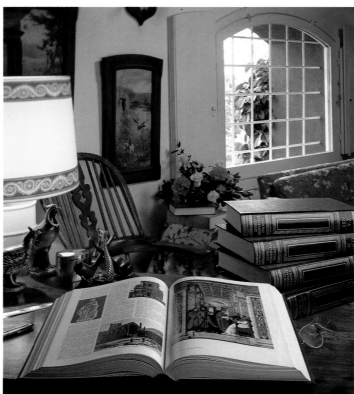

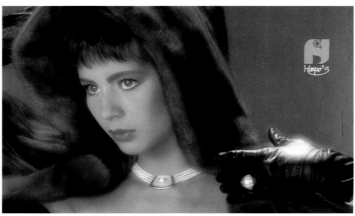

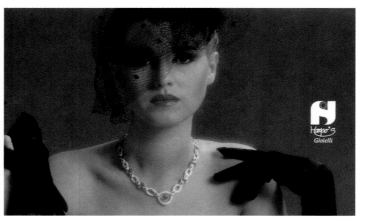

GREG RATTÁ

.

Via Cibrario, 32
I-10144 Torino
Tel./Fax: 011 487 177

Fotografia per la comunicazione

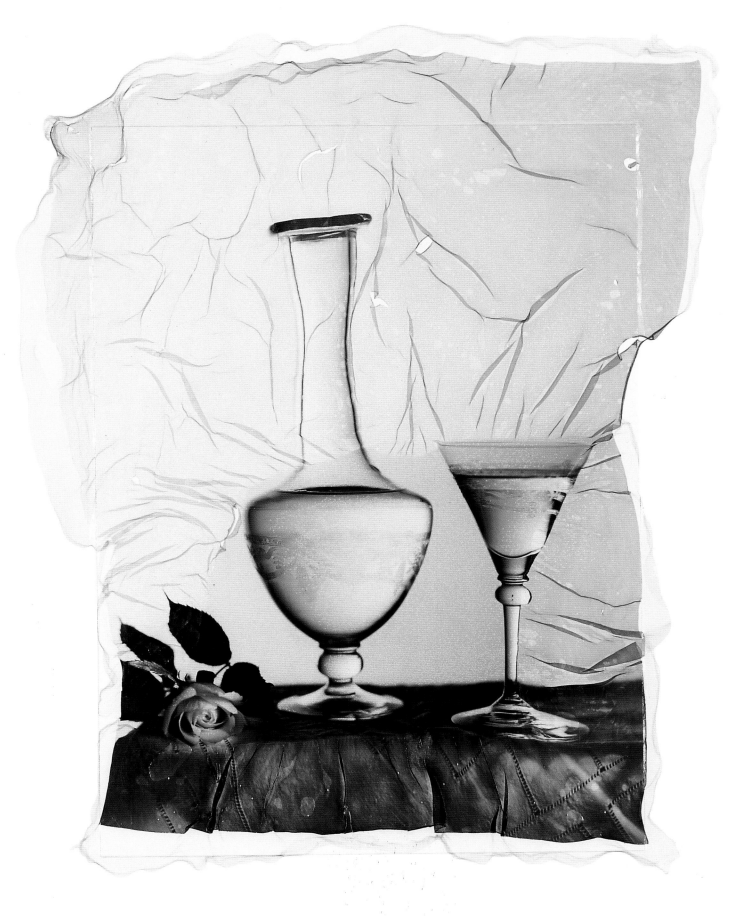

EZIO FERRERI

• • • • • • • • • • • • •

Via Catania, 35
90141 Palermo-I
Tel : +39 91 6259673
Fax : +39 91 6259670

Member AFIP, SIAF.	*Associato AFIP, SIAF.*	*Membre AFIP, SIAF.*
Advertising - Still-life.	*Pubblicità - Still-life.*	*Publicité - Natures mortes*
Illustration - Industry.	*Illustration - Industriale.*	*Illustration - Industrie.*
Photographs in studio or on location.	*Riprese in studio ed in location.*	*Prises de vue en studio ou à l'extérieur.*

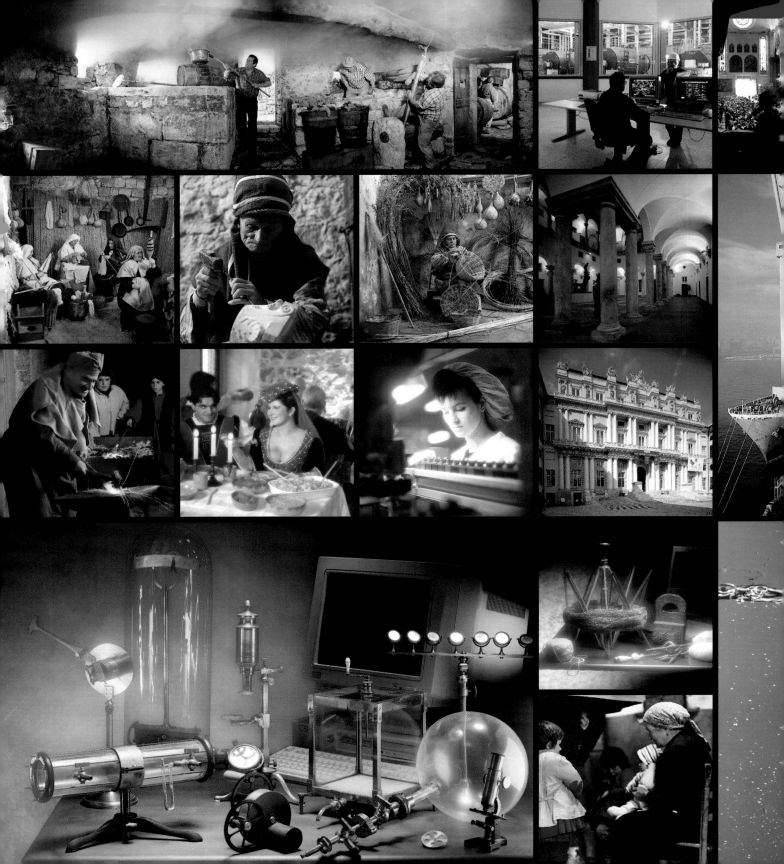

AGOSTUDIO
di Francesco Agostini

Via Diodoro Siculo, 36
Tel. (02) 66106640 · Fax 66106637
20125 Milano

Still Life

Industrial

ANTONIO FINAZZI
FOTOGRAFO
Via Pizzo Arera 20 - 24060 Chiuduno(BG) - Italy - Tel. e Fax 035/4427277

ENZO ISAIA

· · · · · · · · · · · · · · · ·

Corso Quintino Sella 11
I-10131 Torino
Tel. & Fax: 011 819 30 81

Specialities:	Specializzazione:
Cars - Still life - Industrial	*Automobili - Industriale - Still-life*
Reportage	*Reportage*

Si riconosce la mano inconfondibile di Sottsass.

PIRELLA GÖTTSCHE LOWE *PER SHAKER*

Un dito è per la nuova caraffa termoisolante Sherazade.
Uno per il nuovo bicchiere di cristallo della serie Ginevra. Uno invece per

l'oliera 5070. E uno per le posate Nuovo Milano. L'ultimo è per il servizio di piatti La Bella Tavola.
La mano di Sottsass rivolge al tempo

il suo pensiero più profondo: marameo.

ALESSI

ALESSI S.P.A. 28023 CRUSINALLO (VB). SE CI MANDATE IL VOSTRO NOME E INDIRIZZO CON LA SIGLA SH/DV POTREMO FARVI AVERE UN CATALOGO ILLUSTRATO DEI NOSTRI PRODOTTI. SHOW ROOM DI MILANO - CORSO MATTEOTTI, 9.

RAFFAELLO BENEDETTI BRÀ

▪ ▪ ▪ ▪ ▪ ▪ ▪ ▪ ▪ ▪ ▪ ▪ ▪ ▪

*Via San Siro 31
I-20149 Milano
Tel. (02) 4986035
Fax: (02) 48003241*

PAOLO
CECCHIN
FOTOGRAFO

VIA PRINCIPESSA CLOTILDE 85
10144 TORINO ITALY
TEL.(011) 8995616 - 912472 - FAX (011) 912541

CESARE GENUZIO
* * * * * * * * * * * * * *

Via Montereale, 139
33170 Pordenone
Italy
Tel : 0039 434 366664
Fax : 0039 434 553243

Commercial and advertising
photography.
Architecture, furniture, still life, industry,
corporate.

Fotografia per la pubblicità
e l'industria.
Architettura, arredamento, still life,
monografie aziendali.

A MORE A PRIMA VISTA

GIULIANO LOMBARDI

● ● ● ● ● ● ● ● ● ● ● ● ● ● ●

Via Don L. Milani, 92
I-41100 Modena
Tel: 059 / 253073
Fax: 059 / 253433

Associato AFIP
Cliente: Leporati

Agenzia: RC & A Comunicazione
Art Director: Corrado Riccomini

n max. 6500

italimage®

Italimage fotografi associati
2, via Altaguardia 20135 Milano Italy
voice +39 2 583.063.85 fax +39 2 583.100.89
www.boutique-creativa.it/italimage

PICCOLI & PICOLLI
.
Via Cancano 2
I-20152 Milano
Italy
Tel. 02 456 2556

LUCA PERAZZOLLI
· · · · · · · · · · · · ·
Via Santa Sofie, 14
I-20122 Milano
Italy

OTTAVIO TOMASINI / GIUSEPPE CELLA
■ ■ ■ ■ ■ ■ ■ ■ ■ ■ ■ ■ ■ ■ ■

Via Camozzi, 8
I-25126 Brescia
Tel: (030) 4 72 78
Fax: (030) 377 22 35

Via Alcaini, 10
I-24123 Bergamo
Tel. (0337) 43 83 93
Fax: (035) 22 25 96

Associato AFIP-GADEF

Also director of photography on film

OTTAVIO TOMASINI / GIUSEPPE CELLA
■ ■ ■ ■ ■ ■ ■ ■ ■ ■ ■ ■ ■ ■ ■

Via Camozzi, 8 *Via Alcaini, 10*
I-25126 Brescia *I-24123 Bergamo*
Tel: (030) 4 72 78 *Tel. (0337) 43 83 93*
Fax: (030) 377 22 35 *Fax: (035) 22 25 96*

Associato AFIP-GADEF *Also director of photography on film*

photographer
Paolo Mazzanti

Via degli Abeti, 108
61100 PESARO · ITALY

Tel. + (39)(721)403912 (ISDN)
Fax + (39)(721)403914 (ISDN)

E-mail: mazzanti@abanet.it

twenty years of commercial/advertising photography

RA

RENATO MARCIALIS
"Beverage and Food"
via Iacopo Palma, 8 - I - 20146 Milano
tel. +39-2-406354 - fax +39-2-4075441

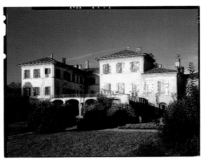

Giorgio Majno

Fotografo Via Cappuccio 7 • Milano
Tel e Fax 02.72000400

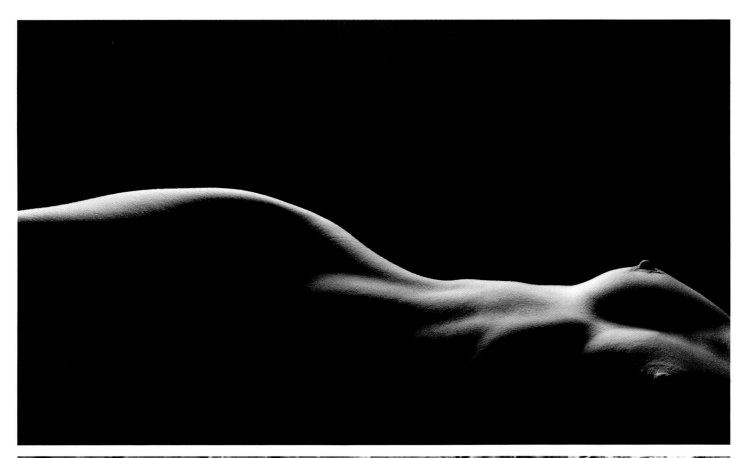

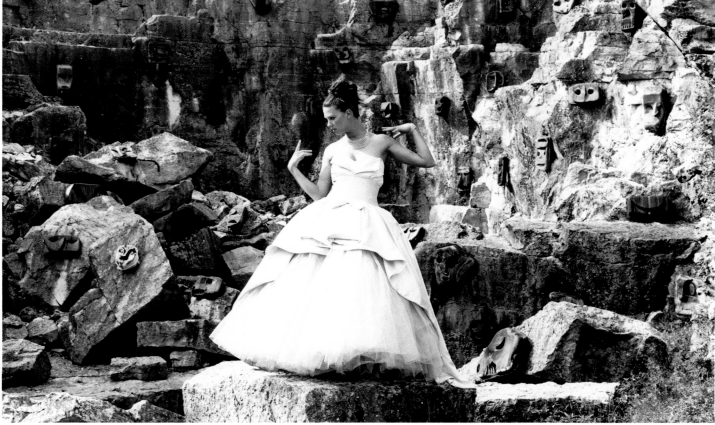

StudioF
otograf
icoL'oc
chiello

■ ■ ■ ■ ■ ■ ■ ■ ■ ■ ■ ■ ■ ■ ■ ■

Via Trozzetti,77
I- 36061 Bassano del Grappa (VI)
tel. 0424/30018
fax 0424/30765

still-life moda location

StudioF
otograf
icoL'oc
chiello

.
Via Trozzetti,77
I- 36061 Bassano del Grappa (VI)
tel. 0424/30018
fax 0424/30765

still-life moda location

Agip Alenia Spazio Alitalia

Ansaldo Assitalia Cartiera

Fedrigoni Confindustria

Data Management Enel Ilva

Ina Italimprese Mediocredito-

Centrale Sigma Tau Unipede

design: TEIKNA/Claudia Neri

Edoardo Montaina

fotografia

00198 Roma Via Chiana, 87 T [0761] 326265

cellulare [0336] 773779

BERNARDO RICCI

.

Via Calamelli, 12
I-40026 Imola (BO)
Tel/Fax, (0542) 64 18 10 / (0336) 55 59 53

Associato AFIP-SIAF

GUIDO ALBERTO ROSSI

■ ■ ■ ■ ■ ■ ■ ■ ■ ■ ■ ■ ■ ■ ■ ■

Via Terraggio,17
I-20123 Milano
Tel. (02) 87 46 93
Fax: (02) 805 77 39
e-mail: tibitaly @ micronet.it

Stock:
The Image Bank Worldwide

Specialzed in Travel and Aerial
Photography. 25 Books published so far.

MAURIZIO CIGOGNETTI

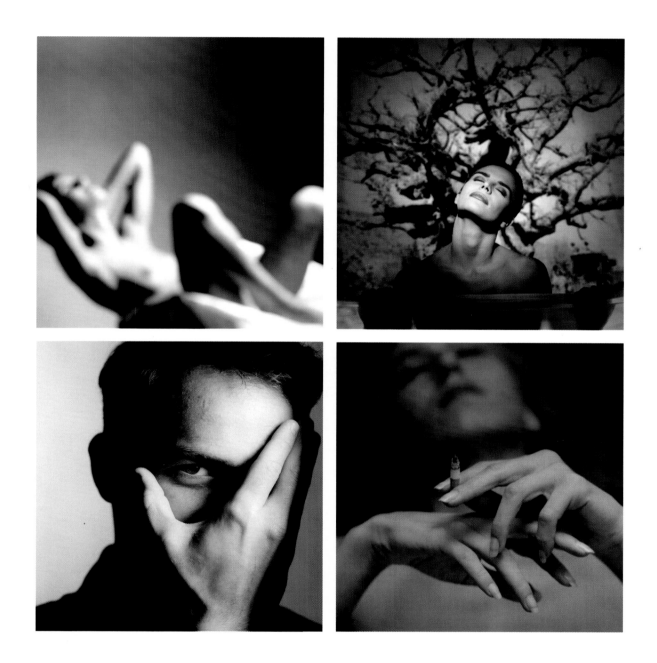

VIA CISLAGHI, 26 - 20128 MILANO - ITALY
TEL. 02-27001760 - FAX 02-27001774
HTTP://HYPERIT.COM/CIGOGNETTI

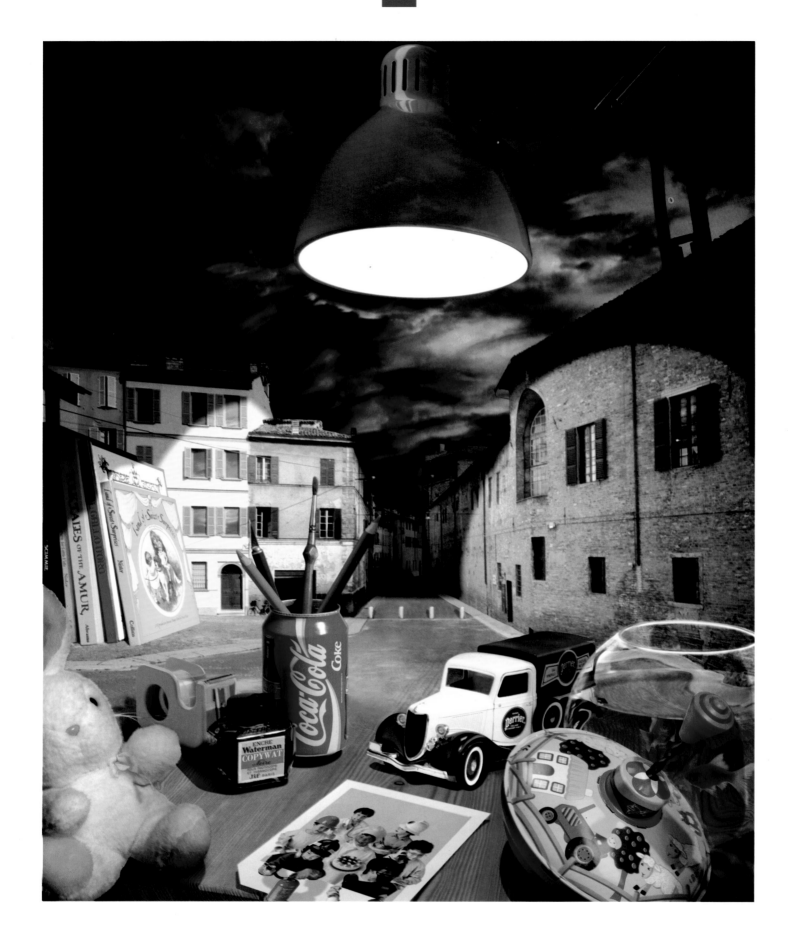

DANIELE BROIA, FLORIANO FINZI
.
FOTOSCIENTIFICA S.N.C. DI FINZI E BROIA
Via Paradigna, 76
43100 Parma - Italy
Tel: (0521) 271447 / 271457
Fax: (0521) 271467
fotoscie@mbox.vol.it

Foto per la pubblicità, il food,
l'arredamento, still-life,
elaborazioni digitali
Associati AFIP

DANIELE BROIA, FLORIANO FINZI
· · · · · · · · · · · · · ·
FOTOSCIENTIFICA S.N.C. DI FINZI E BROIA
Via Paradigna, 76
43100 Parma - Italy
Tel: (0521) 271447 / 271457
Fax: (0521) 271467
fotoscie@mbox.vol.it

Foto per la pubblicità, il food,
l'arredamento, still-life,
elaborazioni digitali
Associati AFIP

VITALIANO LOPEZ
.
STUDIO ORIZZONTE
Via Barberini, 60
I-00187 ROMA
Tel. (06) 4825333 - 4744637
Fax. (06) 4743339

ANTONIO BARRELLA
● ● ● ● ● ● ● ● ● ● ● ● ● ●
STUDIO ORIZZONTE
Via Barberini, 60
I-00187 ROMA
Tel. (06) 4825333 - 4744637
Fax. (06) 4743339

STEFANO MUSCETTI
• • • • • • • • • • • • • • • • •

STUDIO PRISMA
Via S. Rocco, 6
I-20135 Milano
Tel. 02-58309706
Fax 02-58305432

PHOTOGRAPHY & ELECTRONICS

*Il cielo in una stanza, volare, una zebra a
pois... nulla è impossibile !!*

*A yellow submarine, purple rain,
strawbarry fields forever...
nothing is impossible !!*

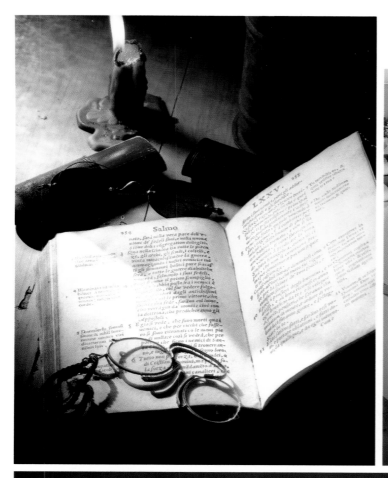

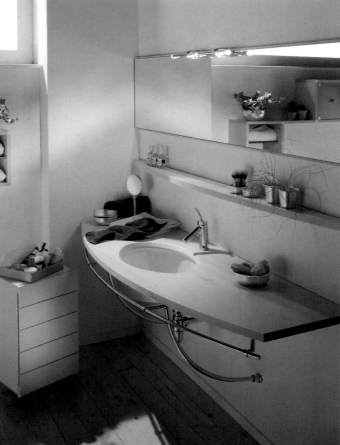

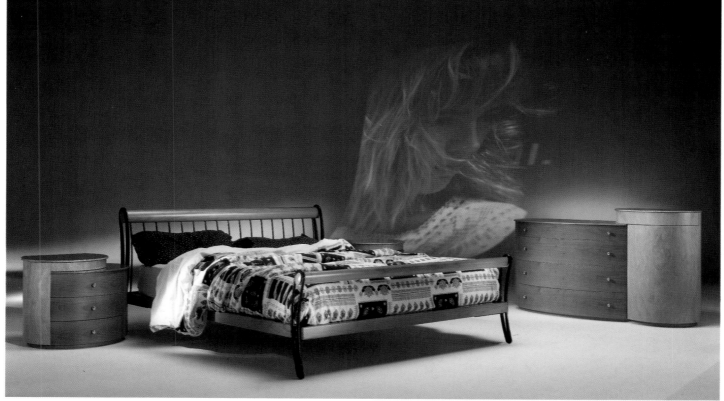

ITALCOLOR SRL

∎ ∎ ∎ ∎ ∎ ∎ ∎ ∎ ∎ ∎ ∎ ∎ ∎ ∎ ∎ ∎

ARREDAMENTO STILL LIFE D'ARREDO
ass. AFIP
Del Governatore Piero

Teatro di posa:
Via Svizzera, 14 - Roseto degli Abruzzi
Tel: (085) 889 92 45

fotografo da tre generazioni con teatro
di posa e laboratorio di 800 mq. totali.
Da sempre fotografiamo
arredamento e still-life d'arredo

Sede:
Via Nazionale, 175 - $
Roseto degli Abruzzi
Tel & Fax (085) 899 02 81

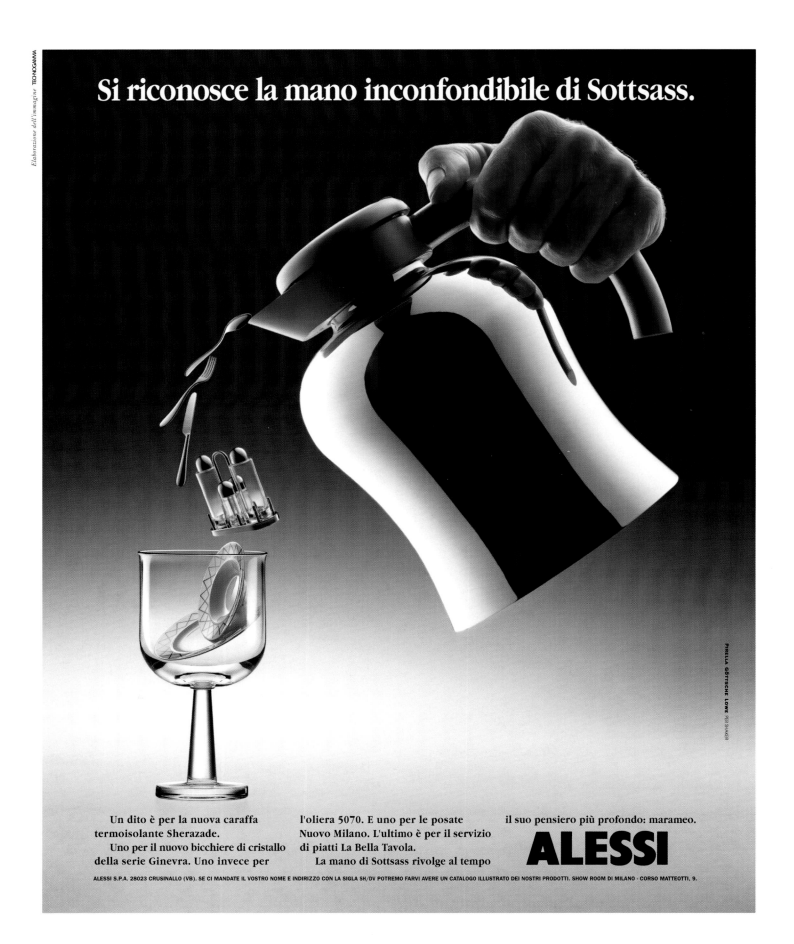

RAFFAELLO BENEDETTI BRÀ

.

Via San Siro 31
I-20149 Milano
Tel. (02) 4986035
Fax: (02) 48003241

P O R T U G A L

■ ■ ■ ■

P O R T U G A L

■ ■ ■ ■

P O R T U G A L

	International page	Local page
ALMEIDA, MANUEL DE ÓSCAR	135 7	
CABRITA GIL, MARIO	134 6	
DÓRIA, JOÃO LUIS	132 4	
PICTO	130-131 2-3	
STUDIO 8A	133 5	

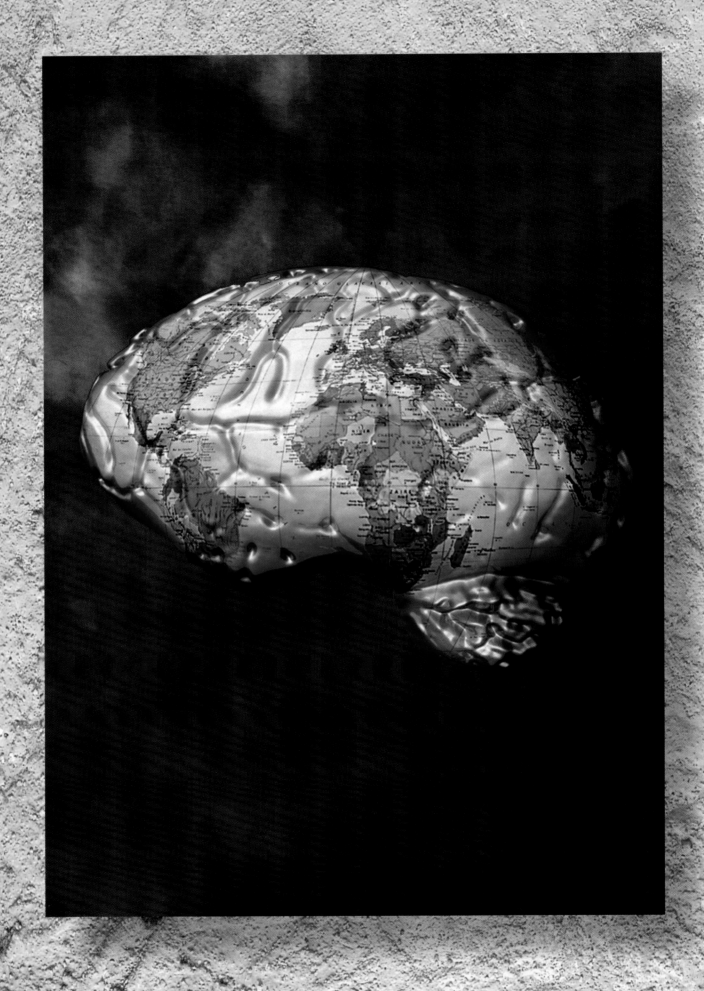

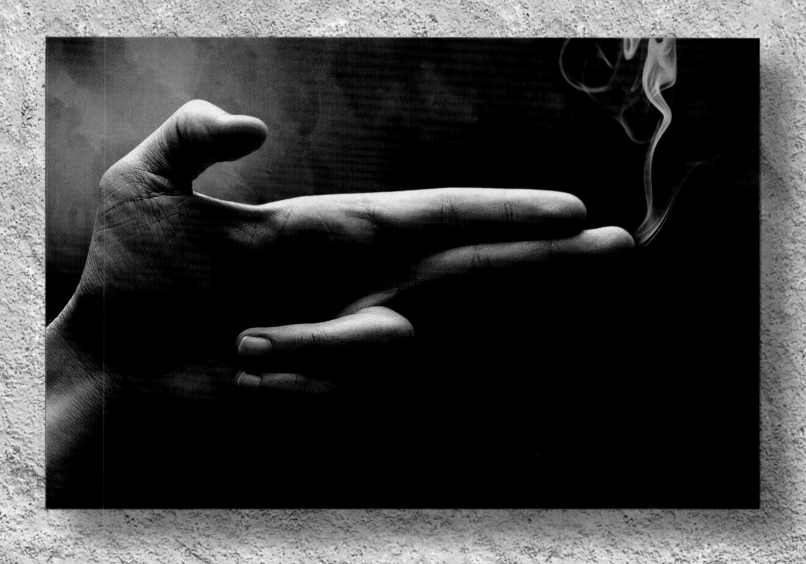

Rua Luís Fernandes, 32A • 1200 Lisboa
Tel 396 14 01 • 395 64 08 • Fax 395 64 10 • picto92 @mail.telepac.pt

P•I•C•T•O

Rua Tomás de Figueiredo, 12-2º Esq.
1500 LISBOA - PORTUGAL

Tel. 351.1.760 83 38
Fax. 351.1.760 54 90
Mobile: 0931.25 47 24

Design · Carmen Sissi

João Luís Dória

Catálogo/Catalogue
for Dalmata

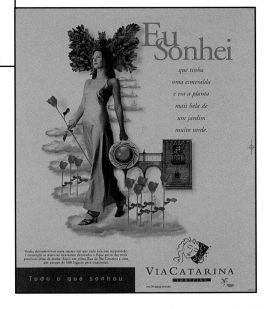

Capa/Cover
for Homem Magazine

Catálogo/Catalogue
for Do Homem

Campanha/
Advertising Campaign
for HPP

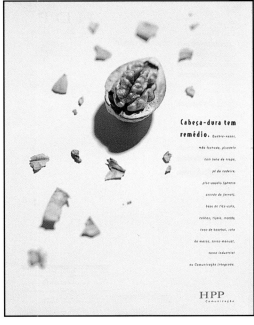

Campanha/
Advertising Campaign
for Via Catarina

FOTOGRAFIA

RUA LUCIANO FREIRE, 8-A
1600 LISBOA - PORTUGAL
TEL. (01) 796 0007 FAX: (01) 795 4106

http://www.geocities.com/Paris/2008

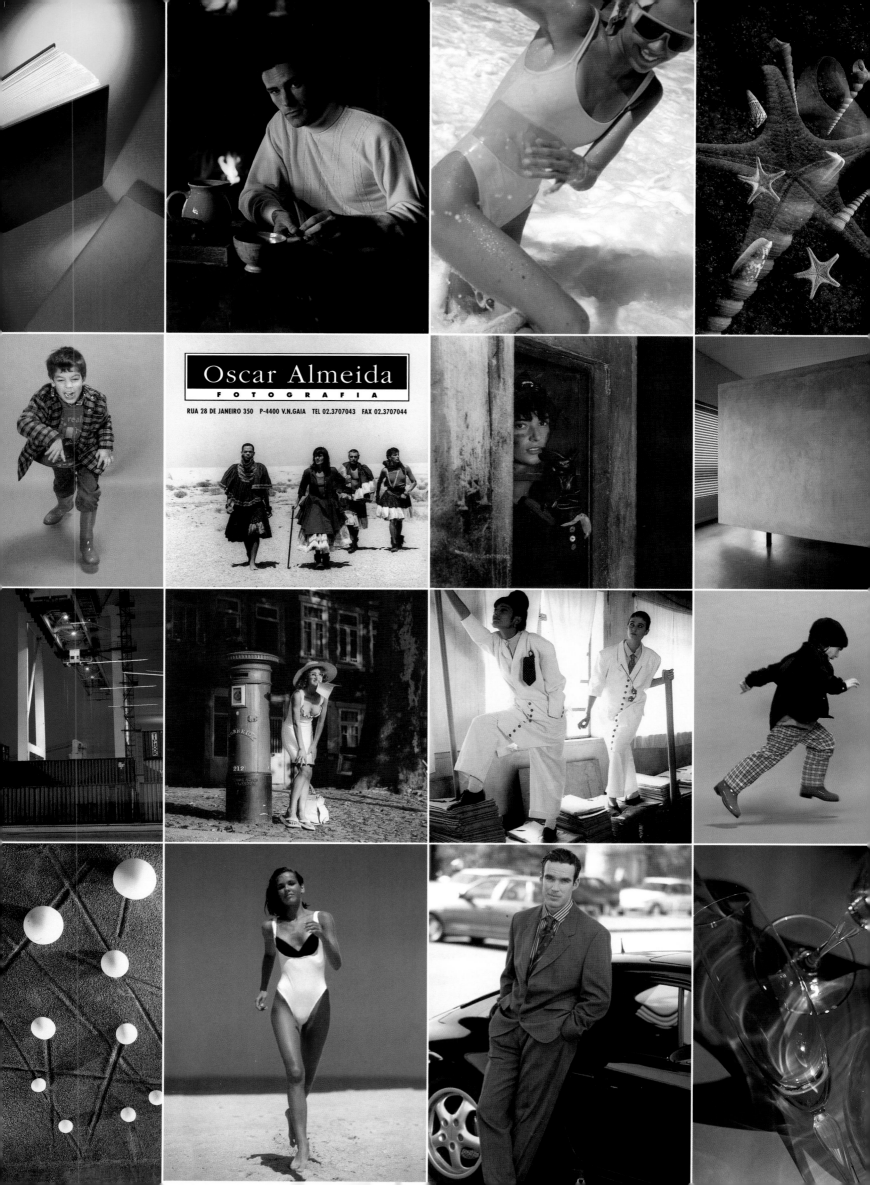

Oscar Almeida
FOTOGRAFIA
RUA 28 DE JANEIRO 350 P-4400 V.N.GAIA TEL 02.3707043 FAX 02.3707044

S P A I N

E S P A G N E

S P A N I E N

	International page	Local page
A.J.J. ESTUDI SCP	169	33
AF/EP	184	48
AFP/PMC	138	2
ALONSO PEREZ, CARLOS	202	66
ANGEL INVARATO, MIGUEL	180	44
ARARA & PELEGRIN	162	26
ARNÓ, FRANCESC	142-143	6-7
BLANCAFORT, JORDI	148-149	12-13
BOU, JOSEP	170-171	34-35
BARBERO CASTILLO, JOSEP	156-157	20-21
CHAMIZO, JESÚS MARTÍN	182-183	46-47
COLL, PEDRO	174-175	38-39
DE BENITO, ANTONIO	193	57
DE BUSTOS, FERNANDO	165	29
EGEA JOSÉ, ANTONIO	158-159	22-23
EIKON FOTOGRAFÍA SL	198	62
ESCODA BORRAS, JOSEP MA	166	30
GOMEZ, RODOLFO	185	49
GOMEZ BUISAN, RAFAEL	200	64
HIERRO, PERE	160-161	24-25
IRUDI CENTRO DE LA IMAGEN	201	65
J. CRISS FOTOGRAFO	190-191	54-55
JORDI MAS LLOVERAS	152-153	16-17
LOPEZ DE ZUBIRIA, JOSÉ LUIS	167	31
LUNES, FINA	172-173	36-37
MALÉ, JAIME	144-145	8-9
MARIN, CARLOS & CUEVAS, MAITE	199	63
MARLI, ALBERT	176-177	40-41
MOLINOS, ROBERTO	186-187	50-51
MONTAÑES & GEBBIA	139	3
MONTE, ENRIC	181	45
MORGADAS, JORDI	178-179	42-43
MORINI, STEFANO	150-151	14-15
PALACIOS, JOSÉ MARIA	192	56
PERIS CASTRO, EDUARDO	196-197	60-61
PONS, EUGENI	163	27
PUTMAN, TONY	164	28
ROCA, JOSEP MA	154-155	18-19
ROIG & PORTELL	146-147	10-11
SARDA, JAVIER	140-141	4-5
VARGAS, RAFAEL	168	32
VISUAL ESTUDIOS	194-195	58-59
YEBRA, CARLOS	188-189	52-53

AFP/PMC Barcelona. Tel. (93) 418 45 25

Han colaborado: FUJI FILM, KODAK, CASANOVA PROFESIONAL, EGM, GRAFI-IMAGE, JOBO, MACBA, MANUAL COLOR, MITO, POLAROID, SONO I VEGAP.

PREMIOS LUX 96

retrato

arquitectura
Lux Oro FERRAN FREIXA

moda
Lux Oro CESAR ORDÓÑEZ

industrial
Lux Oro DANIEL FONT

editorial
Lux Oro JAVIER SARDÁ

alimentación
Lux Oro SIQUI SANCHEZ

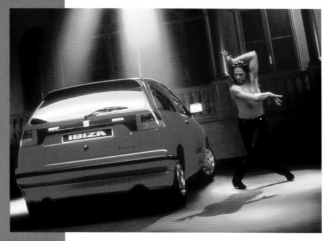

publicidad
Lux Oro AGUSTÍ GIFRE

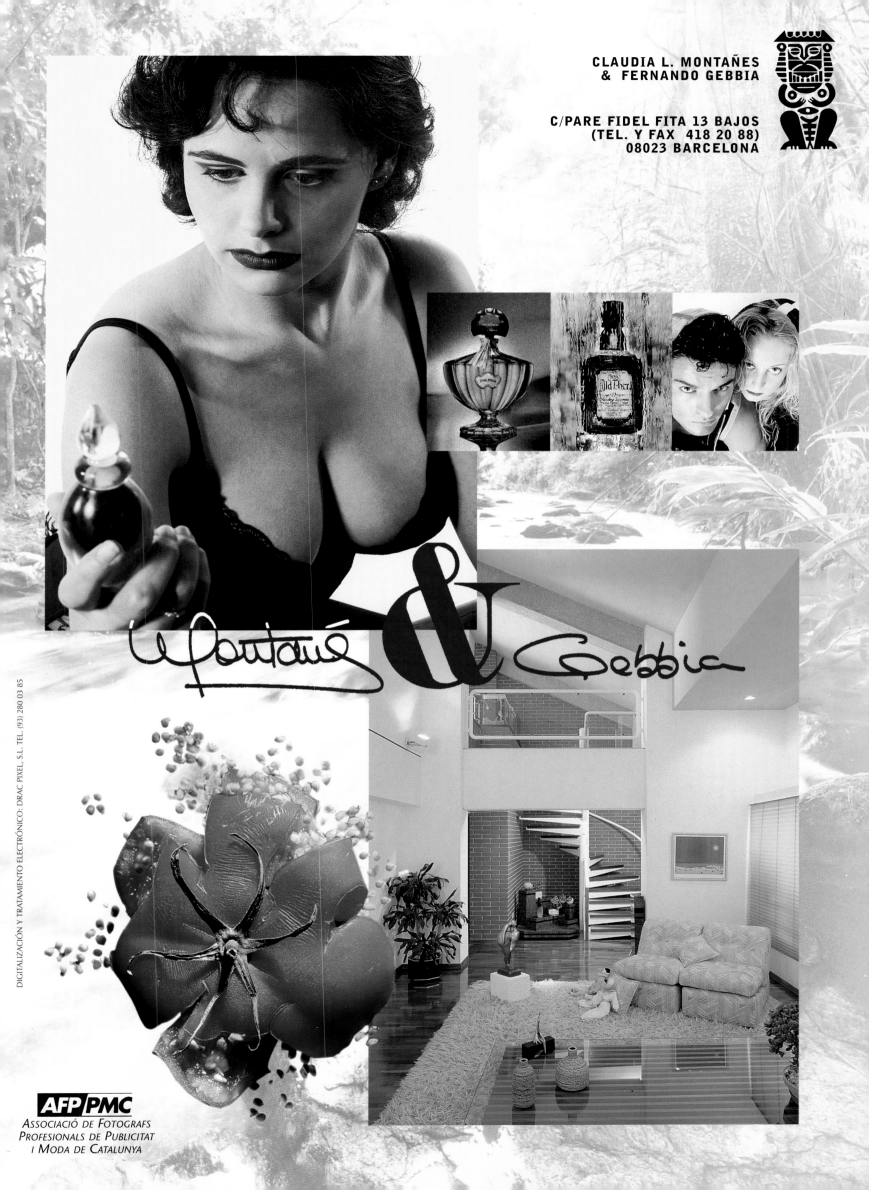

CLAUDIA L. MONTAÑES
& FERNANDO GEBBIA

C/PARE FIDEL FITA 13 BAJOS
(TEL. Y FAX 418 20 88)
08023 BARCELONA

DIGITALIZACIÓN Y TRATAMIENTO ELECTRÓNICO: DRAC PIXEL, S.L. TEL. (93) 280 03 85

AFP PMC
ASSOCIACIÓ DE FOTOGRAFS
PROFESIONALS DE PUBLICITAT
I MODA DE CATALUNYA

FOTOS

JAVIER SARDÁ
TEL (343) 418 43 05

TEODORA LAMADRID 31 08022 BARCELONA FAX (343) 418 67 03 internet WEB at: www.mito.ibernet.com/fotos_sarda

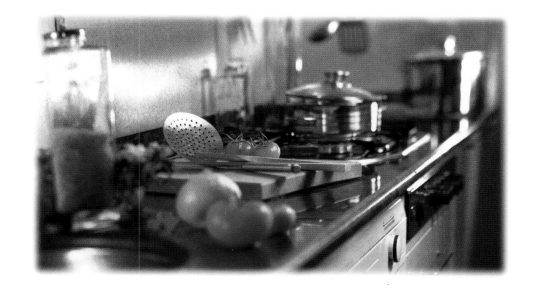

TEODORA LAMADRID 31 08022 BARCELONA FAX (343) 418 67 03 internet WEB at: www.mito.ibernet.com/fotos_sarda

WINTERTHUR
Seguros

JAVIER SARDÁ
TEL (343) 418 43 05

Gral. Mitre,95 · baixos esquerra · 08022 Barcelona · Tel. (93) 417 85 14 · Fax (93) 418 70 22

JAIME MALÉ
▪ ▪ ▪ ▪ ▪ ▪ ▪ ▪ ▪ ▪ ▪ ▪ ▪ ▪

*Gran Via De Les Corts
Catalanes 554
E-08011 Barcelona
Tel : + 323 5511
Fax : + 323 5817*

JAIME MALÉ
▪ ▪ ▪ ▪ ▪ ▪ ▪ · ▪ ▪ ▪ ▪ ▪ ▪ ▪ ▪

Gran Via De Les Corts
Catalanes 554
E-08011 Barcelona
Tel : + 323 5511
Fax : + 323 5817

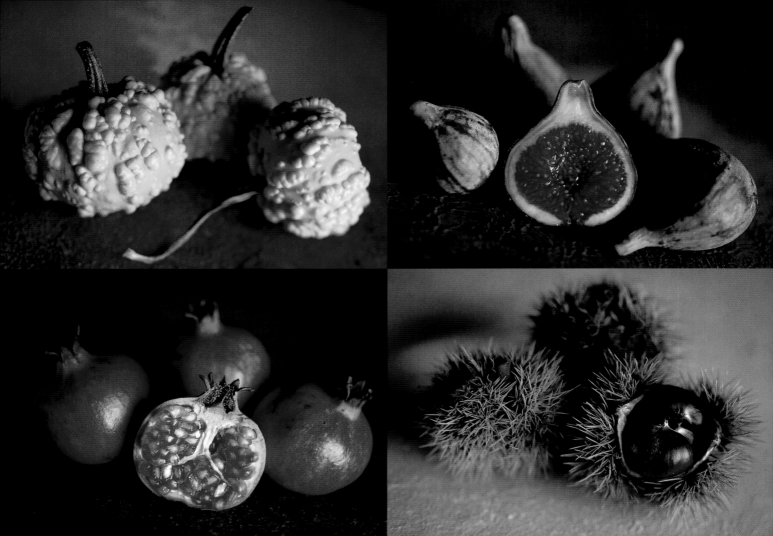

FOTOGRAFIA
ESTILISME

ROIG
&
PORTELL

FOTOGRAFIA
ESTILISME

ROIG
&
PORTELL

Mestre Dalmau 7-9 08031 Barcelona Tel. 427 91 86 Fax 427 62 48

JORDI BLANCAFORT
· · · · · · · · · · · · · · ·

Bailen 152 1º 1º
08037 Barcelona
Tel ; (93) 459.43.46 Fax: (93) 207.53.94

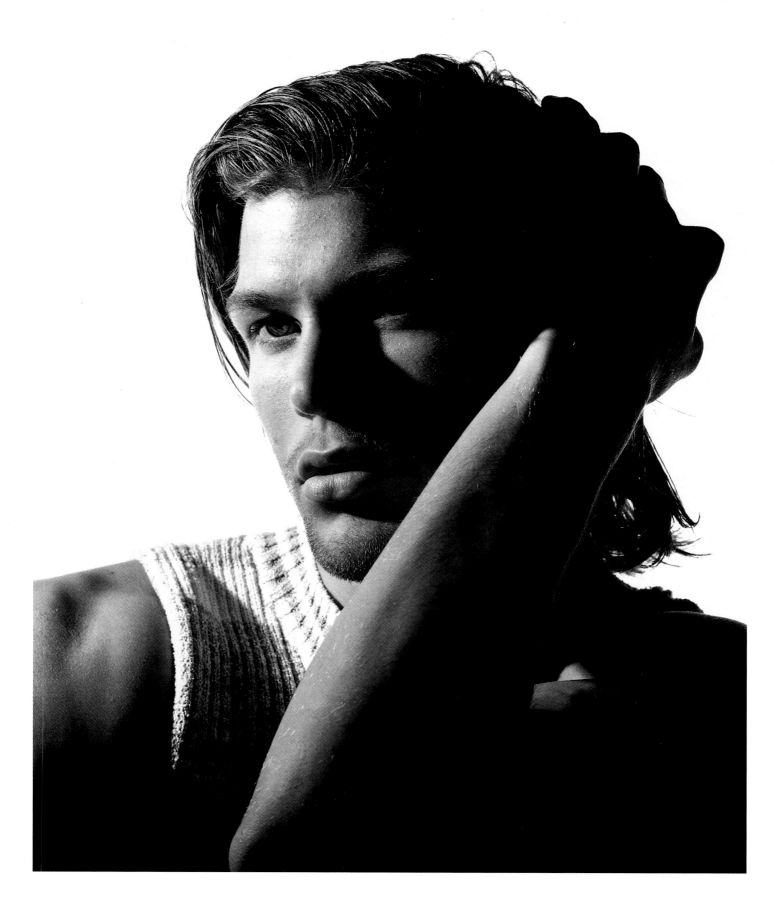

JORDI BLANCAFORT
• • • • • • • • • • • • • •
Bailen 152 1º 1º
08037 Barcelona
Tel ; (93) 459.43.46 Fax: (93) 207.53.94

stefano
morini
fotógrafo

Milà i Fontanals, 14-26. 4º-9ª. 08012 Barcelona.
Tel/Fax: 34-3-458 70 75

JORDI MAS FOTÓGRAF

JORDI MAS LLOVERAS
Baldiri Reixach, 28
E-17003 Girona
Tel : (972) 21 36 32 / (908) 89 92 27
Fax : (972) 21 36 32

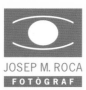

JOSEP M. ROCA
FOTÒGRAF

LAUS PLATA DE FOTOGRAFIA '95
CALENDARIO VW-AUDI
TANDEM DDB NEEDHAM CAMPMANY GUASCH

FIAP ORO TANDEM BARCELONA

SOL ORO. SAN SEBASTIAN TANDEM BARCELONA

SOL BRONCE. SAN SEBASTIAN TANDEM BARCELONA

BEST PACK PLATA ALIMENTARIA MC CANN ERICKSON

FIAP BRONCE MC CANN ERICKSON

OSEP M. ROCA - TEL 217 91 13 - FAX 217 89 88 - BCN

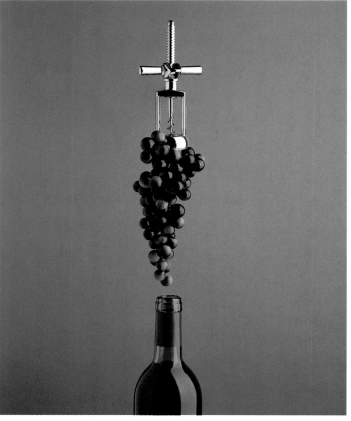

JOSEP BARBERO CASTILLO
■ ■ ■ ■ ■ ■ ■ ■ ■ ■ ■ ■ ■ ■

AVDA. Sant Pere 11
25005 Lleida
España
Telf : (+973) 24 50 48
Mobil: 908 19 50 73
Studi 11
Avda Batlle Porqueres 67
E-25005 Lleida
España
Telf : (+973) 22 18 36

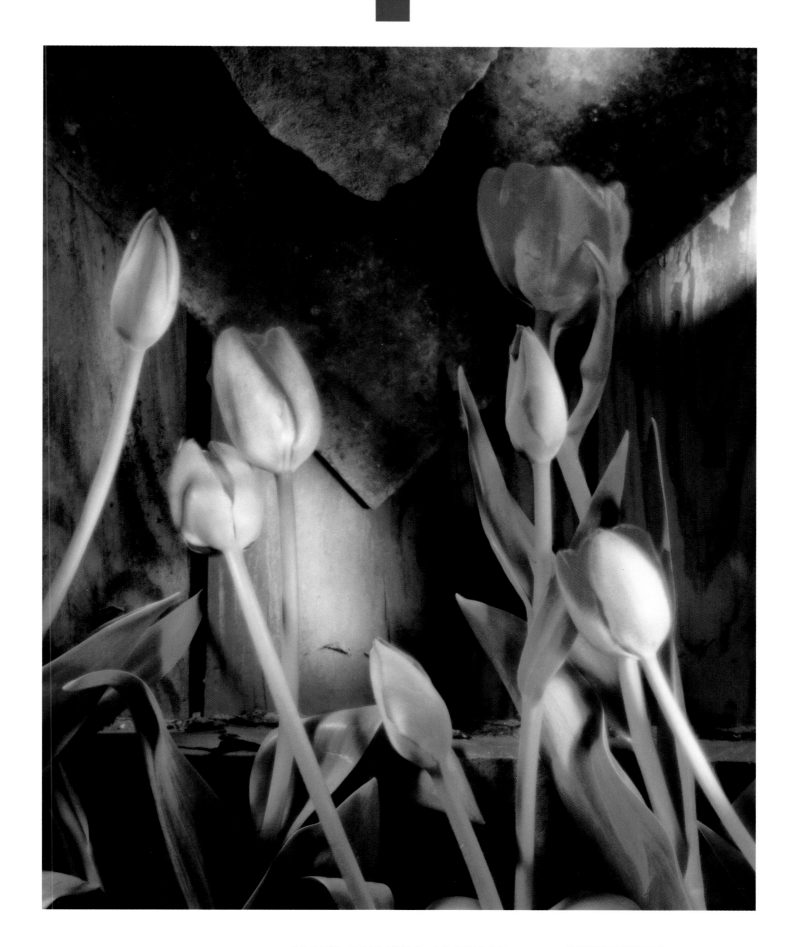

JOSEP BARBERO CASTILLO
.

AVDA. Sant Pere 11
25005 Lleida
España
Telf : (+973) 24 50 48
Mobil: 908 19 50 73
Studi 11
Avda Batlle Porqueres 67
E-25005 Lleida
España
Telf : (+973) 22 18 36

ASSOCIACIÓ DE FOTÒGRAFS
PROFESSIONALS DE PUBLICITAT
I MODA DE CATALUNYA

JOSÉ ANTONIO EGEA

· · · · · · · · · · · · · · · ·

Estudio Egea Comunicación Fotografica SL
Rda San Pedro 32 1ºD
Barcelona
España
Telf: +34 3 319 6167

JOSÉ ANTONIO EGEA
■ ■ ■ ■ ■ ■ ■ ■ ■ ■ ■ ■ ■ ■ ■
Estudio Egea Comunicación Fotografica SL
Rda San Pedro 32 1ºD
Barcelona
España
Telf: +34 3 319 6167

PERE HIERRO
▪ ▪ ▪ ▪ ▪ ▪ ▪ ▪ ▪ ▪ ▪ ▪ ▪ ▪

Pere Hierro - Creativ D'ImatGe
RamblA 18
E-08201 Sabadell
Telf : (93) 726 2268 Fax : (93) 726 2268

Premi Lux MODA-95
Medalla Plata Color Art 91
Moda-Belleza-Lenceria-Baño

PERE HIERRO
∎ ∎ ∎ ∎ ∎ ∎ ∎ ∎ ∎ ∎ ∎ ∎ ∎ ∎

Pere Hierro - Creativ D'ImatGe
RamblA 18
E-08201 Sabadell
Telf : (93) 726 2268 Fax : (93) 726 2268

Premi Lux MODA-95
Medalla Plata Color Art 91
Moda-Belleza-Lenceria-Baño

ARARA & PELEGRIN

Paco Arara & Jose Luis Pelegrin
Roger de Lluria
96 Entlo 1°
08009 Barcelona
España.
Tel: ++34 3 457 42 93 Fax: ++34 3 207 78 58

ASSOCIACIÓ DE FOTÒGRAFS
PROFESSIONALS DE PUBLICITAT
I MODA DE CATALUNYA

Comida
Bodegón
Gente
T.V.

Food
Still Life
People
T.V.

EUGENI PONS

▪ ▪ ▪ ▪ ▪ ▪ ▪ ▪ ▪ ▪ ▪ ▪ ▪ ▪ ▪ ▪ ▪ ▪

Avda. Vidreres, 106
17310 Lloret de Mar
Girona
España
Tel & fax: (972) 37 25 05
Movil: 907 83 46 62

Fotografía Publicitaria,
de Arquitectura e Interiorismo

AFP PMC

ASSOCIACIÓ DE FOTÒGRAFS
PROFESSIONALS DE PUBLICITAT
I MODA DE CATALUNYA

Advertising Photography in
Architecture & Interiors

TONY PUTMAN
• • • • • • • • • • • • • • • • •

Muntaner 575 2º 2º
08022 Barcelona
España
Tel: 93 212 5633 Fax: 93 418 7508

Alimentación
Bodegón
Joyas
Cosmética

Associació de Fotògrafs
Professionals de Publicitat
i Moda de Catalunya

Food
Still-life
Jewelery
Cosmetics

FERNANDO DE BUSTOS
· · · · · · · · · · · · · ·

Pº Del Faro 13-15
E-20008 San Sebastian
España
Tel : (943) 212580 908772126
FAX : (943) 219516
E Mail : fdebustos@jet.es

ASSOCIACIÓ DE FOTÒGRAFS
PROFESSIONALS DE PUBLICITAT
I MODA DE CATALUNYA

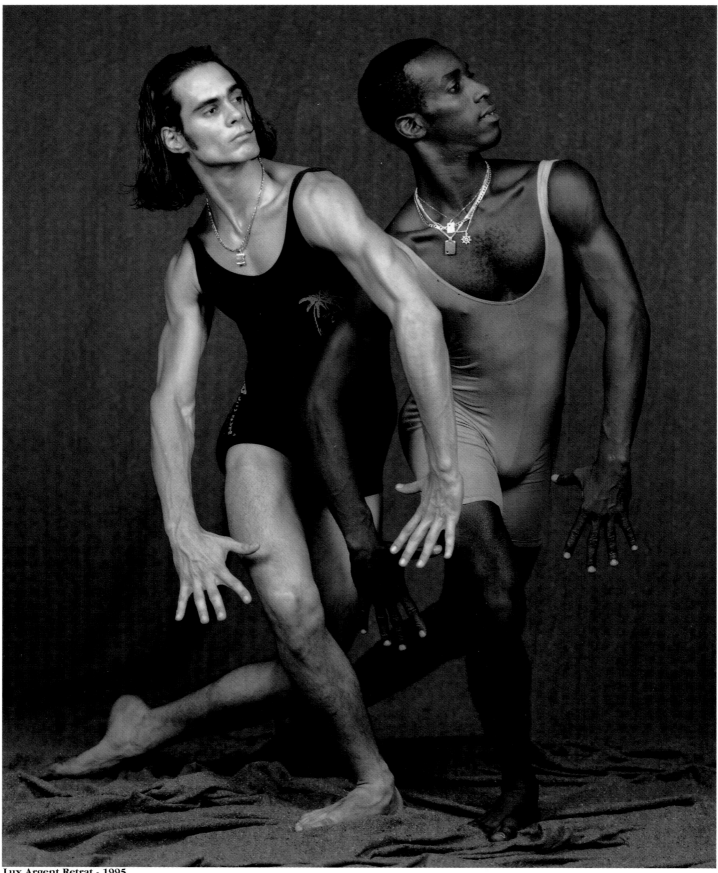

Lux Argent Retrat - 1995

PEP ESCODA PHOTOSTUDIO
▪ ▪ ▪ ▪ ▪ ▪ ▪ ▪ ▪ ▪ ▪ ▪ ▪ ▪ ▪ ▪

Josep Mª Escoda Borras
Carrer Comte Nº 8
E-43003 Tarragona
Telf/Fax : (977)-222263 Movil : (989) 516 424
Catalonia
España

Moda
Retrato
Publicidad
Creativa
Book de Autor

Fashion
Portrait
Advertising
Creative
Author Book

JOSE LUIS LOPEZ DE ZUBIRIA

Pilotegui Bidea, 12
B.° de Igara
E-20009 San Sebastian
Tel. (943) 21 99 03
Mov. (908) 77 46 53
Fax: (943) 21 99 04

ASSOCIACIÓ DE FOTÒGRAFS
PROFESSIONALS DE PUBLICITAT
I MODA DE CATALUNYA

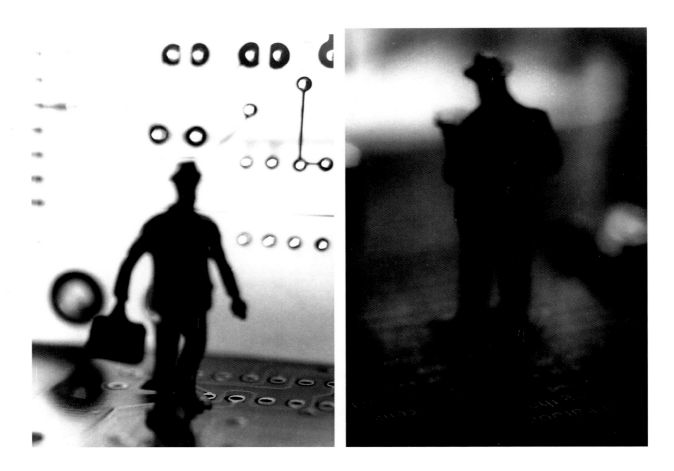

"El temps de la Imaginacio" Premio laus oro Fotografia 1996 para Barcelona 2001 ayto Barcelona

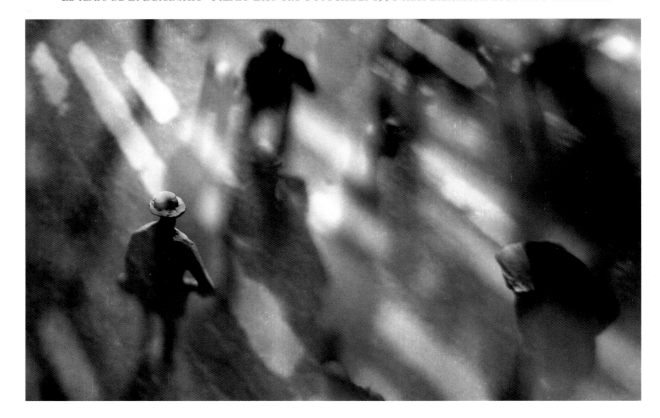

RAFAEL VARGAS

▪ ▪ ▪ ▪ ▪ ▪ ▪ ▪ ▪ ▪ ▪ ▪ ▪ ▪ ▪ ▪ ▪

Gran Via Corts Catalanes, 699 1er 1a
08013 Barcelona
Tel: *++(93) 246 36 02 Fax: ++(93) 232 41 51*
Agent: Photoland, Proyectos Especiales

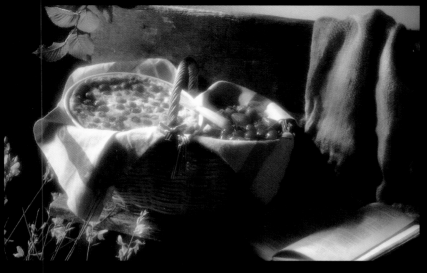

A.J.J. ESTUDI S.C.P.

J.A. Montoya & J. Soldevila
Antoni Gaudí 8
08970 Sant Joan Despí (Barcelona)
España
Tel : (93) 373 8953 Fax : (93) 373 8953

Fotografía Editorial
y Publicitaria
Especialidad en
Bodegón
Gastronómico

AFP PMC

ASSOCIACIÓ DE FOTÒGRAFS
PROFESSIONALS DE PUBLICITAT
I MODA DE CATALUNYA

Editorial & Publicity
Photography
Still Life & Food
Speciality

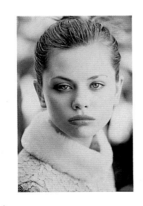

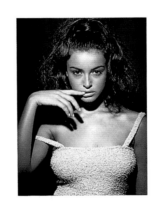
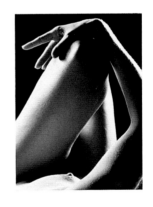
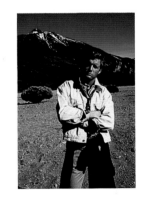

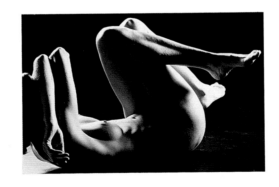
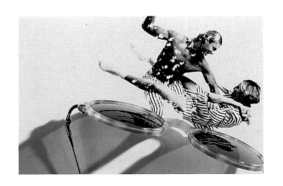

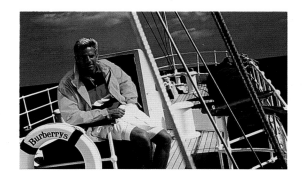
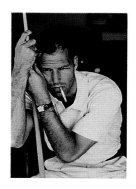
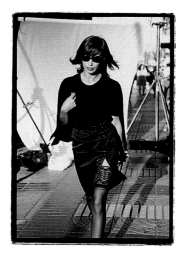

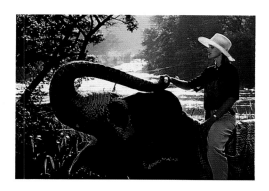
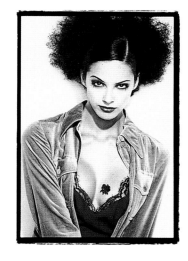
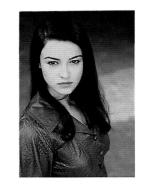
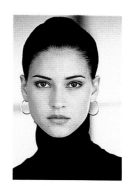

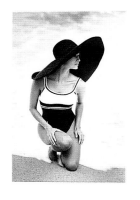
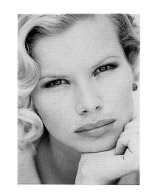
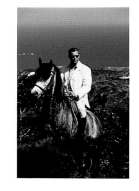
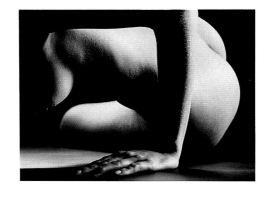

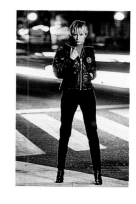
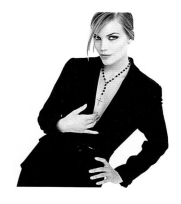
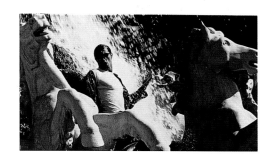
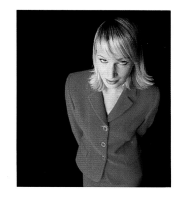

JOSEP BOU
fotògraf

Bertran, 44 baixos, int • 08023 Barcelona • Tel 434 05 07 • Fax 434 05 19

" A kiss "

Obra

Creativa

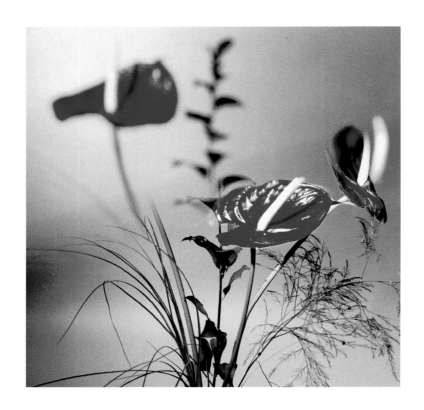

Postal

Navidad

1995

Fina Lunes - Fotógrafa
· · · · · · · · · · · · · · · ·
Enrique Granados, 103
Bajos 1ª
08008 Barcelona
Telf : (93) 218 7055 - 907 250825
Fax : (93) 416 0358

Fashion / Creative Advertising Moda / Publicidad Creativa Mode / Publicité Créative Mode / Creative Werbung

Agencia :

DMBB, S.A.

Cliente :

Arbora, S.A.

Cliente : Family Circle, S.A.

Fina Lunes - Fotógrafa
.
Enrique Granados, 103
Bajos 1ª
08008 Barcelona
Telf : (93) 218 7055 - 907 250825
Fax : (93) 416 0358

Fashion / Creative Advertising Moda / Publicidad Creativa Mode / Publicité Créative Mode / Creative Werbung

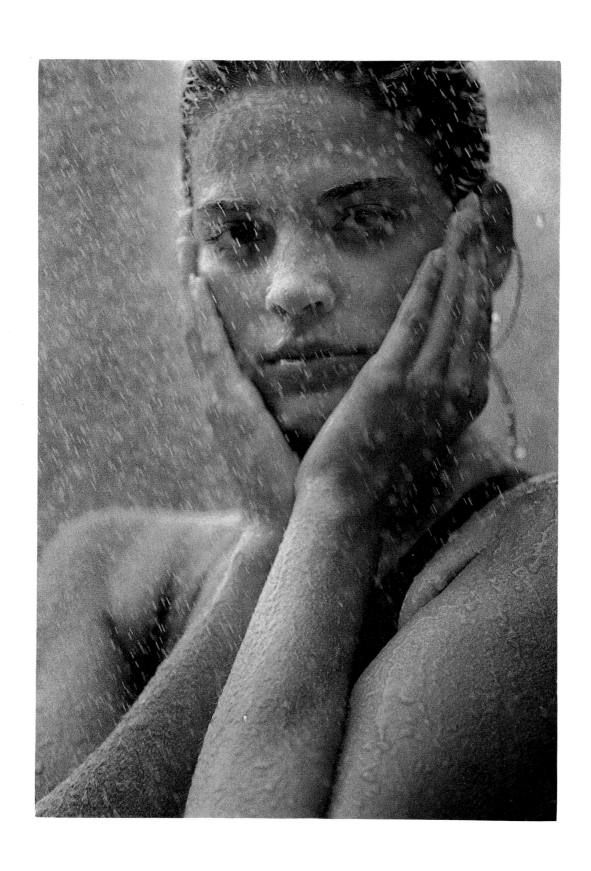

PEDRO COLL
C/CERDANYA, 1
07012 PALMA DE MALLORCA
TEL. (71) 72.10.78
FAX. (71) 71.98.58
E-MAIL: ozoncoll@bitel.es

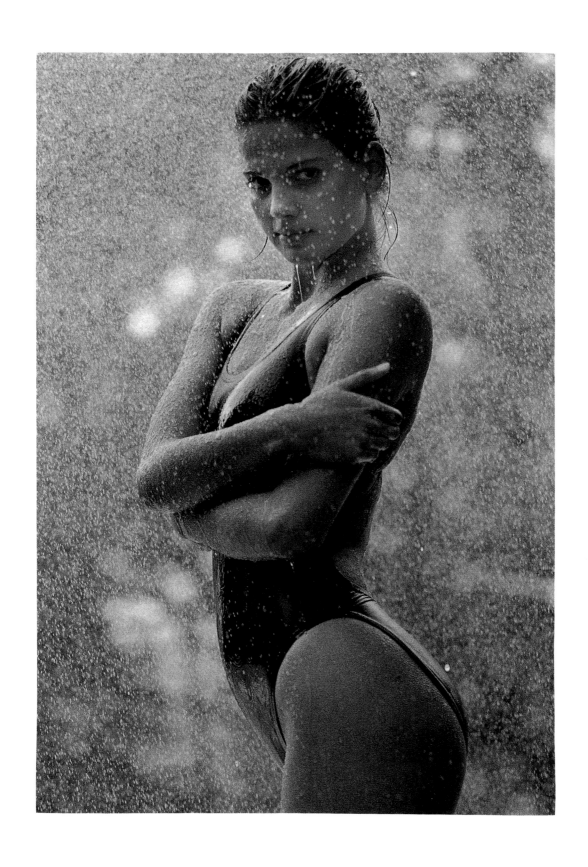

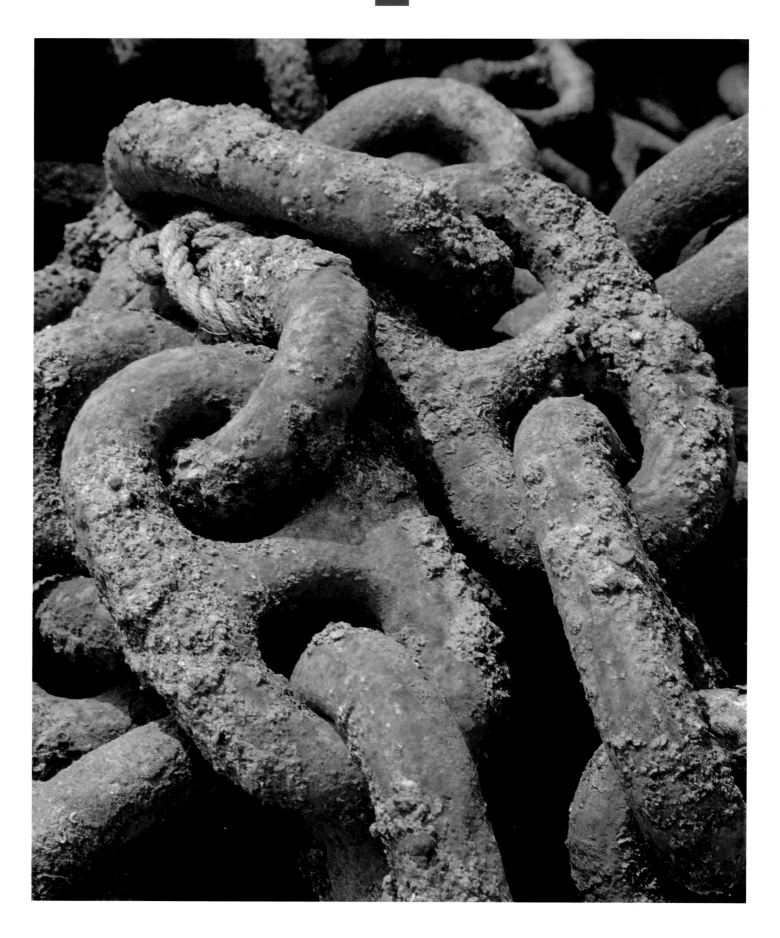

ALBERT MARLI
· · · · · · · · · · · · · ·

Aribau, 252, 3er 1ª
08006 Barcelona
España
Tel : 93 200 81 81 Fax : 93 202 35 76

Client : Productos Palex,S.A.
Foto sin Manipulación Electrónica

ALBERT MARLI
- - - - - - - - - - - - - -
Aribau, 252, 3er 1ª
08006 Barcelona
España
Tel : 93 200 81 81 Fax : 93 202 35 76

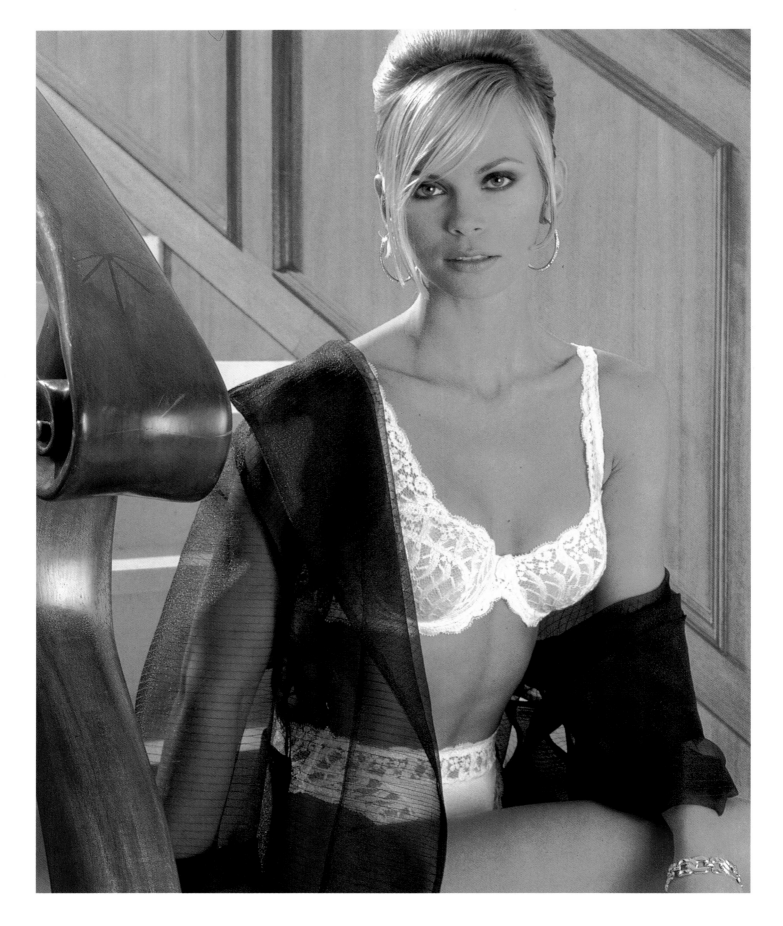

JORDI MORGADAS
∎ ∎ ∎ ∎ ∎ ∎ ∎ ∎ ∎ ∎ ∎ ∎ ∎ ∎ ∎

Diputaciò, 317 - 1.°
E-08009 Barcelona
Tel: (93) 488 25 68
Fax: (93) 488 34 65

Agent:
Mariola
Tel: (93) 488 25 68 - (93) 488 34 65

Specialized in lingerie and bathing costume *Especialistas en moda intima y baño*

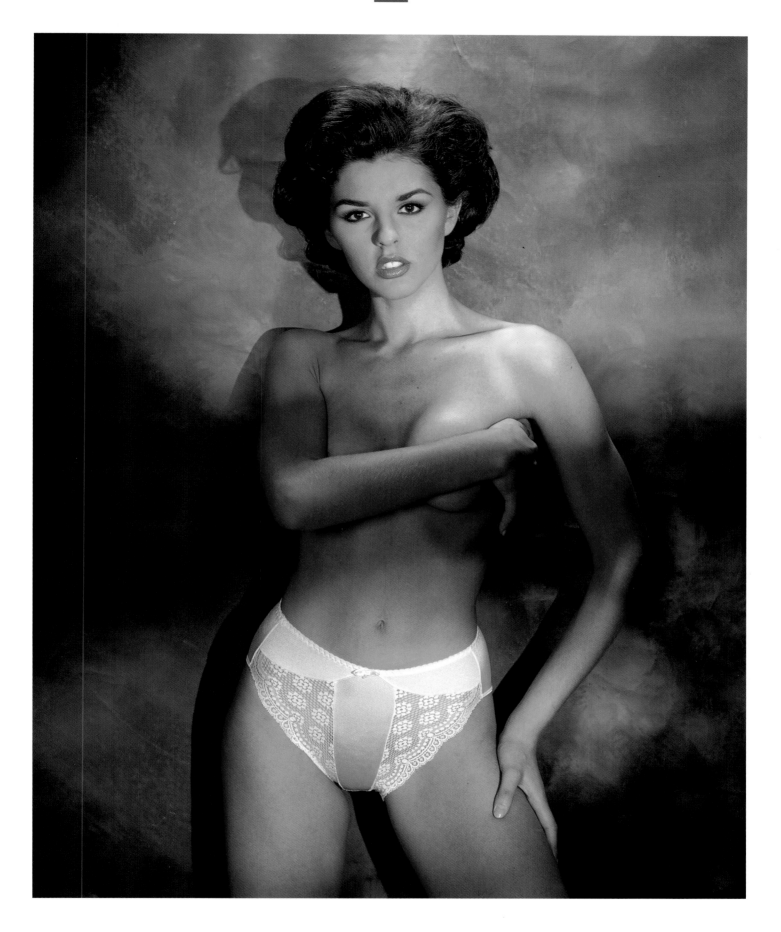

JORDI MORGADAS

.

Diputaciò, 317 - 1.°
E-08009 Barcelona
Tel: *(93) 488 25 68*
Fax: *(93) 488 34 65*

Agent:
Mariola
Tel: *(93) 488 25 68 - (93) 488 34 65*

Specialized in lingerie and bathing costume

Especialistas en moda intima y baño

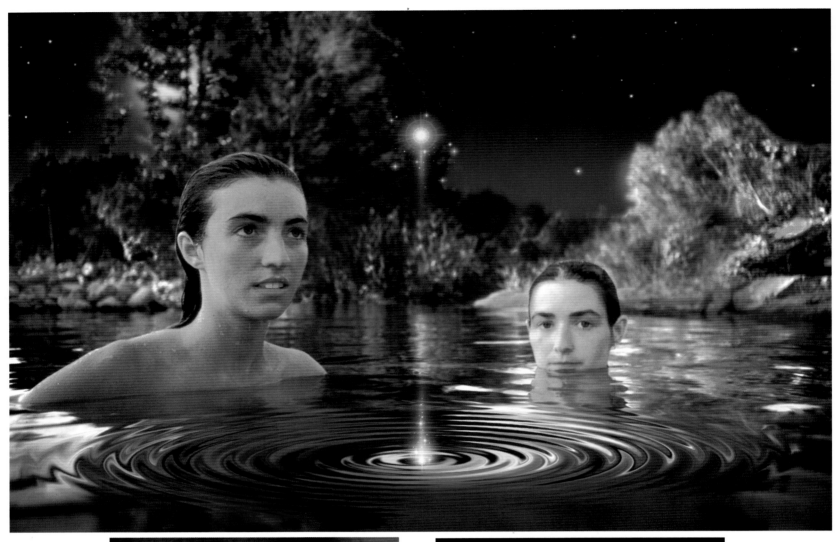

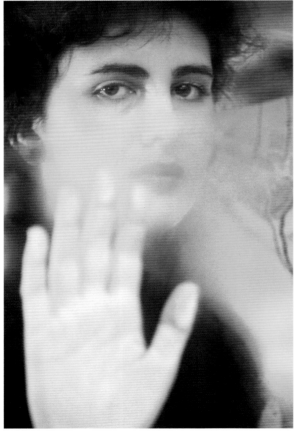

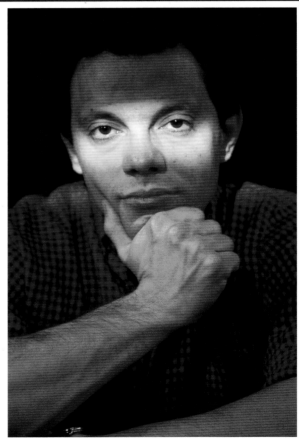

Raimundo Fdez. Villaverde, nº 10
28003 Madrid
Tel. 534 47 18
Fax. 534 98 67
E-MAIL: invarato@lander.es
http://www.lander.es/invarato

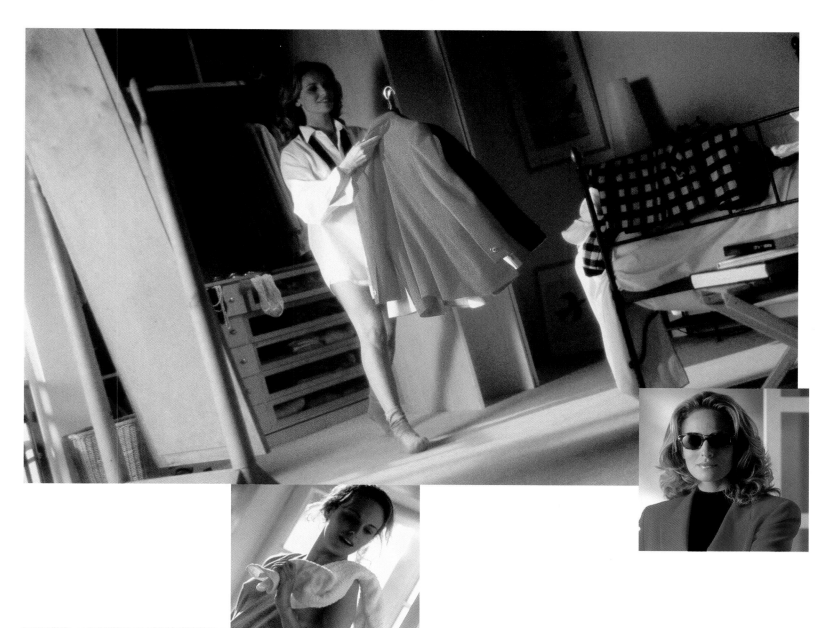

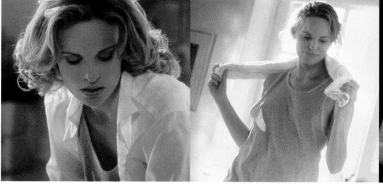

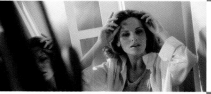

ENRIC MONTE
.

Premia 15 1ª
E-08014 Barcelona
España
Tel : (93) 421 3978 Fax : (93) 422 6633

STILL LIFE

C H A M I Z

Jesús Martín Chamizo
González Solá, 5
28029 Madrid

Tels. 323 05 62 / 06 10
Fax 323 06 10

C H A M I Z

Jesús Martín Chamizo
González Solá, 5
28029 Madrid

Tels. 323 05 62 / 06 10
Fax 323 06 10

No dispares en solitario. Asóciate

9 1 3 5 0 4 7 2 2
(Click Click) Click Click Click Click Click Click Click

Estos 9 Clicks pueden suponer mucho
para tu profesión.
Llámanos y te informaremos
sobre todas las ventajas de pertenecer a la
Asociación Española de Fotógrafos de Publicidad
y sobre todas nuestras actividades.
Solamente por ser asociado tienes derecho
a participar y colaborar en todos
nuestros proyectos y realizaciones.
Te esperamos

REVISTAS PERIODICAS • LIBRO DE ARTE ANUAL • EXPOSICIONES • CURSOS • SEMINARIOS • ASESORAMIENTO • ETC

AF EP
ASOCIACION ESPAÑOLA
DE FOTOGRAFOS DE PUBLICIDAD

MADRID : C/ Juan Hurtado de Mendoza, 9 • 28036 Madrid - Tel. (91) 350 47 22 - Fax (91) 359 69 77/ **VALENCIA** : C/ Santa María Micaela, 18 • 46008 Valencia - Tel. (96) 384 51 48

RODOLFO GOMEZ
FOTOGRAFIA PUBLICITARIA

C/ General Palanca, 33
28045 Madrid (ESPAÑA)
Tlf.: (91) 530 81 63 Fax: (91) 530 89 54

MIEMBRO DE *AF EP*

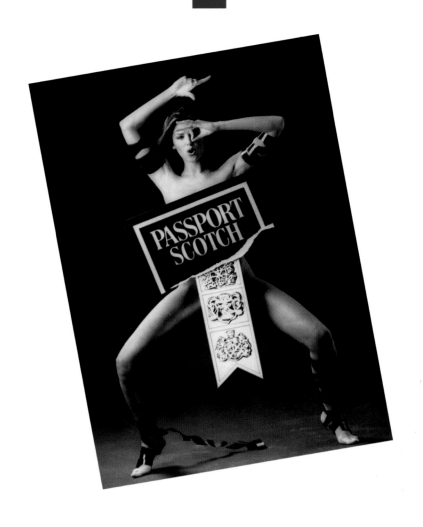

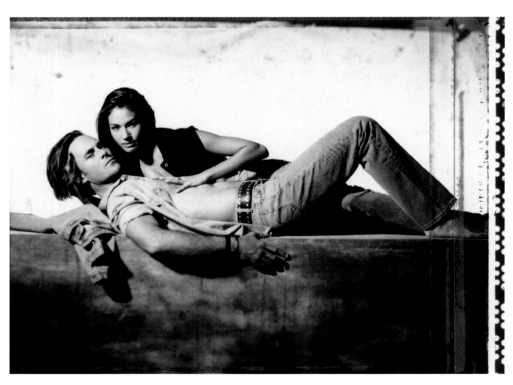

Roberto Molinos

MANGO Producciones S.L.. C/ . Navaleno, 5 28033 Madrid Telf.: +34.1.766.2678 Fax.: +34.1.766.9215

Roberto Molinos

MANGO Producciones S.L.. C/ . Navaleno, 5 28033 Madrid Telf.: +34.1.766.2678 Fax.: +34.1.766.9215

CARLOS YEBRA
- - - - - - - - - - - - - -
Santorcaz 4
28002 Madrid
España
Tel: 34 1-411 4723 Fax: 34 1-563 3759

CARLOS YEBRA

• • • • • • • • • • • • • • •

Santorcaz 4
28002 Madrid
España
Tel: 34 1-411 4723 Fax: 34 1-563 3759

J.CRISS

F O T O G R A F O

Jose Carlos Rodriguez Santos
Avda.Los Mallos, 82 Tel : 981 154372
C/Angel Senra, 35 Tel : 981 238671
Fax : 981 154372 Mobile : 908 981631
15007 La Coruña

ASOCIACION ESPAÑOLA
DE FOTOGRAFOS DE PUBLICIDAD

Plató de 200m Fotógrafo especializado en Moda, Libros, Belleza, Publicidad, Niños, Bodegones, Interiorismo.
Studio 200m Photographer specialising in Fashion, Books, Beauty, Advertising, Children, Still life, Interiors.
Studio 200m Photographe spécialisé dans Mode, Livres, Beauté, Publicité, Enfants, Nature Morte, Intérieurs.

J.CRISS

FOTOGRAFO

Jose Carlos Rodriguez Santos
Avda.Los Mallos, 82 Tel : 981 154372
C/Angel Senra, 35 Tel : 981 238671
Fax : 981 154372 Mobile : 908 981631
15007 La Coruña

AF EP
ASOCIACION ESPAÑOLA
DE FOTOGRAFOS DE PUBLICID

Plató de 200m Fotografo especializado en Moda, Libros, Belleza, Publicidad, Niños, Bodegones, Interiorismo.
Studio 200m Photographer specialising in Fashion, Books, Beauty, Advertising, Children, Still life, Interiors.
Studio 200m Photographe spécialisé dans Mode, Livres, Beauté, Publicité, Enfants, Nature Morte, Intérieurs

JOSE MARIA PALACIOS
• • • • • • • • • • • • • • •
Gurtubay, 6
28001 Madrid
España
TEL: *576 94 35 - 929 14 38 27* FAX: *578 36 51*

ASOCIACION ESPAÑOLA
DE FOTOGRAFOS DE PUBLICIDAD

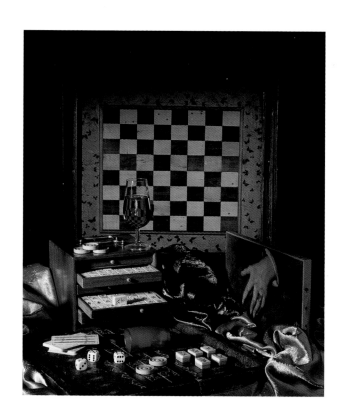

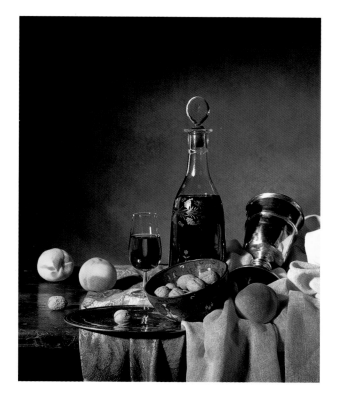

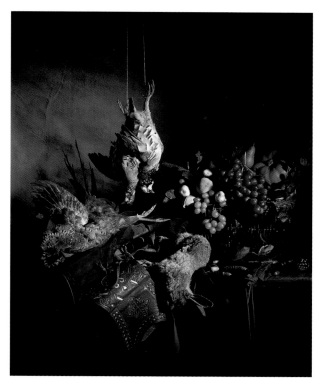

ANTONIO DE BENITO
.

Juan De Dios 8 Bajos
28015 Madrid
España
Telf :(91) 548 4450

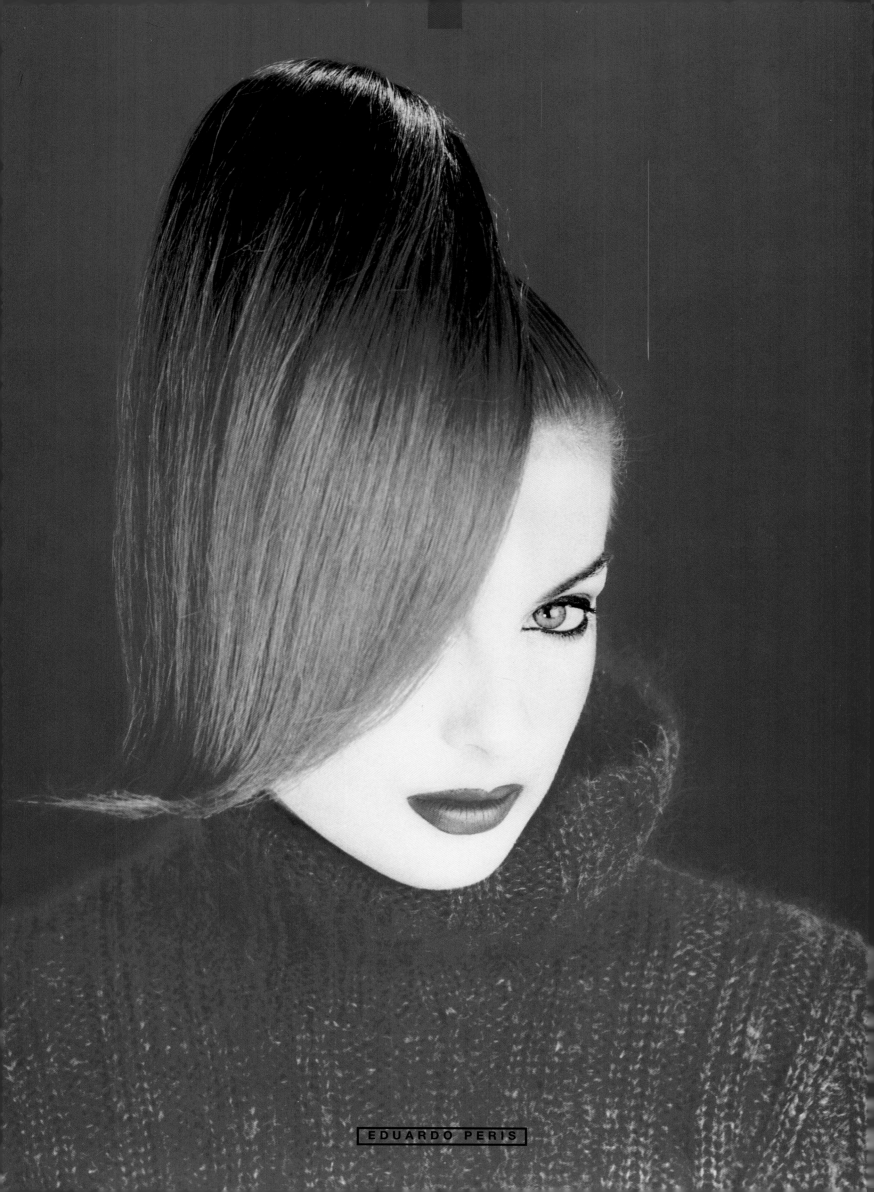

EDUARDO PERIS

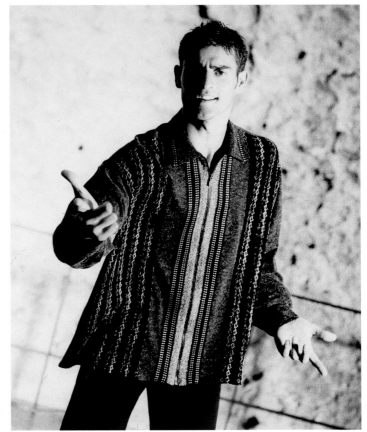

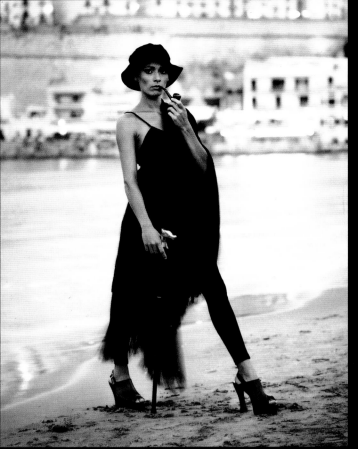
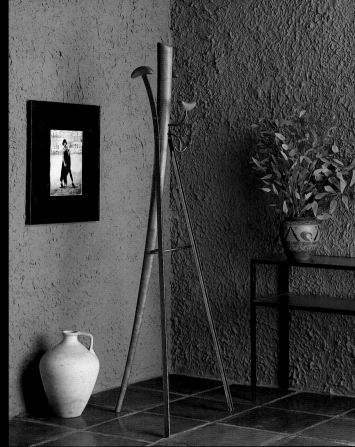

CARLOS MARIN & MAITE CUEVAS

Fotógrafo Estilista

Urb. Cerro Santiago - PARC. 11 y 12

Tfno. y Fax (941)390193 - Móvil: (908) 976397

26560 AUTOL (La Rioja) ESPAÑA

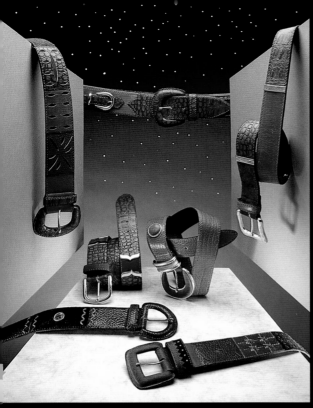
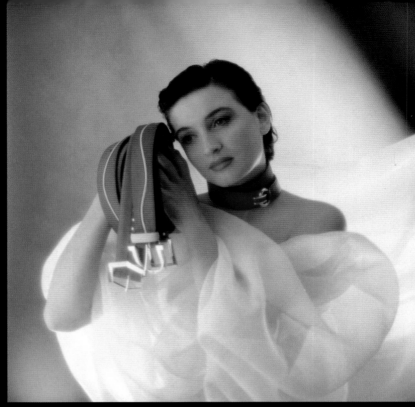
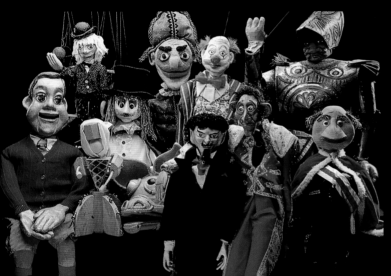
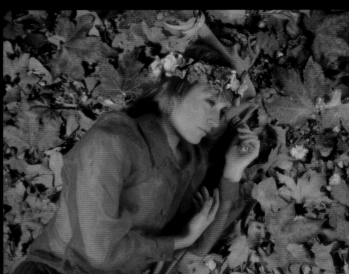

CENTRO DE LA IMAGEN

JAVIER LUCAS ALONSO
■ ■ ■ ■ ■ ■ ■ ■ ■ ■ ■ ■ ■ ■ ■

Kale Nagusia, 17
Zarautz (Gipuzkoa)
Telf / Fax : (943) 133003

14-02-1960 Licenciado en ciencias
de la información
Aficionado desde los 15, y 5 años
trabajando en medios gráficos. 11 años
instalado en la fotografía comercial

Especializado en: Retrato-Moda,
Publicidad Industrial,
Retoque Fotográfico y Aerografía

CARLOS ALONSO PEREZ

·········

FOTO ALVIX S.L.
C, Torrecedeira-103
Pontevedra
Tel : 986-238561

Estudio, industrial, cientifica, aerea
(Digital con Filmadora de 35 - 9 x 12)

DIGITAL PHOTOGRAPHY
. . . .
FOTOGRAFIÁ DIGITAL
. . . .
DIGITAL FOTOGRAFIE

	International page	Local page
ALBEROLA, PACO	**207**	71
FOTOMECANICA		
RAFAEL	**206**	70
MIRO, JOAN	**208**	72
ORESTIS		
MAGIC BOX	**204-205**	68-69

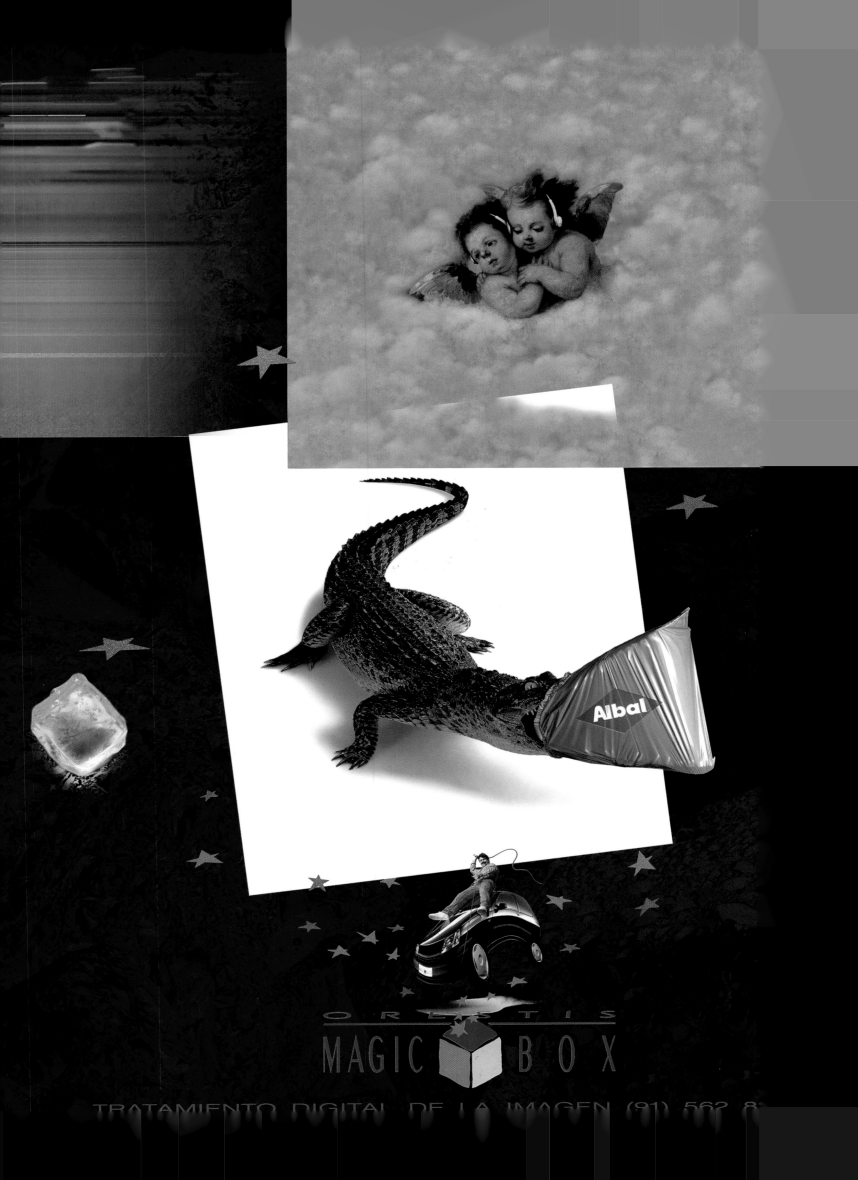

ORESTIS
MAGIC BOX
TRATAMIENTO DIGITAL DE LA IMAGEN (91) 562 8

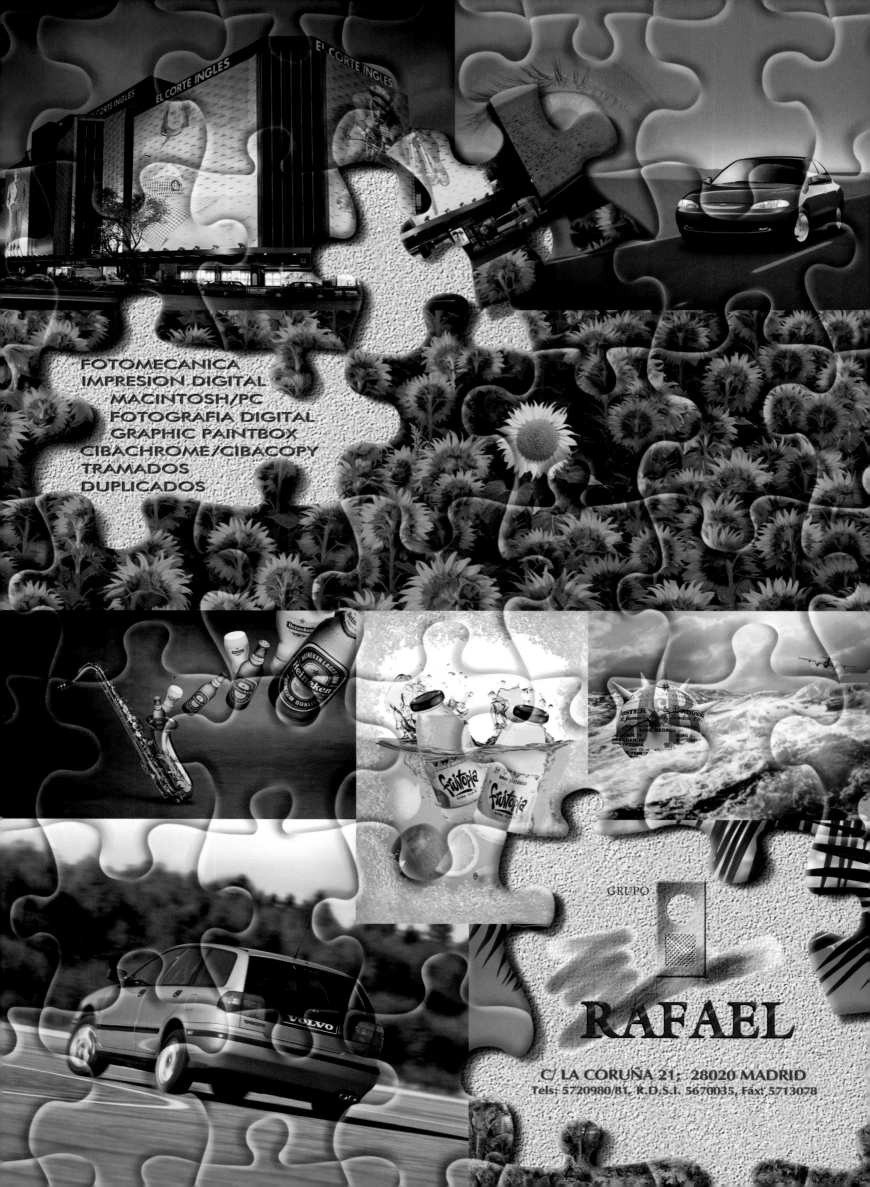

FOTOMECANICA
IMPRESION DIGITAL
MACINTOSH/PC
FOTOGRAFIA DIGITAL
GRAPHIC PAINTBOX
CIBACHROME/CIBACOPY
TRAMADOS
DUPLICADOS

GRUPO

RAFAEL

C/ LA CORUÑA 21, 28020 MADRID
Tels: 5720980/81, R.D.S.I. 5670035, Fax: 5713078

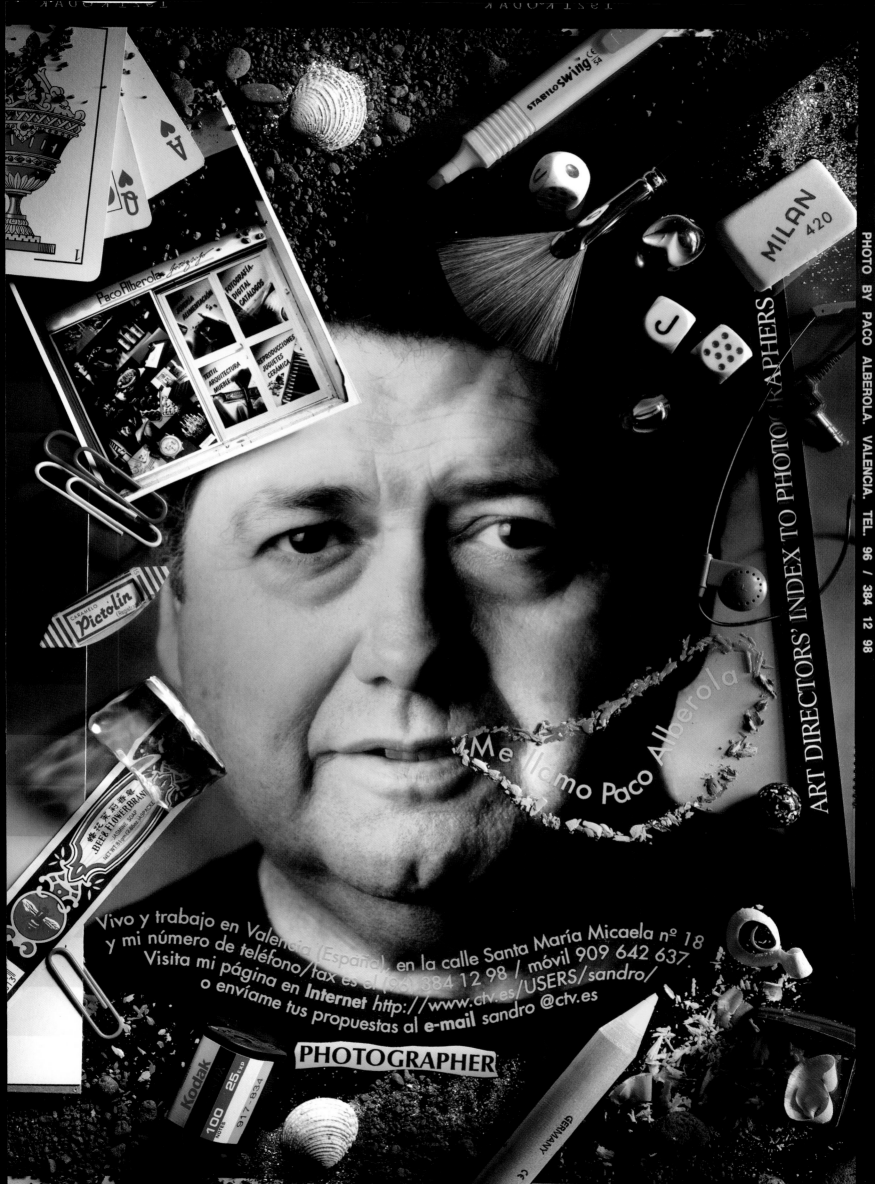

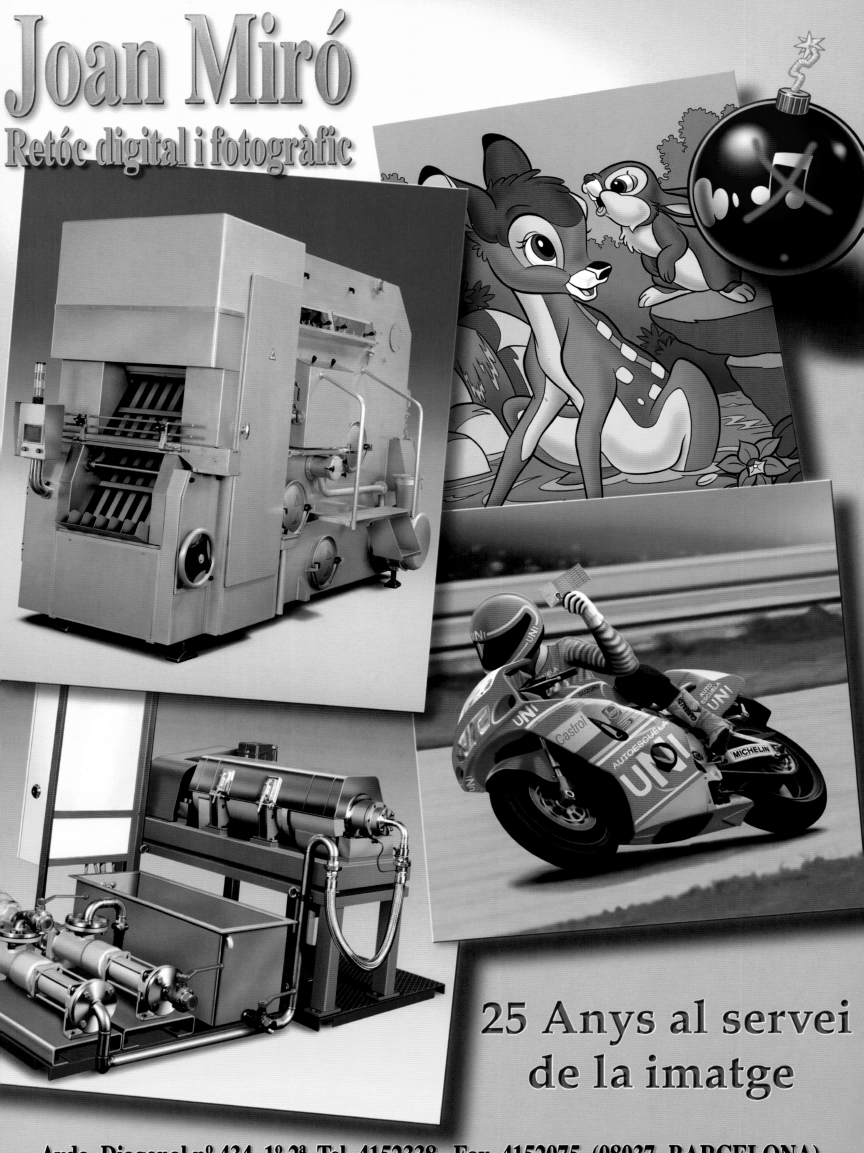

Joan Miró
Retóc digital i fotogràfic

25 Anys al servei
de la imatge

Avda. Diagonal nº 434, 1º 2ª. Tel. 4152338, Fax. 4152075 (08037- BARCELONA).

UNITED KINGDOM
· · · ·
GRANDE-BRETAGNE
· · · ·
GROSSBRITANNIEN

	International page	Local page		International page	Local page		International page	Local page
ATKINSON, ANDREW	270	62	KELLY, DAVID	236	28	ROBERTSON,		
BAJZERT, JULIAN	238	30	KNOWLES,			DOUGLAS	239	31
BANANA PHOTOGRAPHY			JONATHAN	248-250	40-42	ROSS, JOHN	217	9
COMPANY	212	4	KOMAR, BOB	230	22	RYAN, TERRY	244-246	36-38
BEDDIS, TERRENCE	231	23	LLEWELYN DAVIES,			SEAWARD, DEREK	233	25
BELL, CHRIS	220	12	PATRICK	228	20	SEYMOUR, ANDY	257	49
BELLARS, JOHN	215	7	LOGAN, GEORGE	247	39	SHIPMAN, STEVE	271	63
BINGEL, BERRY	221	13	LYTTLE, CARL	219	11	SIMON STOCK		
BURDEN, DESMOND	211	3	MACPHERSON, TIM	237	29	PHOTOGRAPHY	275	67
CAVALIER, STEVE	222-223	14-15	MACQUEEN,			TAIT, CHARLES	213	5
CRISFORD, COLIN	260	52	DUNCAN	214	6	VENNING, PAUL	224	16
DANN, GEOFF	232	24	MARTIN, BOB	258-259	50-51	WALES, DON	234	26
GALLETLY, MIKE	269	61	MASSEY, RAY	235	27	WALLACE, STRUAN	268	60
GATWARD, PHIL	274	66	MEEKUMS, BARRY	242-243	34-35	WEBSTER, PAUL	254-256	46-48
HARRIS, MATT	272	64	MILNER, NICK	227	19	WHALE, ANDY	261	53
HENDERSON,			MYRDAL, JAY	241	33	WHITE, WILL	265	57
GRAHAM	218	10	NEWNHAM, ALAN	240	32	WHITFIELD, JOHN	229	21
HULME, MALCOLM	262	54	NOY, TALY	266	58	WIEDER, FRANK	252-253	44-45
IRVINE, SIAN	273	65	ORSMAN, GILL	263	55	WILLIAMS, HUW	225	17
JOSEPH, MICHAEL	216	8	PEDERSEN, DENNIS	226	18	WONNACOTT,		
KAINE, JEFF	264	56	RIGG, NICHOLAS	251	43	MARTIN	267	59

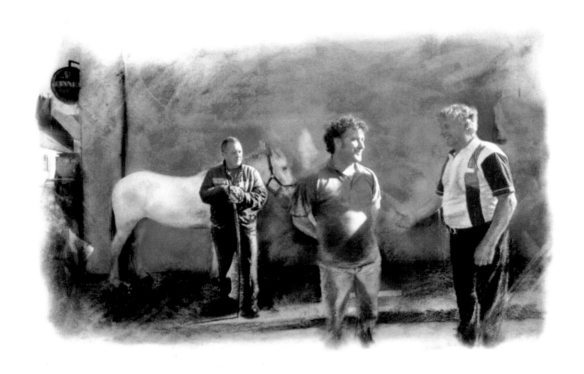

DESMOND BURDON

Studio 4
38 St Oswalds Place
London SE11 5JE
Tel: +44 171 582 0559
Fax: +44 171 582 4528
dburdon@dircon.co.uk

London	Düsseldorf	Milan	New York
Stella Pye	Milena Najdanovic	Photogroup	Susie Miller
Tel: +44 171 221 0524	Tel: +49 211 966 07 66	Tel: +39 2 498 04 26	Tel: +1 212 427 9604
Fax: +44 171 792 4770	Fax: +49 211 966 07 67	Fax: +39 2 481 937 88	Fax: +1 212 427 7777

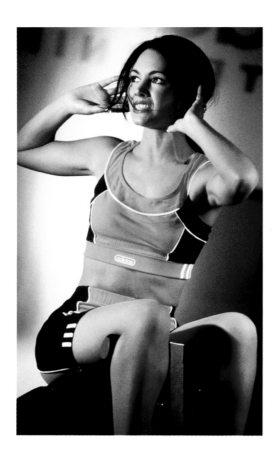

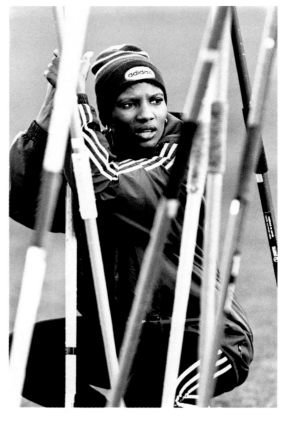

BANANA
• • • • • • • • • • • • • • • • •

Unit 12
Montford Enterprise Centre
West Ashton Street
Manchester M5 2XS
Tel./Fax: +44(-0)161 737 6789
email: ray@bananaphoto.demon.co.uk
WWW: http://www.bananaphoto.demon.co.uk

If the definition of photography is painting with light,
the our stuff is childish scribble.

CHARLES TAIT
▪ ▪ ▪ ▪ ▪ ▪ ▪ ▪ ▪ ▪ ▪ ▪ ▪ ▪ ▪

CHARLES TAIT PHOTOGRAPHY
Kelton, St. Ola
Orkney KW15 1TR
Tel: (01856) 873738 - Fax: (01856) 875313
Car: (0860) 762 694 - GSM mobile: (0385) 220 269
ISDN: (01856) 870179
E-mail: 100445.1544@compuserve.com
www.orkneyislands.com/charlestait

Orkney-based
Landscapes, travel, advertising,
nature, panoramics.

Photo library - Scottish Islands (Orkney, Shetland,
Western Isles) - Scotland - France - Wildlife - Venice &
Dolomites. New: St Kilda & Hadrians Wall

DUNCAN MACQUEEN

▪ ▪ ▪ ▪ ▪ ▪ ▪ ▪ ▪ ▪ ▪ ▪ ▪ ▪ ▪ ▪

101 Constitution Street
Leith
Edinburgh EH6 7AE
Tel: +44 (0)131 553 2447 – +44 (0)171 437 4791
Facsimile: +44 (0)131 553 1582
MOBILE: 0973 542346

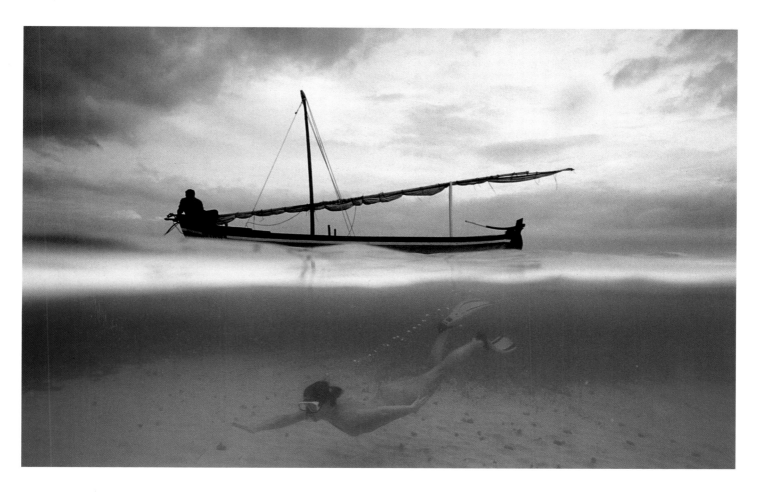

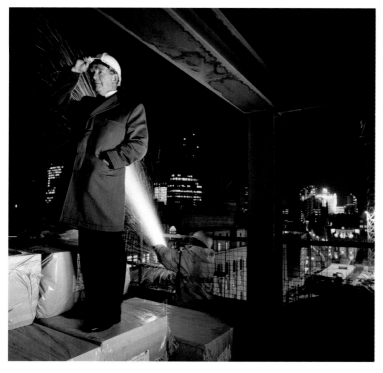

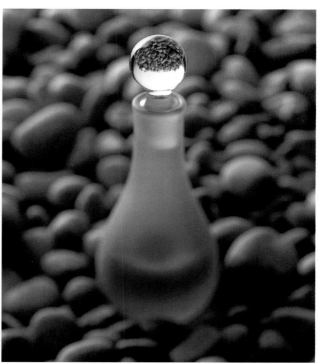

JOHN BELLARS

.

142 Central Street
London
EC1V 8AR
Tel: 0171 814 9810
Mobile: 0973 733959

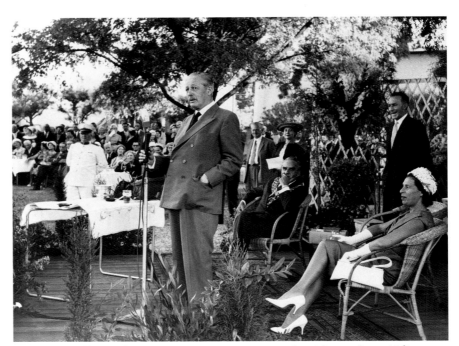

Macmillan making 'WIND OF CHANGE' speech - Johannesburg 1960

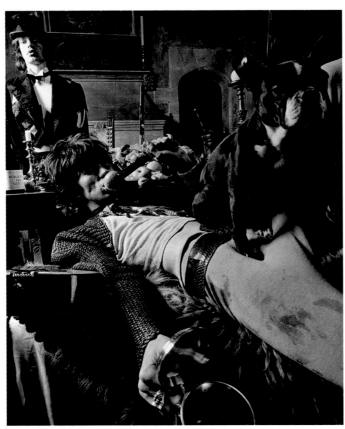

Mick and Keith of 'ROLLING STONES'
for 'BEGGARS BANQUET 1968'

MICHAEL JOSEPH

46 Clapham Common
North Side
London SW4 OAA
Tel: +44 (0)171 720 0525
Fax: +44 (0)171 622 6366

33 years shooting War in South Vietnam, Personalities, Fashion, Beauty, Cars, Nudes, Orgies, etc!
Books published: 'World of Children', 'Complete Photography Course', 'Hitchhikers Guide to Galaxy'

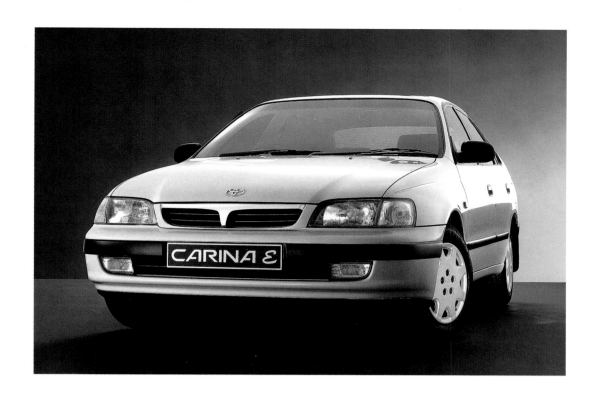

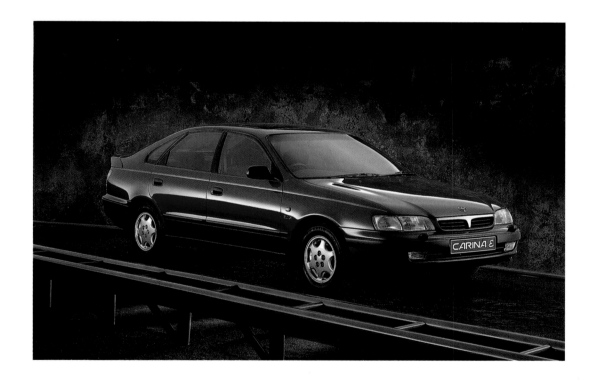

JOHN ROSS
• • • • • • • • • • • • • •
Studio 1 Clink Wharf
Clink Street
London SE1 9DG
Tel: +44 (0)171 378 8080
Fax: +44 (0)171 378 8083

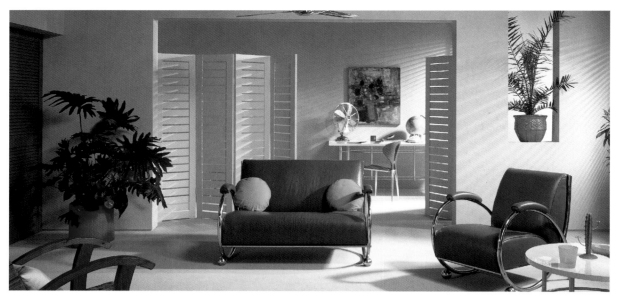

GRAHAM HENDERSON

14 Mandela Street
London
NW1 0DU
Tel: +44 (0)171 388 0416
Fax: +44 (0)171 387 4259

Carl Lyttle

t: 0171 287 0884

14a Dufours Place · London W1V 1FE

represented by Victoria Curtis t: 0956 504513

CHRIS BELL

.

Unit 8
Cedar Way
Camley Street
London NW1 0PD
Tel: +44 (0)171 388 4500
Fax: +44 (0)171 388 4119
Mobile: 0850 652911

BERRY H.G. BIGNEL

BINGEL PHOTOGRAPHY
TEL: (01358) 742571

Corporate • Locations • Travel

STEVE CAVALIER

25, Woronzow Road
St. John's Wood
London NW8 6AY
Tel: +44 (0)171 586 7418
Fax: +44 (0)171 586 7419

STEVE CAVALIER
.

25, Woronzow Road
St. John's Wood
London NW8 6AY
Tel: +44 (0)171 586 7418
Fax: +44 (0)171 586 7419

RECENT CLIENTS INCLUDE:
Barclays, Becks, British Telecom, Citroën, Daihatsu, Lloyds Bank,
Lockheed Martin, Nestlé, Philips, Red Bull, Sainsbury, Sanyo, Tesco

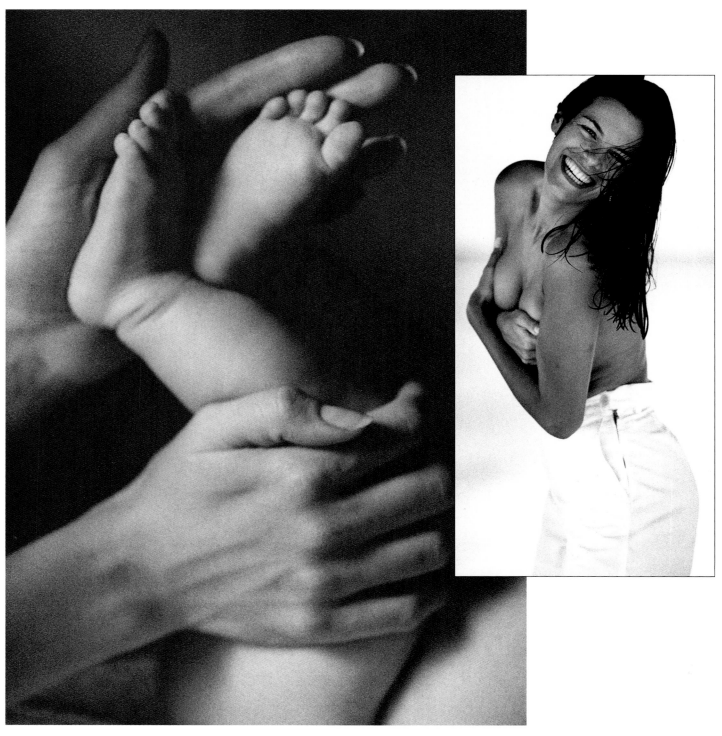

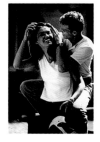
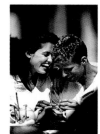
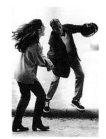

PAUL VENNING
.

1 Stable Yard
Danemere Street
London
SW15 1LT
England
Tel: +44 (0)181 780 0442
Fax: +44 (0)181 780 0441
Mobile: 0836 738842

HUW WILLIAMS PHOTOGRAPHY
.

5 Cedar Way
Camley Street
London NW1 0PD
Tel: 0171 383 4491
Fax: 0171 383 4491
Mobile: 0860 776 520

DENNIS PEDERSEN
.

Hoxton Towers
51 Hoxton Square
London N1 6PB
Tel. (0171) 613 0603 - Fax: (0171) 613 1302
Mobile: (0374) 990 857

Agent:
IMPRESARIA INTERNATIONAL
Tel. (0171) 253 9505

NIK MILNER
· · · · · · · · · · · · · · ·

Studio B9
Linton House
164-180 Union Street
London
Tel: 0171 633 0963
Fax: 0171 633 0963

PATRICK LLEWELYN-DAVIES
················

32 Great Sutton Street
London EC1V 0DX
Tel: +44 (0)171 253 2838
Fax: +44 (0)171 250 3375
http://photobase.home.ml.org

JOHN WHITEFIELD
.

164- 180 Union Street
London SE1 0LH
Tel: +44 (0)171 928 2639
Fax: +44 (0)171 928 2639
Mobile: 0468 525509

BOB KOMAR
• • • • • • • • • • • • • • • •

BOB KOMAR PHOTOGRAPHY
The Soap Factory
9 Park Hill
London SW4 9NS
Tel: +44 (0)171 622 3242
Fax: +44 (0)171 498 6445

TERRENCE BEDDIS

· · · · · · · · · · · · · · ·

Tel: 0171 251 5333

GEOFF DANN
.
164 Whitecross Street
London EC1Y 8QN
Tel: +44 (0)171 251 2873
Fax: +44 (0)171 490 7730

Still life, studio, location, editorial, advertising

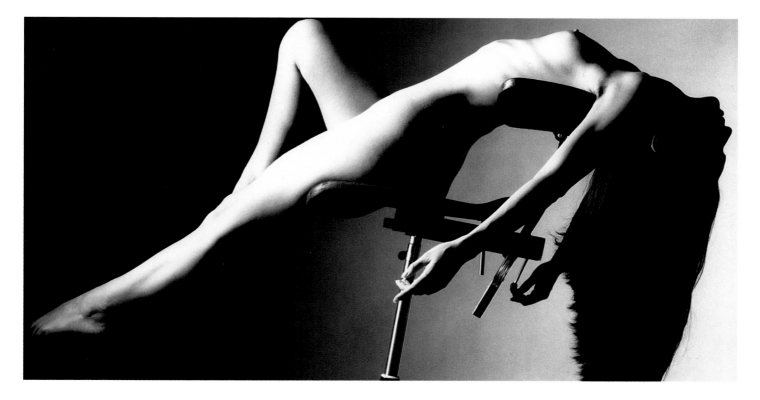

DEREK SEAWARD
· · · · · · · · · · · · · · · ·

Unit 2 Tower Workshops
Riley Road
London
SE1 3DG
Tel: 0171 237 2880
Fax: 0171 394 0364

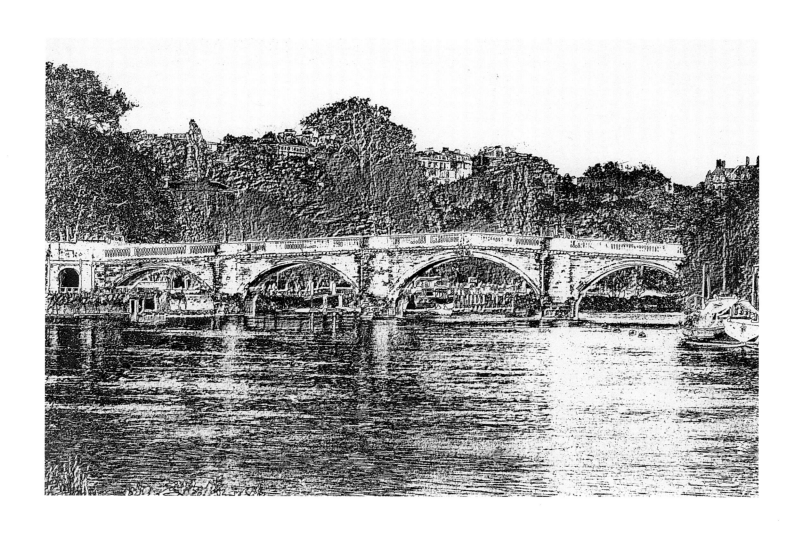

DON WALES
.
9 The Coachworks
80 Parsons Green Lane
Fulham
London SW6 4HU
Tel: +44 (0)171 610 6773
Fax: +44(0)171 610 6772
Mobile: 0860 859779

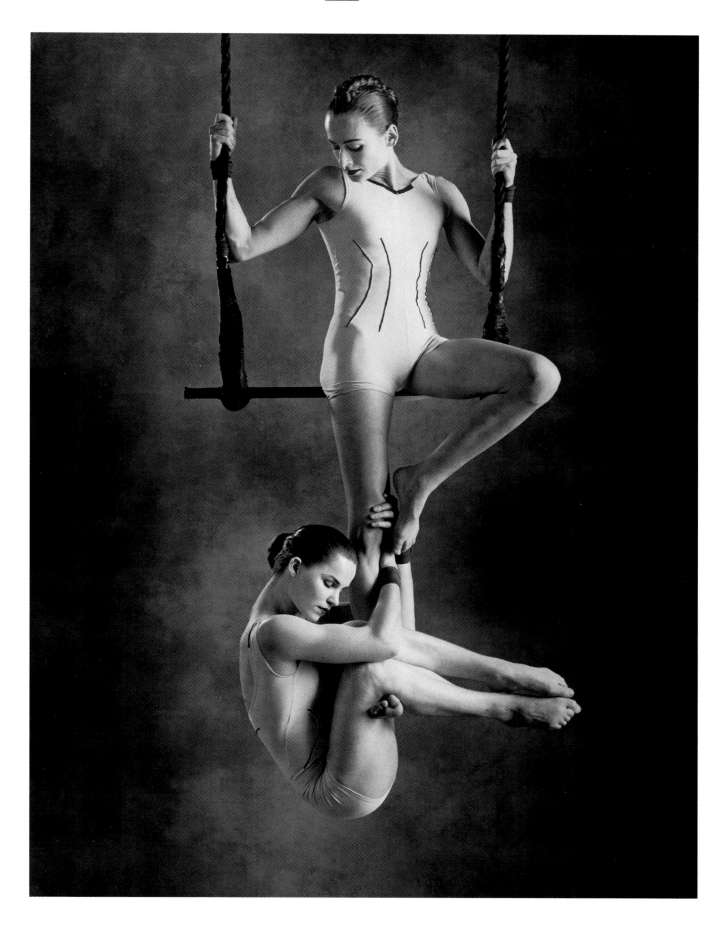

RAY MASSEY
● ● ● ● ● ● ● ● ● ● ● ● ● ● ● ●
The Church Hall
Camden Park Road
London NW1 9Ay
Tel: +(44) 0171 267 9550
Fax; +(44) 0171 267 5612

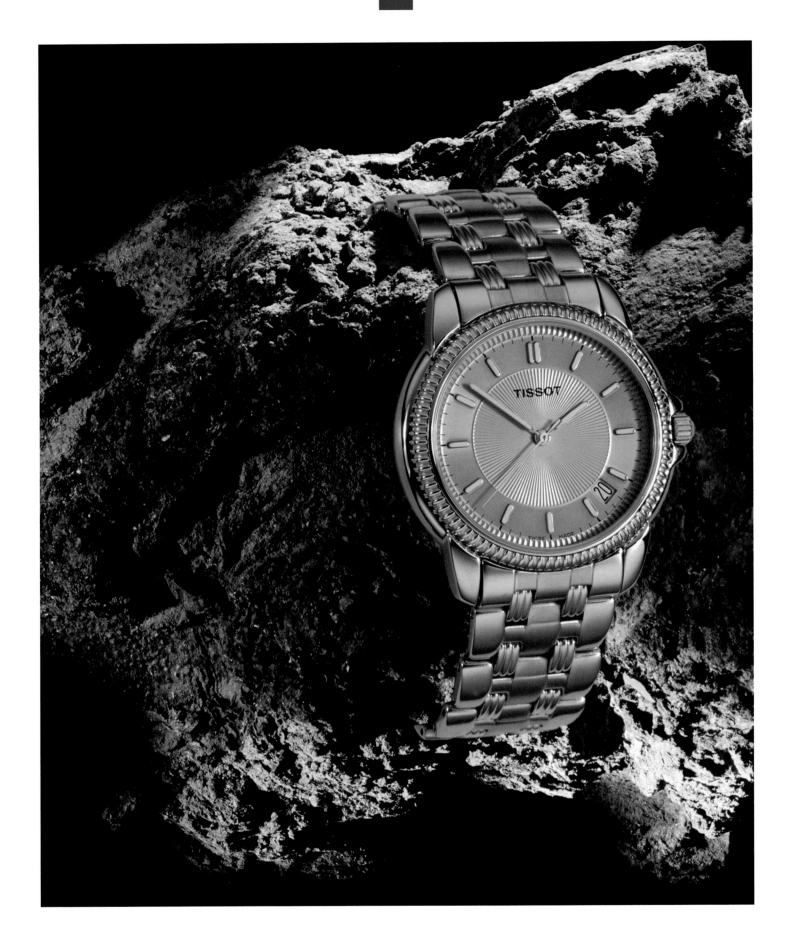

DAVID KELLY

.

Cassidy Road
London SW6 5QN
England
Tel: +44 (0)171 736 6205
Fax: +44 (0)171 384 2240
E-mail: davidkelly@aol.com

TIM MACPHERSON
• • • • • • • • • • • • • • •

6 Apollo Studios
Charlton Kings Road
London NW5 2SB
Tel: 0171 482 3032
Fax: 0171 482 3042
Mobile: 0374 211874

Julian Bajzert

Margrave Studios,
Heathmans Road,
Parsons green,
London SW6 4TJ.

Telephone 0171 736 6262
fax 0171 736 4707
mobile 0836 53 6789

Clients On this page: Lea & Perrins, Kingfisher, The Halifax Building Society.

DOUGLAS ROBERTSON
.

DOUGLAS ROBERTSON PHOTOGRAPHY
42 Royal Park Terrace
Edinburgh EH8 8JA
Scotland
Tel: +44 (0)131 467 7028
Fax: +44 (0)131 467 7028

Clients: Kwik Fit, Royal Bank of Scotland, Deloitte & Touche, The Guardian,
CIPFA, Scottish Homes, UNISON, Labour Party, and many others.

ALAN NEWNHAM

∙ ∙ ∙ ∙ ∙ ∙ ∙ ∙ ∙ ∙ ∙ ∙ ∙ ∙

Unit 2
40-48 Bromell's Road
Clapham Common
London SW4 0BG
Tel: +44 (0)171 498 2399

JAY MYRDAL

• • • • • • • • • • • • • • •

11 London Mews
London W2 1HY
Tel:=44 (0)171 262 7441 - Mobile: 0468 000013
Fax: +(0)171 262 7476
E-mail; j-myrdal@dircon.co.uk
http://www.users.dircon.co.uk/~j-myrdal

Large format studio and location photography
In house dicomed digital manipulation

BARRY MEEKUMS
• • • • • • • • • • • • • • •

Tel: +44 (0)171 574 0900

London Agent
Tony Skinner
Tel: +44 (0)181 932 0028

Milan Agent
Visual Team
Tel: +39 (2) 480 10070

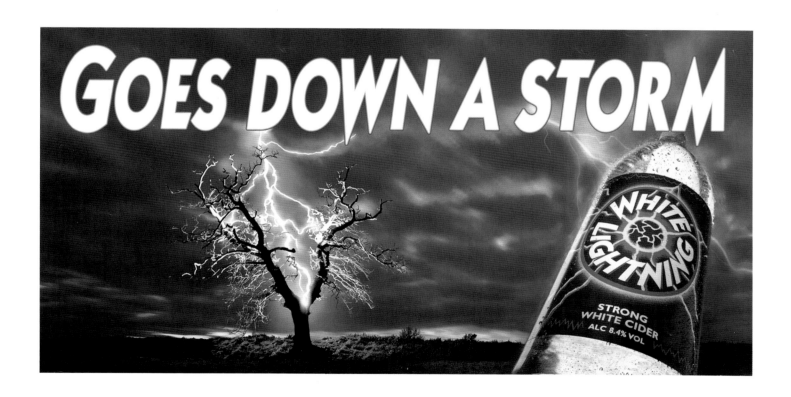

BARRY MEEKUMS

.

Tel: +44 (0)171 574 0900

London Agent
Tony Skinner
Tel: +44 (0)181 932 0028

Milan Agent
Visual Team
Tel: +39 (2) 480 10070

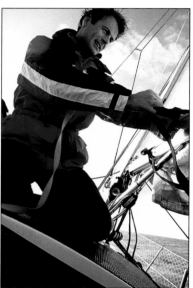

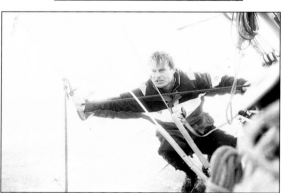

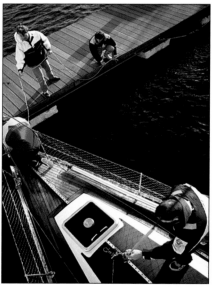

TERRY RYAN

TERRY RYAN PHOTOGRAPHY
193 Charles Street
Leicester LE1 1LA
Tel: (0116) 254 4661 - Fax: (0116) 247 0933

Photographed for / Photographié
Toggi and Splashdown
Agency :- Key Parker Ltd

To view portfolio please telephone or fax.

Pour consulter portfolio,
veuillez téléphoner / Faxer.

244
·
36

TERRY RYAN
• • • • • • • • • • • • • •

TERRY RYAN PHOTOGRAPHY
193 Charles Street
Leicester LE1 1LA
Tel: (0116) 254 4661 - Fax: (0116) 247 0933

Photographed for / Photographié
Client :- Cellnet
Art Direction :- Iain Rumming

To view portfolio please telephone or fax.

Pour consulter portfolio,
veuillez téléphoner / Faxer.

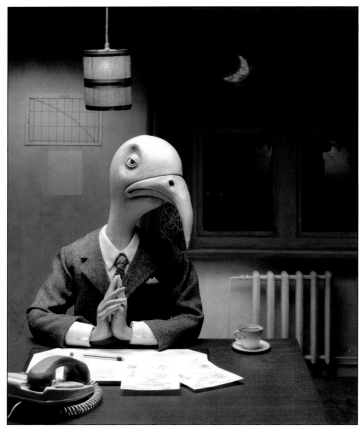

TERRY RYAN
• • • • • • • • • • • • • • • • •

TERRY RYAN PHOTOGRAPHY
193 Charles Street
Leicester LE1 1LA
Tel: (0116) 254 4661 - Fax: (0116) 247 0933

Photographed for / Photographié
Marks & Spencer P.L.C. *top left*
Moss Bros Group P.L.C. *top right*
Tait Paper Products *bottom right*
Uncle Bens Rice *bottom left*

To view portfolio please telephone or fax.

Pour consulter portfolio,
veuillez téléphoner / Faxer.

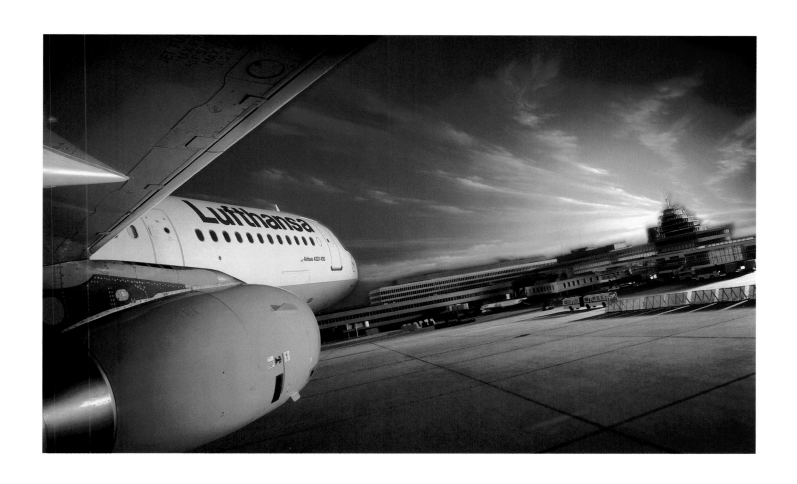

GEORGE LOGAN
.

50A Rosebery Avenue
London EC1R 4RP
Tel: 0171 833 0799
Fax: 0171 833 8189

Ogilvy & Mather Frankfurt.
A.D. Christian Mommertz / Mike Reis.
Lufthansa.

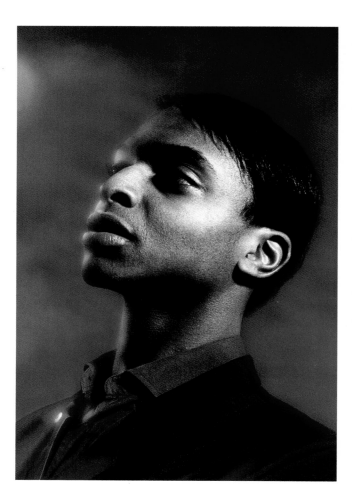
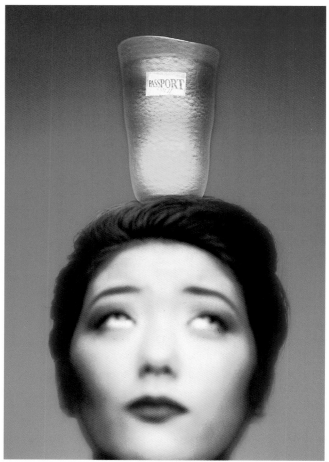

JONATHAN KNOWLES
- - - - - - - - - - - - - - - -

48A Chancellors Road
London W6 9RS
Tel: +44 (0)181 741 7577
Fax: +44 (0)181 748 9927

JONATHAN KNOWLES
∙ ∙ ∙ ∙ ∙ ∙ ∙ ∙ ∙ ∙ ∙ ∙ ∙ ∙ ∙ ∙

48A Chancellors Road
London W6 9RS
Tel: +44 (0)181 741 7577
Fax: +44 (0)181 748 9927

JONATHAN KNOWLES
• • • • • • • • • • • • • • •

48A Chancellors Road
London W6 9RS
Tel: +44 (0)181 741 7577
Fax: +44 (0)181 748 9927

NICHOLAS RIGG
▪ ▪ ▪ ▪ ▪ ▪ ▪ ▪ ▪ ▪ ▪ ▪ ▪ ▪ ▪

Top Floor
45 Mitchell Street
London EC1V 3QD
Tel: +44 (0)171 490 3594
Fax: +44 (0)171 250 1083

FRANK WIEDER

+44 (0)171 482 38 30
+44 (0)181 981 35 60
England

FRANK WIEDER
.

+44 (0)171 482 38 30
+44 (0)181 981 35 60
England

PAUL WEBSTER
.
2c Macfarlane Road
Shepherds Bush
London
W12 7JY
Tel: 0181 749 0264
Fax: 0181 740 8873
E-mail: paulsnap@dircon.co.uk

Food and Drink specialist.
Digital photography and malipulation

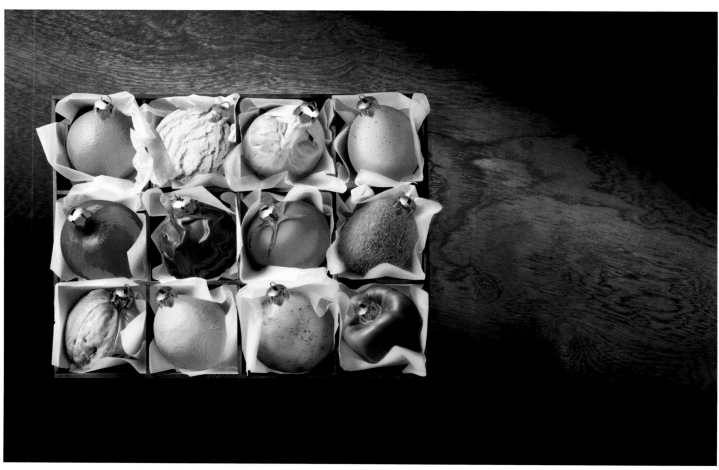

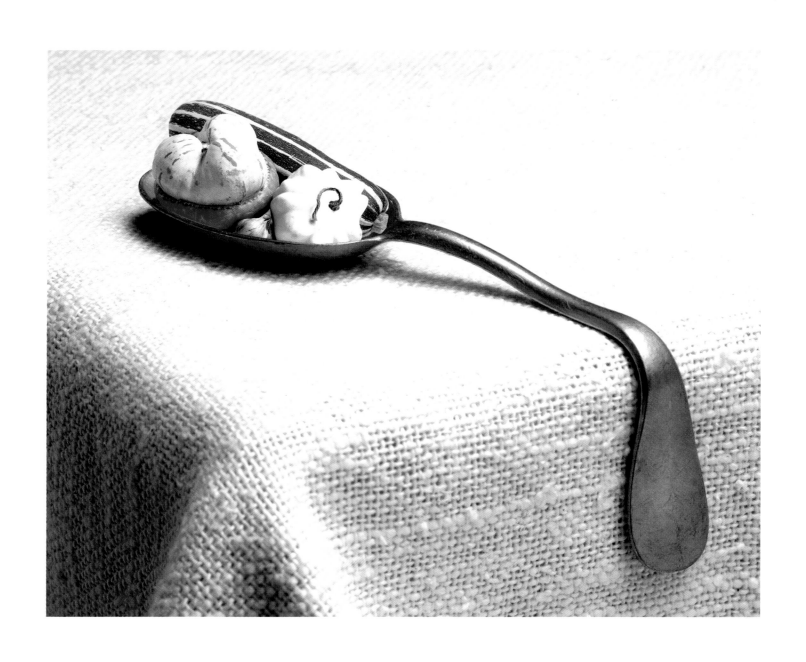

PAUL WEBSTER
.
2c Macfarlane Road
Shepherds Bush
London
W12 7JY
Tel: 0181 749 0264
Fax: 0181 740 8873
E-mail: paulsnap@dircon.co.uk

Food and Drink specialist.
Digital photography and malipulation

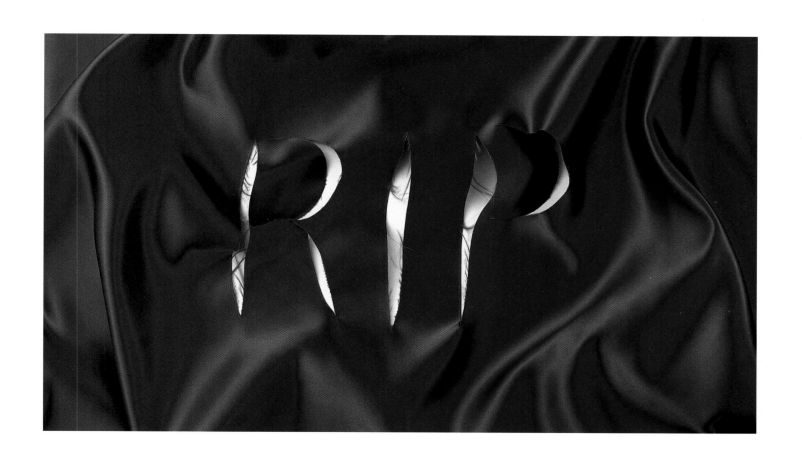

ANDY SEYMOUR
.

82 Princedale Road
Holland Park
London W11 4NL
Tel: +44 (0)171 221 2021
Fax: +44 (0)171 792 0702

Client: Ash

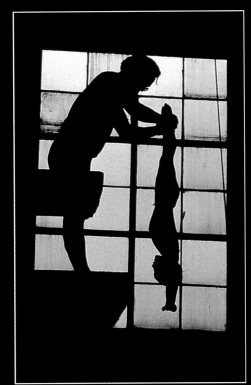

BOB MARTIN

BOB MARTIN SPORTS PHOTOGRAPHER
14 West End Gardens
Esher, Surrey
KMO 8LD
UK
Tel: +44 (0)1372 464111
Fax: +44 (0)1372 468335

Sports & action specialist.
Work appears internationaly in sports & news, editorial & advertising

BOB MARTIN

BOB MARTIN SPORTS PHOTOGRAPHER
14 West End Gardens
Esher, Surrey
KM0 8LD
UK
Tel: +44 (0)1372 464111
Fax: +44 (0)1372 468335

Sports & action specialist.
Work appears internationaly in sports & news, editorial & advertising

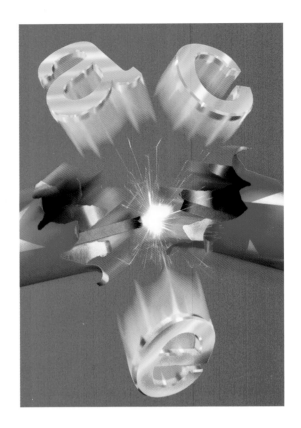

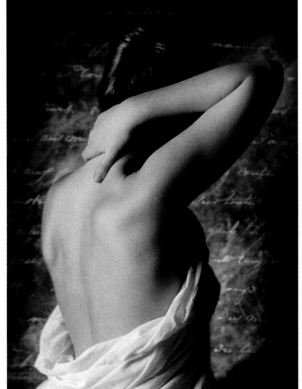

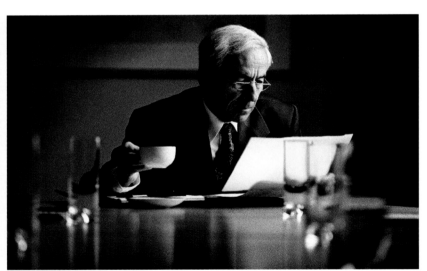

COLIN CRISFORD
· · · · · · · · · · · · · · · · ·

ACE STUDIOS
Satellite House
2 Salisbury Road
London SW19 4EZ
Tel: +44 (0)181 944 9944 Fax: +44 (0)181 944 9940
Mobile: (0410) 411666

Represented by
RACHEL McGUINNESS

ANDY WHALE
.
16-24 Underwood Street
London N1 7JQ
0171 608 3743
Agent: Anthea Bowen 0860 389 352

MALCOLM HULME
.

MALCOLM HULME PHOTOGRAPHY
6A Pratt Street - Camden
London NW1 0AB
Tel: +44 (0)171 388 7314
Fax: +44 (0)171 387 4694

Agent:
HELEN GIMSON
Mobile: +44 (0)973 552 449 - Office: +44 (0)181 744 9833

GILL ORSMAN

• • • • • • • • • • • • • • •

The Stable
6-8 Cole Street
London SE1 4YH
Tel: +44 (0)171 378 1867
Fax: +44 (0)171 357 6909
Mobile: 0831 855 324

JEFF KAINE

· · · · · · · · · · · · · · · ·

STUDIO 10A
10A Lant Street
London SE1 1QR
Tel: +44 (0)171 357 9256
Fax: +44 (0)171 357 9258

Stock Photography Through Studio 10A Libraryy

WILL WHITE
· · · · · · · · · · · · · · · ·

3 Lamp Office Court
Lambs Conduit Street
London
WC1N 3NF
Tel: 0171 404 0318
Fax: 0171 430 0411

TALY NOY
. .

East Studios
40A River road
Barking
Essex IG11 0DW
Tel: 0181 507 7572 - Fax: 0181 507 8550

Studio A: 0181 507 8227 | *Studio B: 0181 507 8212* | *Studio C: 0181 507 7572*

MARTIN WONNACOTT
.

DOG-GONE STUDIO
The Business Village
Broomhill Road
London SW18 4JQ
Tel: 0181 870 1860
Fax: 0181 871 5008

STRUAN WALLACE

The Studio
16 Gibraltar Walk
London E2 7lb
Tel: 0171 739 4406 - Fax: 0171 739 8784

Agent: Claire
Tel 01582 768053

Struan specilises in food & drink photography for ads,
packaging and editorial briefs. Please call for portfolio

MIKE GALLETLY
.

Studio 3
The People's Hall
Olaf Street
London W11 4BE
Tel: 0171 221 0925
Fax: 0171 229 1136

ANDREW ATKINSON
.
Lower Ground Floor
6a Poland Street
London W1V 3DG
Tel: +44 (0)171 437 4985
Fax: +44 (0)171 437 4985
Mobile: 0850 0343 44

STEVE SHIPMAN

.

12 Printing House Yard
15 Hackney Road
London E2 7PR
Tel: 0171 739 5858
Fax: 0171 739 1756
Mobile: 0831 355 966

Represented by
Natasha Fox at Impresaria Photographic
Tel: 0171 253 9505 Fax: 0171 251 3219

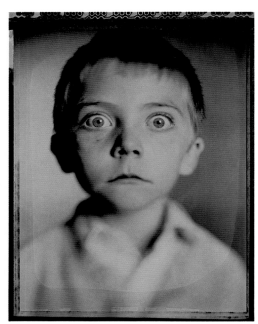
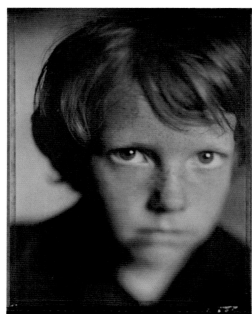
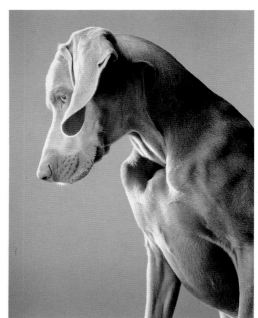

MATT HARRIS

· · · · · · · · · · · · · · · · ·

53. St. Mary's Road
London W5 5RG
Tel: +44 (0)181 840 4822
Fax: +44 (0)181 840 4822
Mobile: 0850 955 585

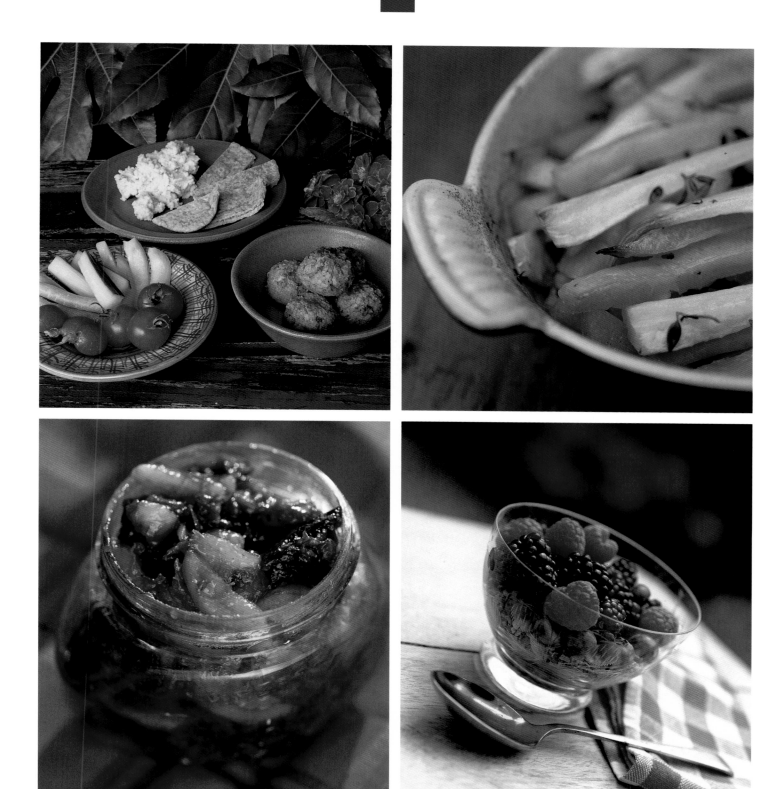

SIAN IRVINE
· · · · · · · · · · · · · ·
12 Printing House Yard
15 Hackney Road
London E2 7PR
Tel: 0171 739 4563
Fax: 0171 739 1756
Mobile: 0850 188 093

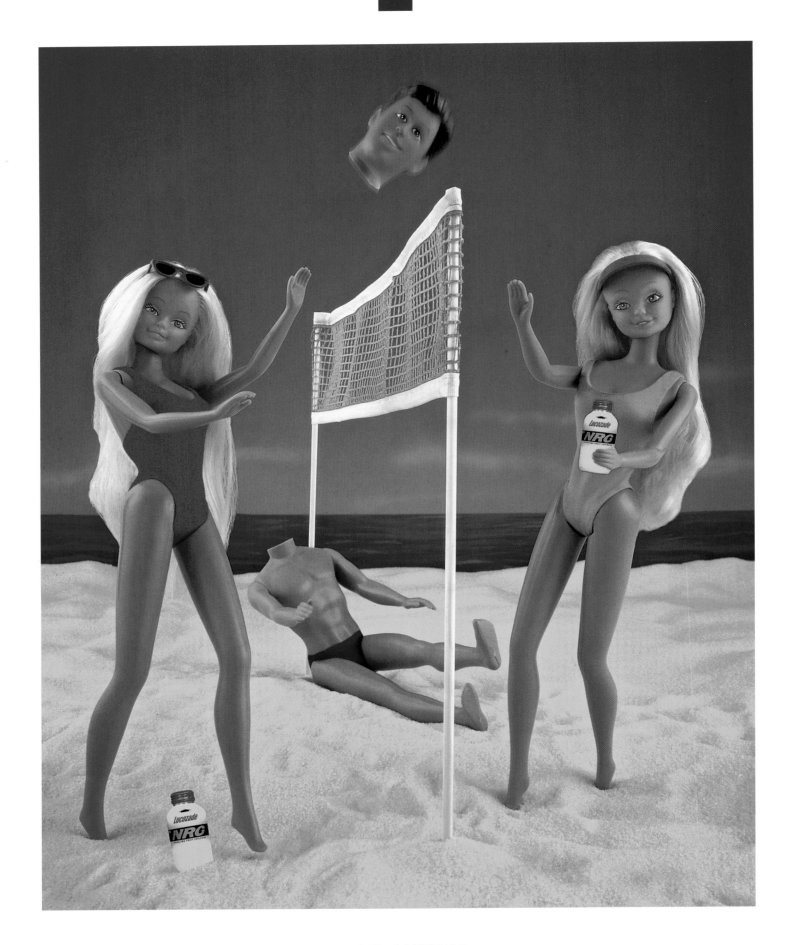

PHILIP GATWARD
.

Unit 14b, Rosemary Works
Branch Place
London N1 5PH
Tel: +44 (0)171 613 1603
Mobile: 0802 654785

Conventional Chemistry and Digital Manipulation

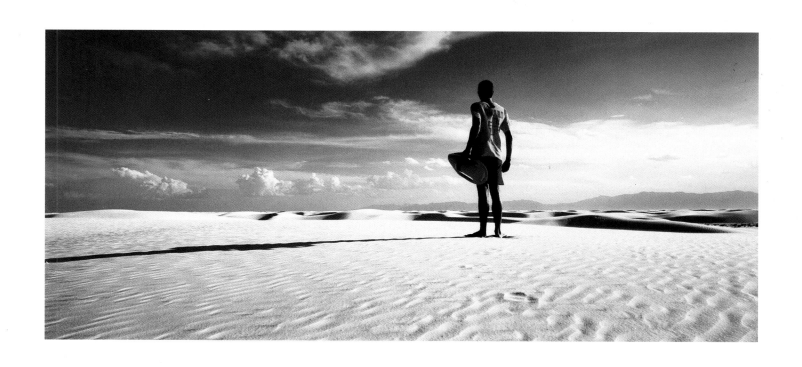

SIMON STOCK
.
Tel: +44 (0)181 340 9147
M: +44 (0)850 707475

Represented in Europe By
Gisela Stiel
Tel: +44 (0)181 968 0324

B E L G I U M

B E L G I Q U E

B E L G I E N

	International page	Local page
BAETENS, PASCAL	279	3
BRUYNSEELS, DANIEL	280	4
CHERPION, ERIC	281	5
DE KINDER, GEORGES	283	7
DE MEYER, MICHEL	284	8
DEPREZ, KOENRAAD	282	6

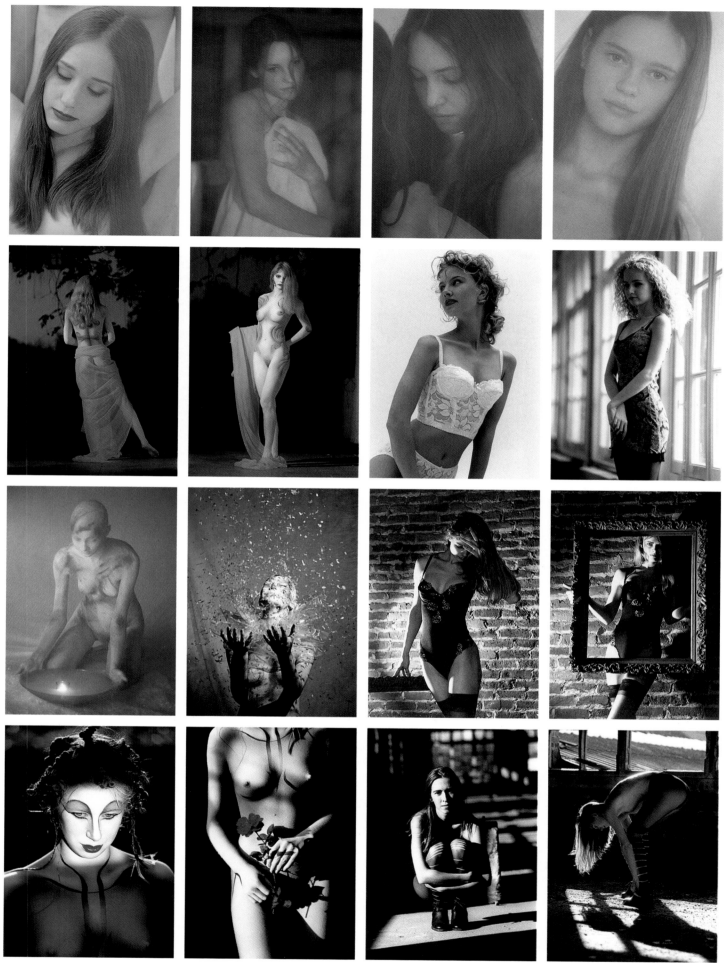

Bodypainting: Jos Brands with Kryolan

PASCAL BAETENS

.

Willem Coosemansstraat 122
B-3010 Kessel-Lo
Belgium
Tel: +32 16 25 84 11 - Fax: +32 16 25 84 70

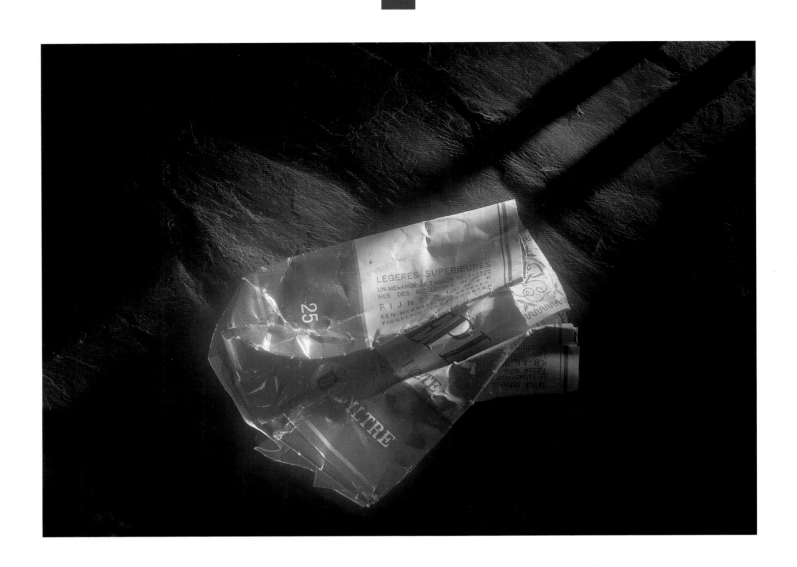

DANIEL BRUYNSEELS

· · · · · · · · · · · · · · ·

BERGENSESTEENWEG 407
B 1600 ST PIETERS LEEUW
TEL : (32-2) 377 69 00
FAX : (32-2) 378 22 19

FOOD, STILLS, LANDSCAPES & INDUSTRY

ERIC CHERPION
.

Rue de l'Orient 65
B-1040 Bruxelles
Tel. (32-2) 648 99 13
Fax: (32-2) 640 49 18

KOENRAAD DEPREZ PHOTOGRAPHY
▪ ▪ ▪ ▪ ▪ ▪ ▪ ▪ ▪ ▪ ▪ ▪ ▪ ▪ ▪

Wielewaalstraat 102
B-9000 Gent
Tel : (09) 227 78 22 - GSM : (075) 26 71 75
Fax : (09) 226 71 75

Still life, people, advertising

ſtill Life

GEORGES
DE KINDER

Brussels # 32-2-346 68 25

MICHEL DE MEYER

Vinkendam 6
B-9120 Beveren
Tel: (03) 755 34 74
Fax: (03) 755 30 15

CLIENT:
Strategic Design Partners

H O L L A N D

· · · ·

H O L L A N D E

· · · ·

H O L L A N D

	International page	*Local page*
DE WINTER, HERMAN	**296-297**	*20-21*
HAGEMAN, KEES	**288-295**	*12-19*
TROMP, JOHN	**287**	*11*
VAN TONGEREN, ROBERT	**298-299**	*22-23*

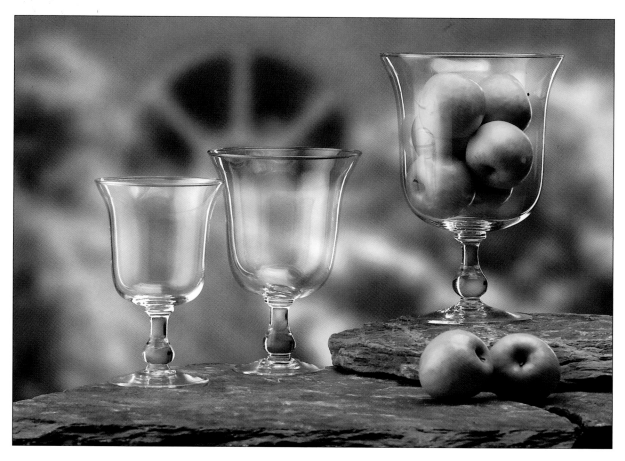

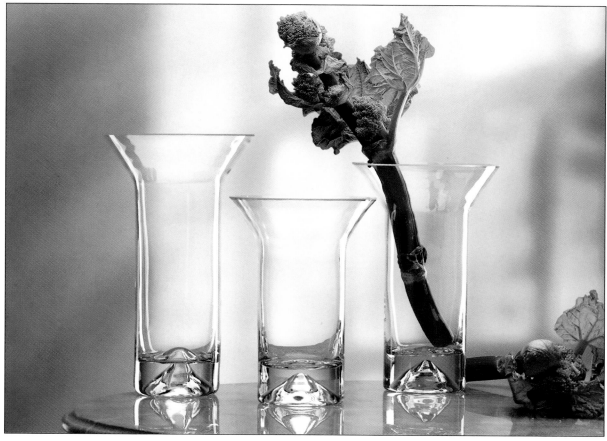

JOHN TROMP
= = = = = = = = = = = = = = = =

STUDIO TROMP
Griseldestraat 2
NL-3077 CN Rotterdam
Tel: (+31-10) 479 36 06
Fax: (+31-10) 479 52 51
ISDN: (+31-10) 292 05 00

Digital Studio Photography

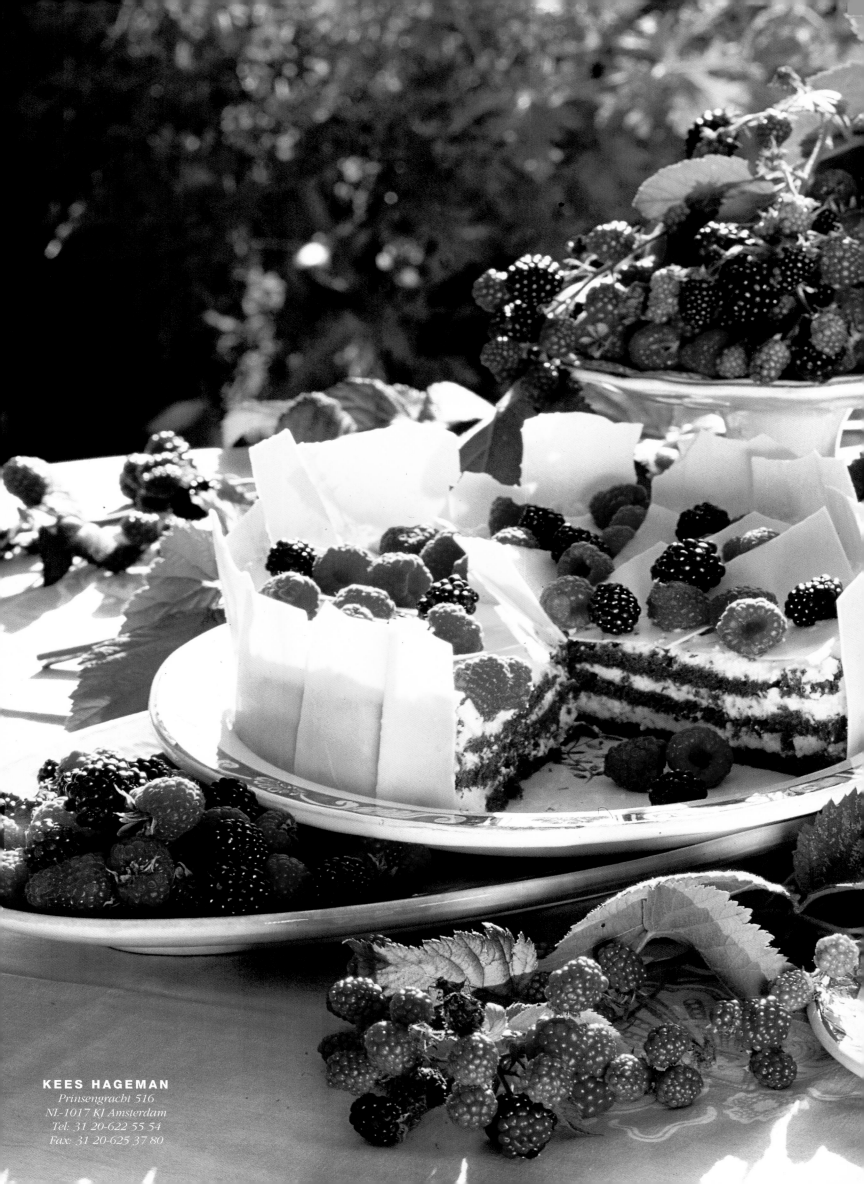

KEES HAGEMAN
Prinsengracht 516
NL-1017 KJ Amsterdam
Tel: 31 20-622 55 54
Fax: 31 20-625 37 80

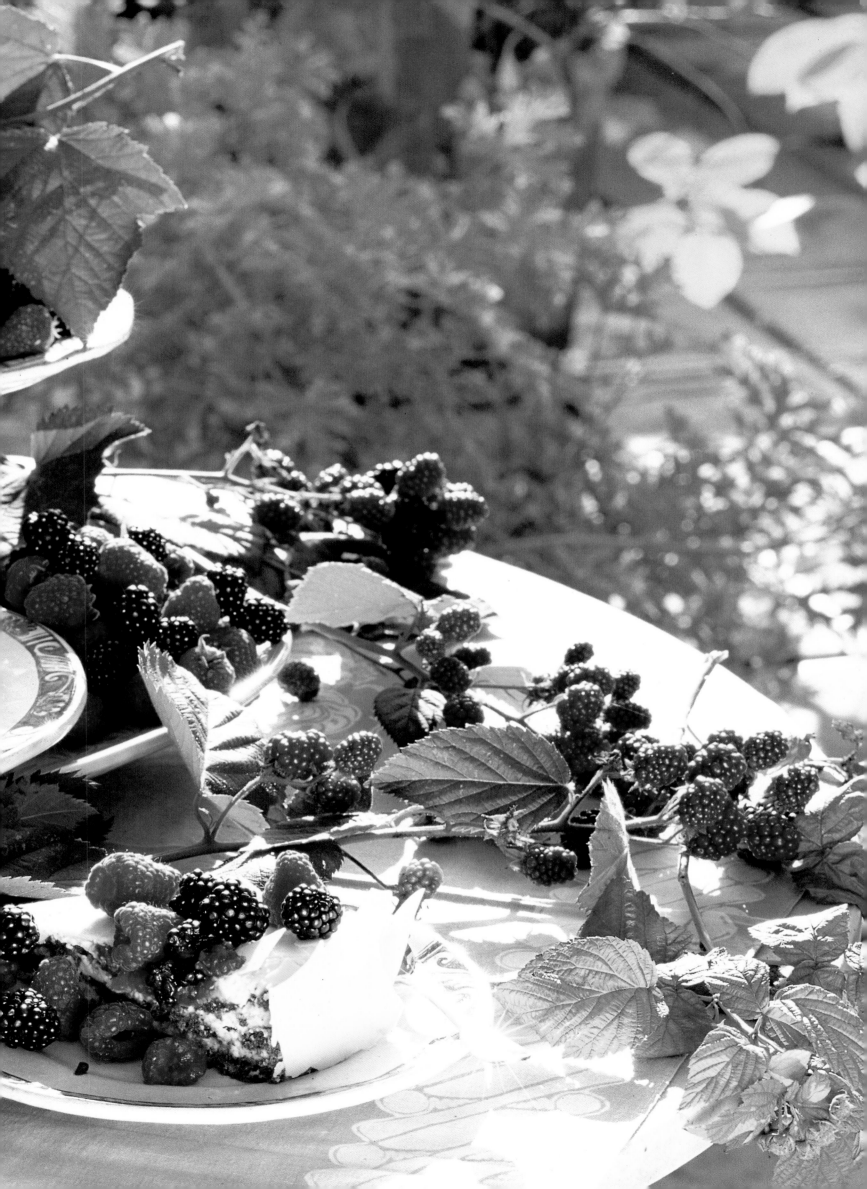

KEES HAGEMAN

KEES HAGEMAN

KEES HAGEMAN
Prinsengracht 516
NL-1017 KJ Amsterdam
Tel: 31 20-622 55 54
Fax: 31 20-625 37 80

KEES HAGEMAN
Prinsengracht 516
NL-1017 KJ Amsterdam
Tel: 31 20-622 55 54
Fax: 31 20-625 37 80

KEES HAGEMAN
Prinsengracht 516
NL-1017 KJ Amsterdam
Tel: 31 20-622 55 54
Fax: 31 20-625 37 80

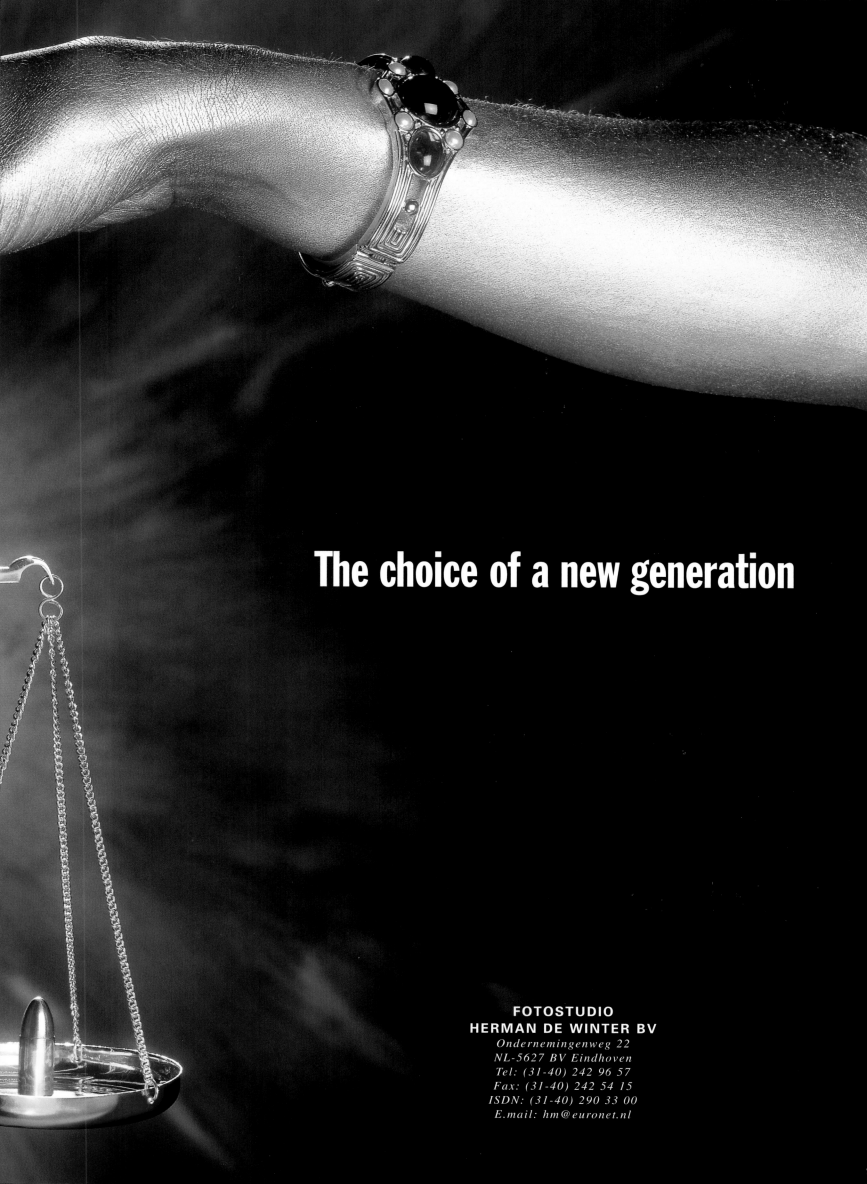

The choice of a new generation

FOTOSTUDIO
HERMAN DE WINTER BV
Ondernemingenweg 22
NL-5627 BV Eindhoven
Tel: (31-40) 242 96 57
Fax: (31-40) 242 54 15
ISDN: (31-40) 290 33 00
E.mail: hm@euronet.nl

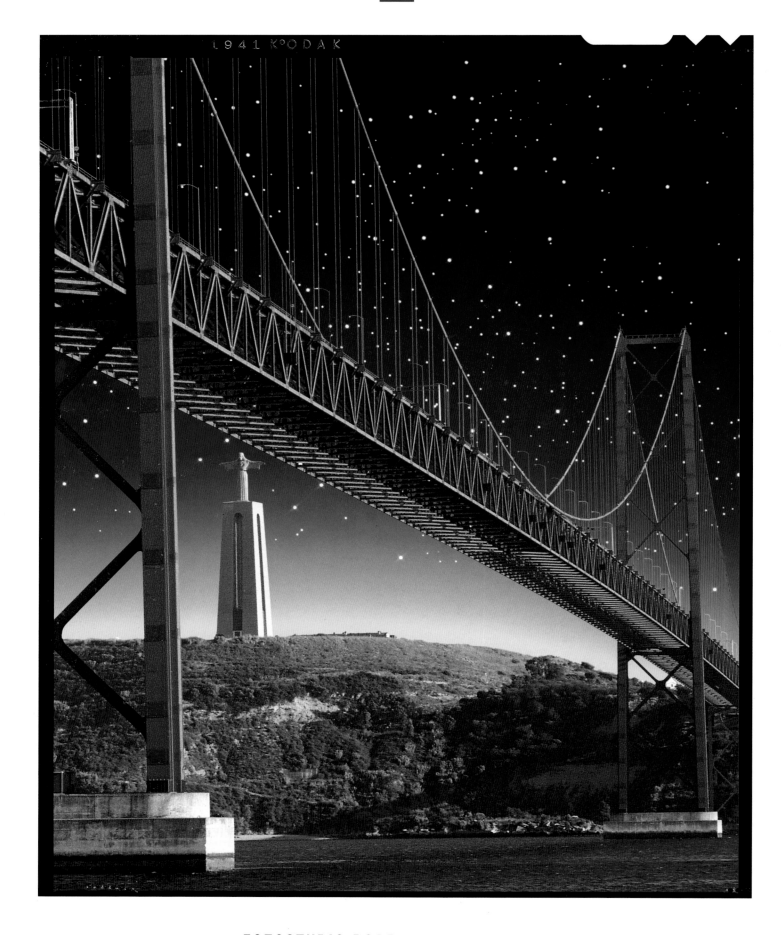

1941 K°ODAK

FOTOSTUDIO ROBERT VAN TONGEREN

■ ■ ■ ■ ■ ■ ■ ■ ■ ■ ■ ■ ■ ■ ■ ■

Julianaplein 105
Postbus 50
NL-6640 AB Beuningen
Tel: (024) 677 32 91
Fax: (024) 677 48 18

■ STILLS ■ FOOD ■ PRODUCTS ■ LOCATION ■ PEOPLE

24,6MB/66MB

FOTOSTUDIO ROBERT VAN TONGEREN

■ ■ ■ ■ ■ ■ ■ ■ ■ ■ ■ ■ ■ ■ ■

Julianaplein 105
Postbus 50
NL-6640 AB Beuningen
Tel: (024) 677 32 91
Fax: (024) 677 48 18

■ STILLS ■ FOOD ■ PRODUCTS ■ LOCATION ■ PEOPLE

F R A N C E

F R A N C E

F R A N K R E I C H

	International page	*Local* *page*
DELEU, SERGE	**304**	*28*
FERRER, PHILIPPE	**312-313**	*36-37*
FORZI, MARC	**310-311**	*34-35*
HEIMERMANN, **ÉTIENNE**	**302-303**	*26-27*
LUCIANI, PASCAL	**314-315**	*38-39*
QUAEGEBEUR, **FABRICE**	**308**	*32*
STUDIO NEW LOOK	**306-307**	*30-31*
UPC	**305**	*29*

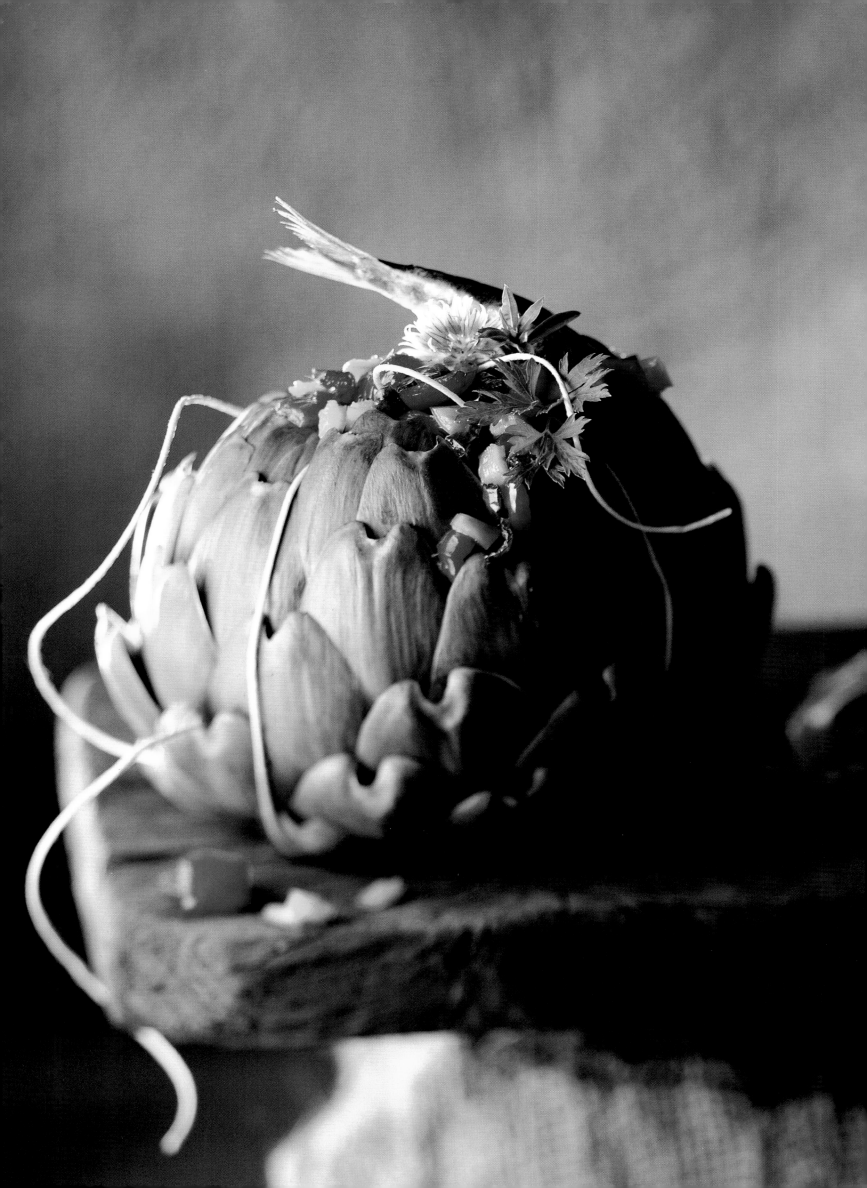

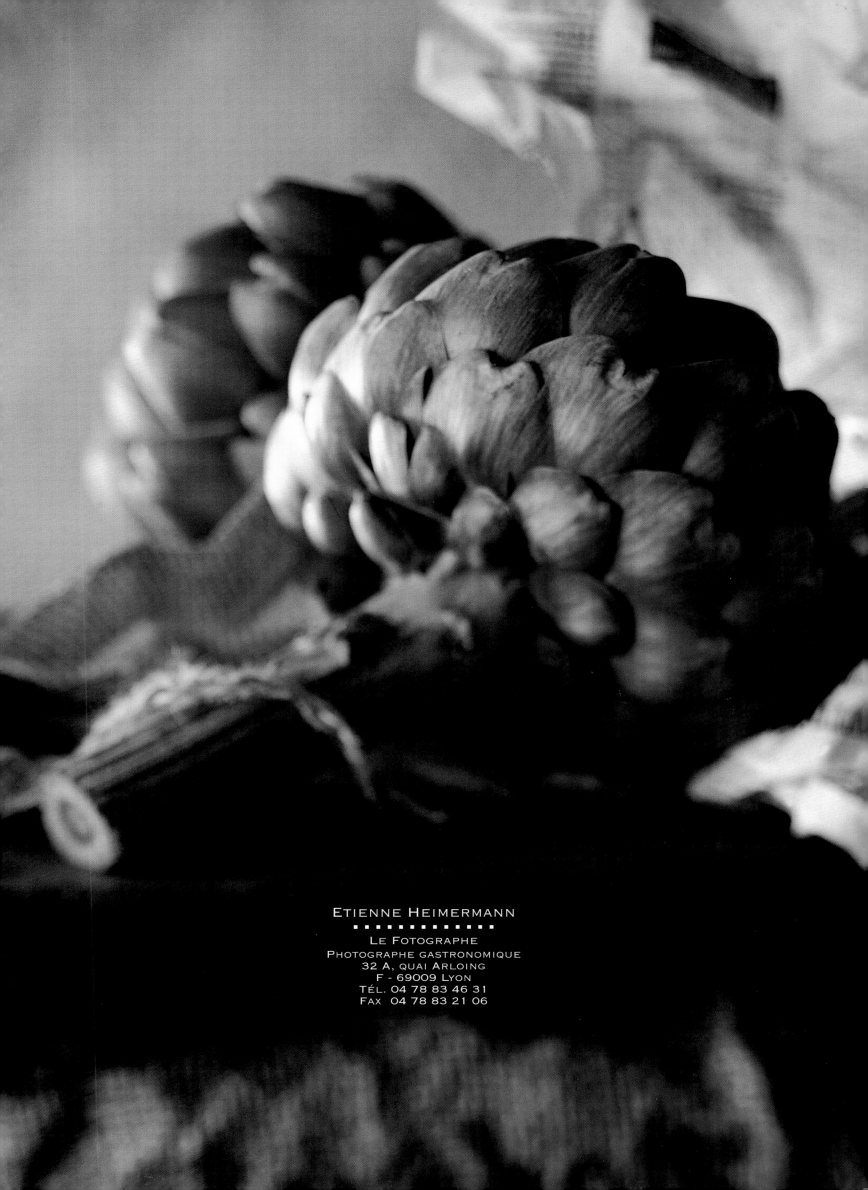

ETIENNE HEIMERMANN
.
LE FOTOGRAPHE
PHOTOGRAPHE GASTRONOMIQUE
32 A, QUAI ARLOING
F - 69009 LYON
TÉL. 04 78 83 46 31
FAX 04 78 83 21 06

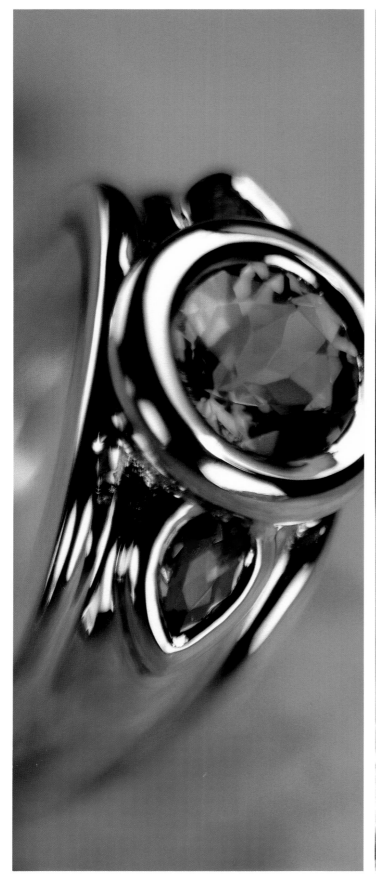

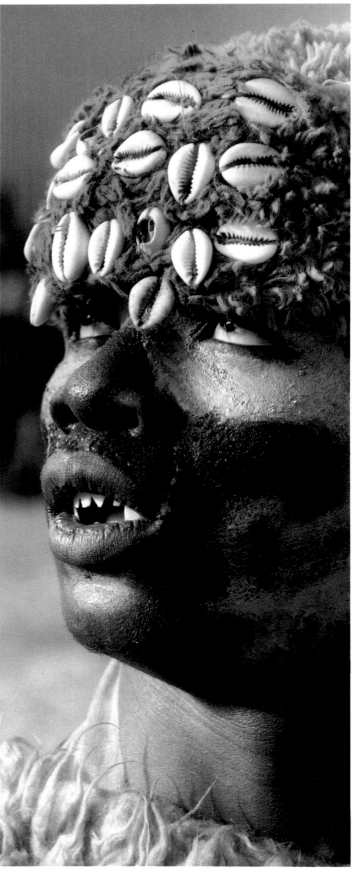

SERGE DELEU
· · · · · · · · · · · · · · · · ·

13 Hameau de Prez
59710 Avelin-lez-Lille
France
Tel: 03 20 61 40 40
Fax: 03 20 59 57 40

Still life,
Food, Jewellery,
Reporting all over the world

Nature morte,
Gastronomie, Bijoux
Reportage monde entier

L'INDÉPENDANCE A UN NOM
UNION DES PHOTOGRAPHES CRÉATEURS

Deux mille en l'an 2000 ! Nous souhaitons rassembler au début du troisième millénaire plus de 2000 photographes professionnels pour la défense de leurs droits et de la déontologie de leur profession. Depuis plus de 20 ans, l'Union des photographes créateurs lutte pour que l'activité de photographe ait les mêmes droits et les mêmes devoirs que les autres activités d'auteur. Elle s'attache à défendre en priorité le droit d'auteur tel qu'il existe en France (Article 14 de la loi du 3 juillet 1985 - droit d'auteur en publicité - Code de la Propriété intellectuelle, Loi n° 92-597 du 1er juillet 1992), ainsi que l'identité sociale de ses adhérents. Les photographes de l'association travaillent dans des secteurs très variés : journalisme, photographie publicitaire, mode, illustration, édition, etc. Cette diversité enrichit chaque jour les dialogues et les collaborations des adhérents au sein de l'organisation. Afin de mieux développer les échanges et le soutien à la création, le fonctionnement de l'Union des photographes créateurs s'articule autour d'un certain nombre de commissions. Cette structure permet d'élaborer efficacement des réponses aux différents problèmes rencontrés par notre profession. Ces commissions sont ouvertes à tous les membres de l'UPC, de façon qu'ils apportent leur énergie et leurs compétences pour promouvoir les objectifs que nous défendons. Les commissions se réunissent régulièrement et centralisent leurs idées, et leur programme de recherche. L'association constitue une force de proposition et de dialogue avec les pouvoirs publics afin que la voix des photographes créateurs soit entendue. Son information juridique permet aux adhérents de mieux connaître leurs droits et de faire valoir leurs intérêts. Actuellement, des photographes représentant l'Union des photographes créateurs siègent au conseil d'administration et à la commission de professionnalité de l'Agessa. L'UPC a participé à l'obtention de la nouvelle assiette de cotisation sociale (BNC+15%). Les reporters-photographes journalistes sont eux aussi présents au sein de l'Union des photographes créateurs, pour défendre la convention collective de l'activité des journalistes. L'urgence des problèmes nous conduit régulièrement à intervenir afin que cessent les traitements discriminatoires sur le plan fiscal : demande d'exonération de la taxe professionnelle pour tous les auteurs photographes - amélioration de la protection sociale des auteurs (maladie, accidents du travail...) - défense du droit à l'information, menacé par le droit des personnes sur leur image. Pour une pratique harmonieuse du métier, l'UPC préconise le respect élémentaire des codes des usages en vigueur. Elle édite des bordereaux-contrat indispensables lors de toute communication de photographies.

L'UPC
L'organisation qui représente l'identité des photographes professionnels créateurs.

Ces documents font autorité et sont devenus des outils essentiels pour des relations transparentes avec les éditeurs ou diffuseurs. Les barèmes indicatifs de l'Union des photographes créateurs informent, chaque année, ses adhérents des conditions de rémunérations moyennes pratiquées dans les secteurs de la presse, de l'édition, de la publicité, etc. Ces informations servent de base de réflexion pour que chacun établisse son barème personnel. Depuis 1989, notre action s'étend aux pays européens : notre souci constant étant d'inscrire les idéaux des associations dans une perspective plus large. C'est ainsi que l'UPC est à l'origine de la création du GROUPE DE LA PYRAMIDE (groupement européen d'intérêt économique) rejoint par plus de douze pays européens qui fait valoir l'existence de 40.000 auteurs européens dans les arts visuels et graphiques et défend et harmonise leurs droits auprès des instances communautaires européenes. De plus, nous sommes largement représentée au sein de la commission des images fixes de la Société civile des auteurs multimédia (SCAM) pour la gestion collective des droits des photographies pour la télévision (canaux hertziens et câble), la copie privée et la reprographie. L'Union des photographes créateurs a participé à la fondation de la Société de l'Image (SDI) pour la gestion individuelle des droits des photographes. Des années de développement, d'évolutions et d'échanges ont fait de cette association un pôle pour les créateurs concernés par la mise en pratique d'une certaine idée de la profession de photographe. Et la présence de plus en plus forte de l'UPC au sein des manifestations photographiques d'importance : Perpignan, Biarritz, les RIP en Arles, SIPI... développe la notoriété de l'association auprès des pouvoirs publics et du grand public. De même, elle nous permet de présenter le métier de photographe créateur de manière plus juste et incite les utilisateurs de nos images à respecter la déontologie de la profession. Des expositions sont organisées chaque année à la Maison des Photographes. Notre galerie bien située et agréblement aménagée offre la possiblité d'accrochages de grande qualité. Centralisée à Paris, l'administration de l'Union des photographes créateurs accueille, par l'intermédiaire des délégations régionales, les adhérents qui résident en province. Ils peuvent se rencontrer et agir grâce aux réunions organisées au sein de ces dernières. Etre à l'Union des photographes créateurs, c'est incontestablement un plus. Et pour ceux qui ne nous ont pas encore rejoint, c'est très simple : il leur suffit de justifier de leur professionnalité dans la photographie, et de régler le montant annuel de la cotisation, qui varie de 250 à 1000 F selon le statut social ●

MAISON DES PHOTOGRAPHES - GALERIE ET ACCUEIL

Président : Pierre Pérouse - Vice-présidents : Philip Harvey, Philippe Dubois
Secrétaire Général : Maurice-Frédérick Calatchi - Trésorier : Philippe Bachelier

Informations professionnelles pour tous les photographes les 1ers et 3èmes mardis de chaque mois dans notre galerie

100, rue Vieille du Temple - 75003 PARIS - Téléphone : 33 - 01 42 77 24 30 - Télécopie : 33 - 01 42 77 24 39

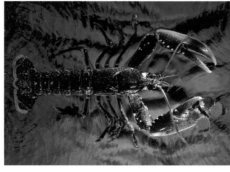

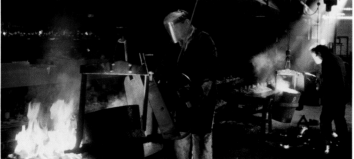

STUDIO NEW-LOOK

Nature Morte
245, rue Jean Jaurès - 59491 Villeneuve d'Ascq
Agent : Catherine DUTHOIT
Tél. 03 20 20 36 06 - Fax. 03 20 20 37 28

Nature Morte, Catalogues, Alimentaire,
Décoration, Linge de Maison,Bijoux,
Reportages Industrie et Environnement.

Prises de vues numériques et argentiques

Still life, Catalogues, Food,
Decor set, Linen, Jewellery
Industrial & Landscape reports.

Traditional & Digital Camera Back

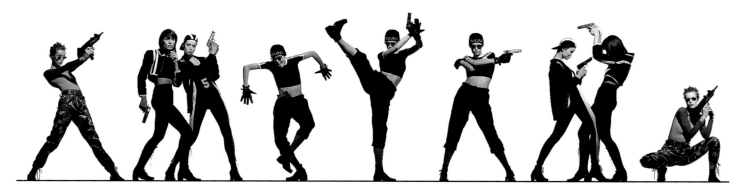

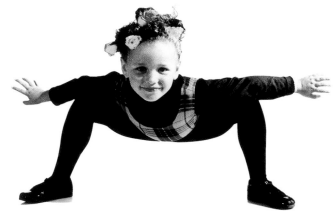

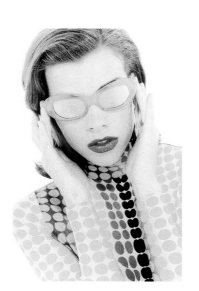

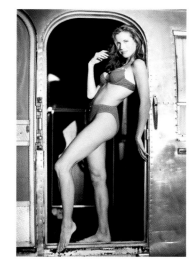

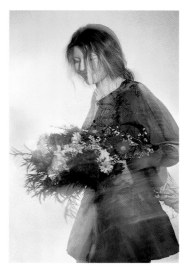

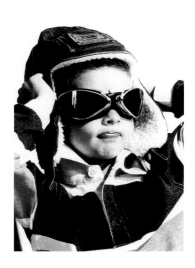

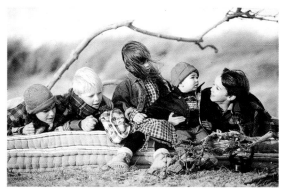

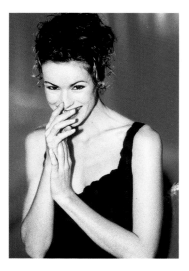

STUDIO NEW·LOOK

Mode
245, rue Jean Jaurès - 59491 Villeneuve d'Ascq
Agent : Catherine DUTHOIT
Tél. 03 20 20 36 06 - Fax. 03 20 20 37 28

Mode
Lingerie
Beauté
People
Publicité

Fashion
Underwear
Beauty
People
Advertising

FABRICE QUAEGEBEUR

● ●

STUDIO 4 x 5
Tél. 03 20 24 02 29
Fax : 03 20 26 17 30

Day light studio. Studio lumière du jour. Tageslichstudio.
Fashion, still life, catalogues, Mode, natures mortes, catalogues, Mode, Stilleben, Kataloge,
editorial, advertising, special effects. édition, publicité, effets spéciaux. Redaktionelles, Werbung, Sondereffekte.
Stock photo. Photothèque. Fotothek.

LAGERFELD

ROCHAS
PARIS

E Y E W E A R

Maserati

5, rue des Lombards 75004 PARIS Tel. 01 40 29 99 36 Fax 01 42 77 46 60 Email marc.forzi@wanadoo.fr

just

for

a

glance

BB
BALENCIAGA
PARIS

MARC FORZI

Photographer

PHILIPPE FERRER

.

3/5 rue Mélingue
F-75019 Paris
Tel. & Fax: (33-1) 40 03 85 11

Représenté par:
François Ha Minh Tinh
Tel. & Fax: (33-1) 44 75 81 65

Beauté - Cosmétique - Joaillerie

PHILIPPE FERRER

▪ ▪ ▪ ▪ ▪ ▪ ▪ ▪ ▪ ▪ ▪ ▪ ▪ ▪

3/5 rue Mélingue
F-75019 Paris
Tel. & Fax: (33-1) 40 03 85 11

Représenté par:
François Ha Minh Tinh
Tel. & Fax: (33-1) 44 75 81 65

Beauté - Cosmétique - Joaillerie

PASCAL LUCIANI
.
3/5 rue Mélingue
F-75019 Paris
Tel. & Fax: (33-1) 40 03 85 11

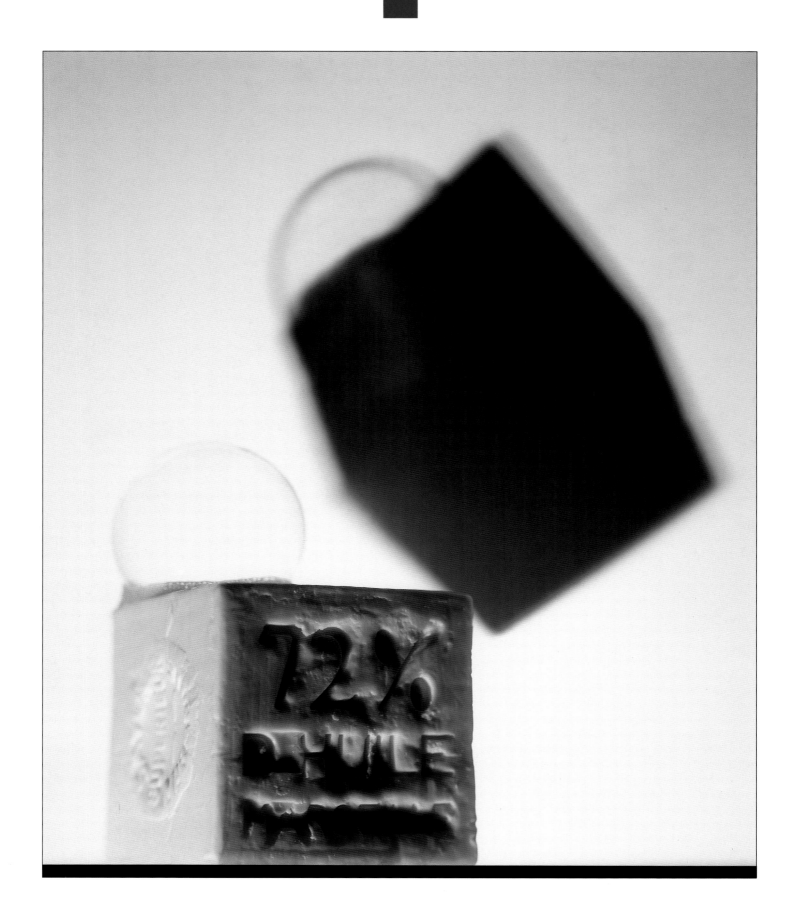

PASCAL LUCIANI
.
3/5 rue Mélingue
F-75019 Paris
Tel. & Fax: (33-1) 40 03 85 11

F R A N C E

F R A N C E

F R A N K R E I C H

Selection Parisienne

	International page	*Local page*
AMAR, MARIE	**318-319**. *42-43*	
BERTRAND,		
YANN ARTHUS	**320-321**. *44-45*	
BROWAR, KEN	**322-323**. *46-47*	
HAUSS, FRIEDEMANN	**328-329**. *52-53*	
HISPARD, MARC	**324-325**. *48-49*	
LARIVIÈRE, JEAN	**330-331**. *54-55*	
MANZETTI, JEFF	**326-327**. *50-51*	

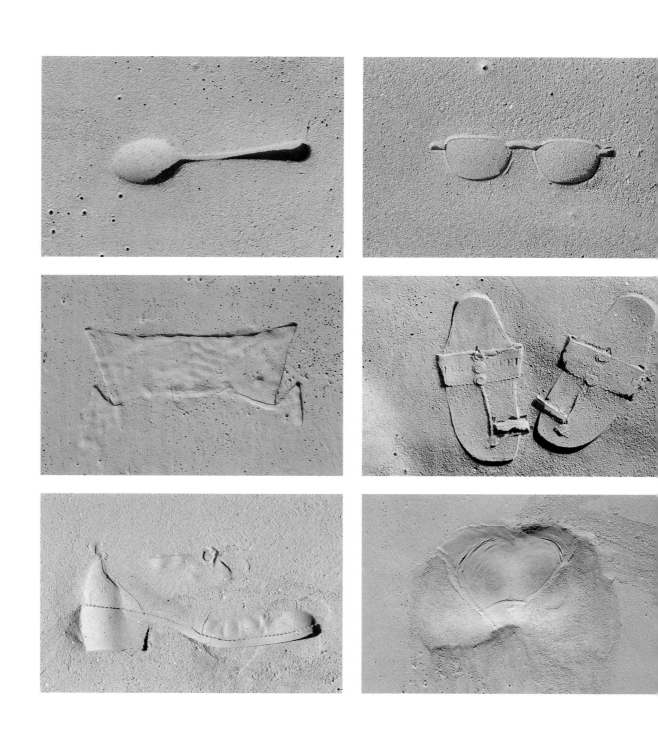

MARIE AMAR
45 , rue Copernic
F-75116 Paris
Tel (33) 01 45 00 03 19

Vestiges du quotidien

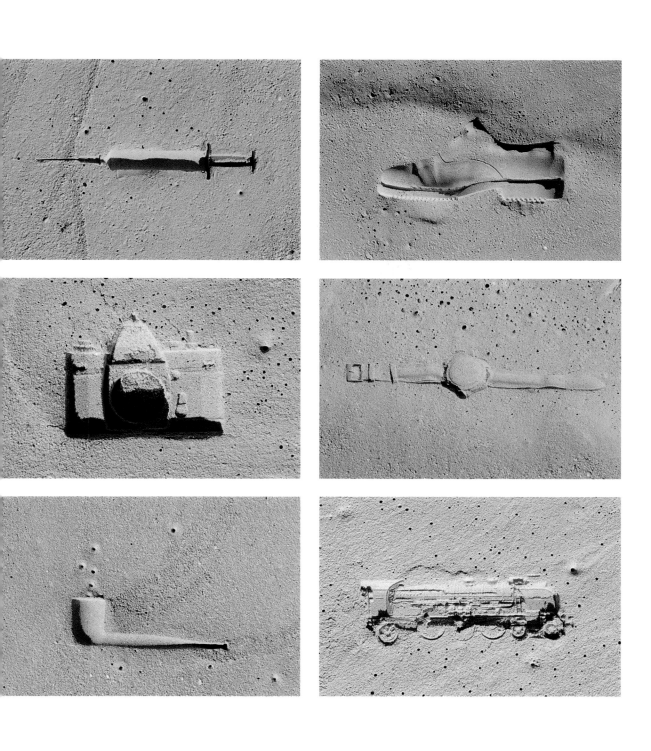

MARIE AMAR
45 , rue Copernic
F-75116 Paris
Tel (33) 01 45 00 03 19

YANN ARTHUS BERTRAND

Représenté par: Allain François et Associés
22, rue de Saussure
F-75017 Paris
Tel: (33) 01 42 27 54 00
Fax: (33) 01 46 22 00 24

BANC DE SABLE A WHITE HAVEN'S BEACH DANS LES
ILES WHITSUNDAY - QUEENSLAND AUSTRALIA

LES FOUS DE BASSAN SUR L'ILE DE ELDEY -
ILES DE VESTMANNAEYJAR. ISLANDE

YANN ARTHUS BERTRAND
Représenté par: Allain François et Associés
22, rue de Saussure
F-75017 Paris
Tel: (33) 01 42 27 54 00
Fax: (33) 01 46 22 00 24

DÉSERT DE MAURITANIE PRÈS DE TICHIT

KEN BROWAR
8, Ave. Victoria F-75004 Paris France
Tel: (33) 01 42 78 40 57
Fax: (33) 01 42 77 21 95

en Angleterre Représenté par à New York

Peter Townsend EN FRANCE Thersea Mahar
36 Lamb Conduit Street CAROL DARDANNE 233 East 50th Street 3F
London WC1N 3LJ 9, RUE DU GÉNÉRAL DELESTRAINT New York NY10022
Tel: (44) 171 831 6767 F-75016 PARIS Tel: (212) 753 7033
Fax: (44) 171 831 7374 TEL ET FAX: (33) 01 47 43 14 41

KEN BROWAR
8, Ave. Victoria F-75004 Paris France
Tel: (33) 01 42 78 40 57
Fax: (33) 01 42 77 21 95

en Angleterre

Peter Townsend
36 Lamb Conduit Street
London WC1N 3LJ
Tel: (44) 171 831 6767
Fax: (44) 171 831 7374

Représenté par

EN FRANCE
CAROL DARDANNE
9, RUE DU GÉNÉRAL DELESTRAINT
F-75016 PARIS
TEL ET FAX: (33) 01 47 43 14 41

à New York

Thersea Mahar
233 East 50th Street 3F
New York NY10022
Tel: (212) 753 7033

MARC HISPARD

Représenté par : DIDIER POUPARD - 19, rue de Bassano - F-75116 Paris - Tel: (33) 01 47 20 20 22 - Fax: (33) 01 47 20 55 44

Dior

COLLECTION AUTOMNE-HIVER 1996-1997

JEFF MANZETTI

JEFF MANZETTI

EN FRANCE

Thérèse Management
Contact : Dominique Desforge
13, rue Thérèse
F- 75001 Paris
Tel: (33) 01 42 96 24 22
Fax: (33) 01 42 96 24 11

EN ITALIE

Stefania Agamennone
Tel: 02 70 10 32 14
Fax: 02 89 50 61 02

EN ALLEMAGNE

Marlène Oblsson
Tel: 040 401 40 50
Fax: 040 490 54 42

FRIEDEMANN HAUSS
.

en Allemagne

Représenté par : Mariane Linke
Trogerstrasse 17
D-81675 München
Tel: +49 89 470 60 76
Fax: +49 89 470 64 67

en France

Représenté par : AGNÈS JACQUET
20, rue Rochechouart
F-75009 Paris
Tel: (33) 01 42 80 12 25
Fax: (33) 01 42 80 27 52

aux Etats-Unis

Représenté par : Judy Casey Inc.
114 East 13th Street
New York NY10003
Tel: +1 212 228 75 00
Fax: +1 212 228 93 39

FRIEDEMANN HAUSS
■ ■ ■ ■ ■ ■ ■ ■ ■ ■ ■ ■ ■ ■

en Allemagne

Représenté par : Mariane Linke
Trogerstrasse 17
D-81675 München
Tel: +49 89 470 60 76
Fax: +49 89 470 64 67

en France

Représenté par : AGNÈS JACQUET
20, rue Rochechouart
F-75009 Paris
Tel: (33) 01 42 80 12 25
Fax: (33) 01 42 80 27 52

aux Etats-Unis

Représenté par : Judy Casey Inc.
114 East 13th Street
New York NY10003
Tel: +1 212 228 75 00
Fax: +1 212 228 93 39

Les bagages et accessoires Louis Vuitton sont vendus exclusivement dans les magasins Louis Vuitt
Paris · Monaco · Tokyo · New York · Los Angeles · Hong Kong ·
Beijing · Londres · Rome · Milan · Munich · Düsseldorf · Genève · Zurich · Sydney ·

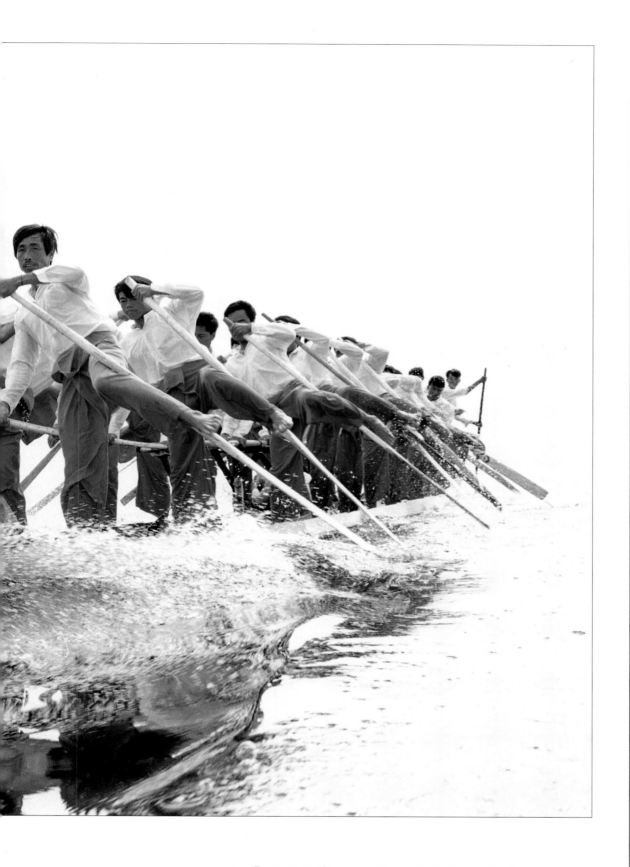

LOUIS VUITTON

JEAN LARIVIÈRE
· · · · · · · · · · · · · ·
16, rue Popincourt
F-75011 Paris
Tel: (33) 01 48 05 70 60
Fax: (33) 01 43 38 52 07